ROBERT BEVERLY HALE

Master Class in Figure Drawing

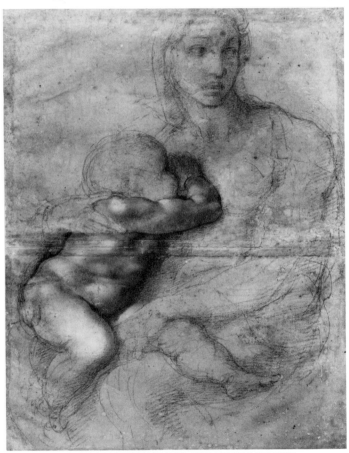

MICHELANGELO BUONARROTI (1475–1564), MADONNA WITH CHILD
black chalk, 21¼" × 15⅝" (54.1 × 39.6 cm)

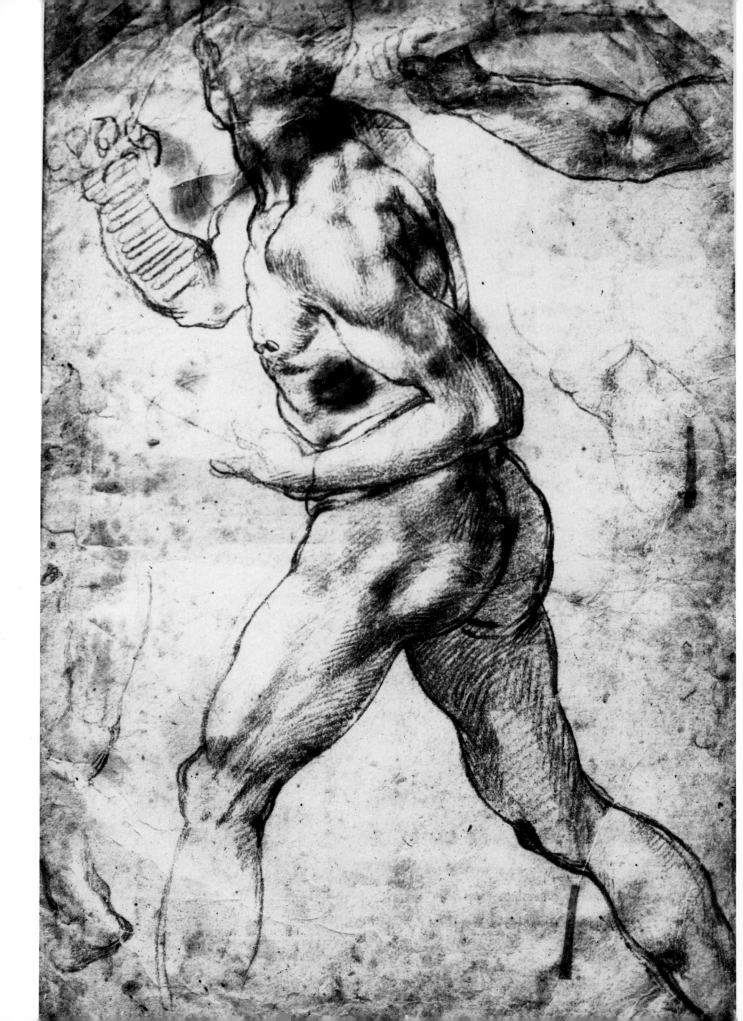

ROBERT BEVERLY HALE
Master Class in Figure Drawing

Compiled and Edited by TERENCE COYLE

WATSON-GUPTILL PUBLICATIONS/NEW YORK

Copyright © 1985 Watson-Guptill Publications
Copyright © 1983 Robert Beverly Hale

First published 1985 in New York by Watson-Guptill Publications,
a division of Billboard Publications, Inc., 1515 Broadway,
New York, N.Y. 10036

Library of Congress Cataloging in Publication Data

Hale, Robert Beverly, 1901–
 Master class in figure drawing.

 Bibliography: p.
 Includes index.
 1. Figure drawing—Technique. I. Coyle, Terence.
II. Title.
NC765.H155 1985 743'.49 85-611
ISBN 0-8230-0224-1

Distributed in the United Kingdom by Phaidon Press Ltd.,
Littlegate House, St. Ebbe's St., Oxford

Manufactured in U.S.A.

First printing, 1985
1 2 3 4 5 6 7 8 9 10/90 89 88 87 86 85

Now and then,
The lightning strikes for them.
And in our wilderness,
They see a garden.
And from a thousand roses,
They deduce the rose.

ROBERT BEVERLY HALE

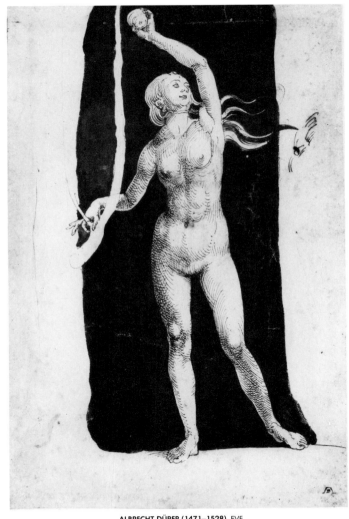

ALBRECHT DÜRER (1471–1528), EVE
pen, 10⁵/₁₆″ × 6½″ (26.2 × 16.5 cm)

CONTENTS

Foreword *by Philippe de Montebello* 9
Foreword *by Rosina Florio* 9
Preface *by Terence Coyle* 10
Introduction *by Robert Beverly Hale* 13

THE RIB CAGE 14
Massing 14
Planes and Values 16
Landmarks 18
Muscles 20
The Breast 23
Deep Muscles of the Back 24
Bones 25
The Vertebral Column 27

THE PELVIS 28
Massing 28
Planes and Values 31
Landmarks 34
Muscles 35
Bones 36

THE UPPER LEG 38
Massing 39
Planes and Values 40
Landmarks 43
Muscles 45
Bones 47

THE KNEE 48
Massing 48
Planes and Values 49
Landmarks 51
Muscles 53
Bones 55

THE LOWER LEG 56
Massing 56
Planes and Values 58
Landmarks 60
Muscles 60
Bones 63

THE FOOT 64
Massing 64
Planes and Values 65
Landmarks 66
Muscles 68
Bones 71

THE SHOULDER GIRDLE 72
Massing 72
Planes and Values 73
Landmarks 74
Muscles 75
Bones 77

THE UPPER ARM 78
Massing 78
Planes and Values 79
Landmarks 83
Muscles 84
Bone 85

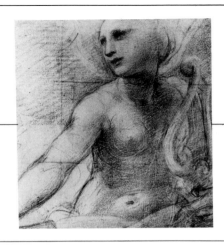

THE LOWER ARM 86
Massing 86
Planes and Values 87
Landmarks 90
Muscles 90
Bones 92

THE HAND 94
Massing 94
Planes and Values 96
Landmarks 98
Short Muscles 102
Bones 103

THE NECK 104
Massing 104
Planes and Values 107
Landmarks 109
Muscles 111
Bones and Deep Muscles 112

THE SKULL 114
Massing 114
Planes and Values 116
Landmarks 117
Child's Skull 121

THE FEATURES 122
The Eye 122
The Nose 130
The Mouth 136
The Ear 139
Proportions 140

Credits 141
Bibliography 142
Index 143

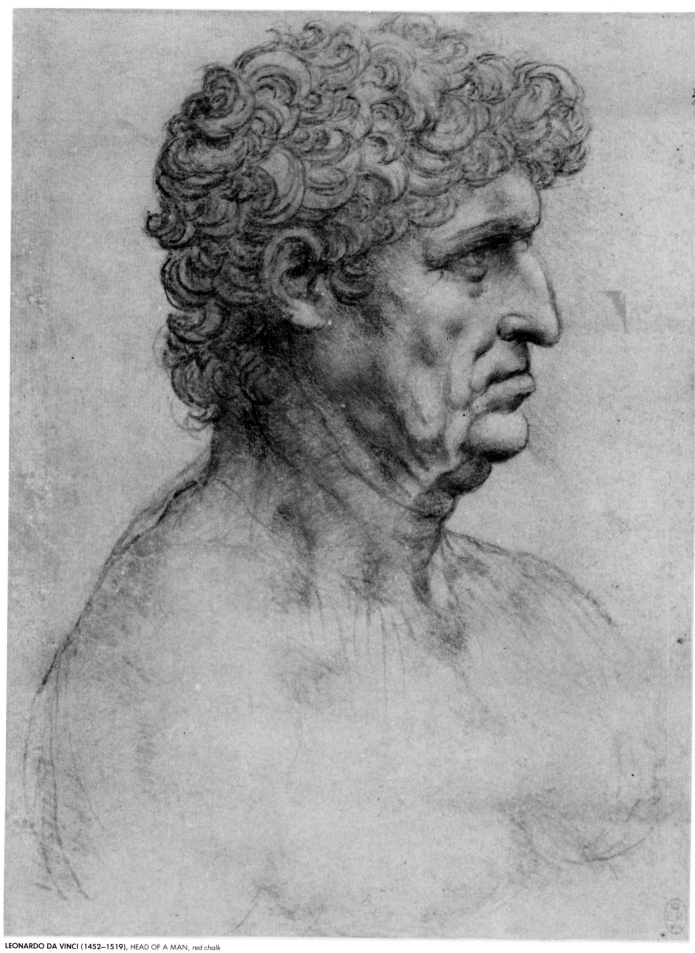

LEONARDO DA VINCI (1452–1519), HEAD OF A MAN, *red chalk*

FOREWORDS

WHEN ROBERT BEVERLY HALE joined the Metropolitan Museum of Art in 1948 as our first Curator of American Painting and Sculpture, he had already won a national reputation as America's preeminent teacher of figure drawing and artistic anatomy. His lectures at the Art Students League of New York—which drew capacity crowds until his retirement from teaching in 1982—had an enormous influence on the careers of literally thousands of American artists, while his pioneering work at the Museum, where he shaped and considerably enlarged the Museum's collection, had lasting impact on the art public.

For decades, Hale's admirers throughout America have hoped that his lectures on drawing and anatomy would become available in book form. I am delighted that this moment has come at last. For this book is not only a permanent record of Hale's teachings, but the crowning achievement of a man who remains an unforgettable presence in the lives of artists throughout America.

PHILIPPE DE MONTEBELLO
Director
Metropolitan Museum of Art, New York

KNOWING ROBERT BEVERLY HALE for many years is to know a great gentleman, a true intellectual, and an extraordinary person.

His demeanor is shy; and he seems unaware that he is much admired by his students, associates, and colleagues. To most of us, he is on a pedestal and we know that he is one-of-a-kind, a diminishing breed. Just about now, he would shyly remind me that my estimation of him is too grand. Indeed! I cannot praise him enough.

The many facets of Robert Beverly Hale's life are remarkable. He is a poet, an imaginative writer, and a dreamer of fantasies.

I remember the day I arrived in his class to talk to him and found him giving a lecture on the anatomy of a foot. Imagine my surprise to find over a hundred students, and Bob Hale without any shoes on, having a simply wonderful time, studying the foot bones. I backed out of the room thinking how intelligent the lecture seemed.

It is gratifying to know that thousands of students studied with him and to each and every one of them, he has left a lifelong remembrance of his knowledge, sense of humor, and his intelligence.

ROSINA FLORIO
Executive Director
Art Students League of New York

PREFACE

THIS BOOK WILL INTRODUCE the beginning student and the working artist to the concepts and guidance of one of the greatest and most successful teachers of figure drawing and artistic anatomy. For Robert Beverly Hale's vast following of seasoned artists who returned year after year to his lectures to refresh their knowledge and techniques, I hope this book will help to make up for their loss when he retired in 1982.

Hale was a dedicated teacher with an unusual gift for communicating in a most practical, stimulating, and imaginative fashion the oftentimes complex ideas of applying the elements and principles of drawing to artistic anatomy. He did this in a way that made the most difficult subjects intellectually stimulating and easy to grasp. He stirred the imagination and encouraged a creative outlook.

For more than thirty-five years, this extraordinary man dedicated his life to teaching countless thousands of students at the Art Students League the basic elements of drawing and anatomy. And somehow, in the course of a very busy career, he also found time to be the first curator of the American Painting and Sculpture Wing of the Metropolitan Museum of Art, as well as an editor of *Art News;* to hold one-man shows of his paintings, preside over numerous organizations, and raise a family. Among other things, he was a published poet of some renown and received the Mayor's first Award of Honor in Arts and Letters in 1977.

In a book for students of figure drawing, a certain amount of order is necessary to make it a valuable learning tool to which one can constantly refer. With Hale's blessing, I have arranged his lectures in the same chapter order that we used in *Anatomy Lessons from the Great Masters*. Within each chapter, I have first approached the subject of each area of the body from the viewpoint of Hale's oft-repeated reminder to think from simple to complex and from mass to detail. In beginning each lecture Hale often alternated between discussion of mass and discussion of detail to help clarify the complex subject matter. He thought that my idea of placing his explanations of mass conceptions first would be suitable when I mentioned that I would clarify the reasons for this arrangement.

Beginners must be made aware of the existence of the skeletal foundations that help to shape the

ROBERT BEVERLY HALE, 1978. *Photograph by Sidney Waintrob.*

outer masses. But at the same time, they must become prepared for their role as artists by learning to simplify and to translate the structural details into larger units of design. This is the artist's way of seeing. Beginners see detail first. Consequently, their structure usually falls apart from the start. Experienced artists see masses—big, simple, abstract elements which they first arrange on their paper or canvas—and then may proceed to more detail, which is incorporated into the dominant abstract design. Certainly experienced artists will already know that it is the bones and muscles that help create the planes and landmarks they use to design the shapes and patterns that define the figure and carry the eye through the composition. They have already learned this by studying anatomy. But whether an experienced artist analyzes a great master drawing to learn its secrets, or begins a drawing of the model in front of him, he thinks of mass first. The size, shape, and direction (or aspect) of the big form on the paper comes first in his mind. That is an important lesson that Hale gives the student.

So many students desperately ask: "What is the best way to begin? How do I proceed? What are the steps I might take from start to finish? How can I check proportions? What about foreshortening and perspective?" Hale clarifies these and hundreds of other questions that arise in figure drawing. This book is an approach to drawing that teaches the student to understand what to do—by himself—so that he can become more independent. Hale teaches the student how the great masters used anatomy in their drawings and compositions. His lectures point out that the surface detail which is so emphasized in many anatomy books, especially the medical ones, is not enough for the artist. The naming or reproducing of details without an understanding of the elements of drawing is little more than rote copying. It is like learning words without grammar and punctuation. Hale does not encourage the mere cataloguing of names and details of bones, muscles, and landmarks with stereotyped rendering formulas for each pose. Instead, he teaches you to become aware of the anatomical forms in terms of the elements and principles of drawing and composition. In other words, what to do with them. That is where the art

begins. That is the lesson of the great masters. That is what *Master Class in Figure Drawing* is about.

Although prints of a wide variety of great master styles have been chosen with a deliberate eye to those which most clearly lend themselves to the clarification of Hale's subject matter, I have leaned heavily on Leonardo and Dürer. This is not only in consideration of their great skill, clarity, and anatomical accuracy, but also because they seem to reflect Hale's spirit, his lifelong dedication to inquiring and solving the problems of drawing the figure that frustrate the student and working artist.

In compiling and organizing Hale's lecture material, my respect and admiration for this unique and wonderful human being increased day by day and chapter by chapter. I am more than rewarded by the thought that this volume will introduce Hale to countless artists and students who never had the advantage of hearing him, and that it will refresh the memories of his many friends and followers who annually attended his lectures at the Art Students League.

Great care has been exercised on my part in the selection, organization, and general presentation of Hale's lectures. I have gathered together what I have felt to be the most representative and pertinent material from Hale's teachings and writings. Should any misquote of Hale or any anatomical inaccuracy be allowed to pass, it must be ascribed to an oversight on my part and will be corrected in a later edition.

I wish to thank Bob Hale's friend, editorial consultant Don Holden, for his enduring support and devotion to this project; Mary Suffudy for her creative input and guidance; Bob Fillie for his superb design of the book; Sue Heinemann for her keen and sympathetic editorial eye; Jacob Bean, Curator of Drawings, and Helen Mules, Assistant Curator, at the Metropolitan Museum of Art for their assistance in the early stages of print selection; the many other museums credited at the back of the book; and, above all, I want to thank my wife Anne Costello Coyle for her patience and encouragement during this long and consuming project.

TERENCE COYLE

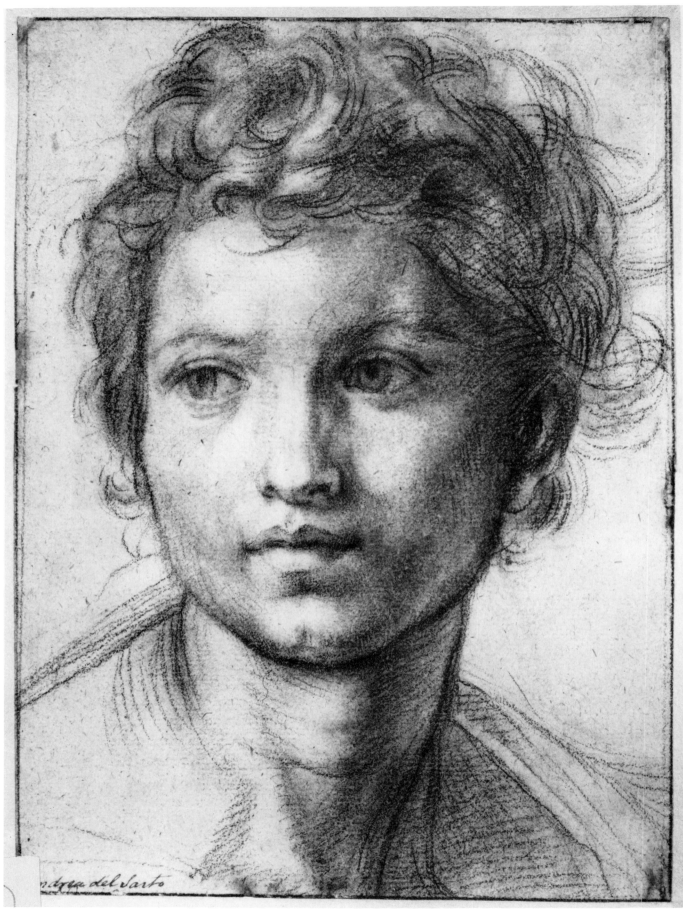

ANDREA DEL SARTO (1486–1530), HEAD OF YOUTH, *black chalk, 10⅝″ × 7⅞″ (27 × 20 cm)*

INTRODUCTION

THESE LECTURES are confined to a somewhat traditional method of drawing which has arisen in our Western civilization. They have to do with the study of artistic anatomy, the elements of drawing, and the ways and means of creating the illusion of reality in the portrayal of the human figure.

Though the basic elements of this method are simple, it is a most difficult matter to communicate them to others. If this were not so, mere exposure to these lectures would produce a good figure draftsman. Actually, no principle, no conception of drawing or of artistic anatomy may be fully grasped until it is experienced through long and continued practice in drawing itself.

The problem of presenting the illusion of a complex form such as the human body approaches a solution as soon as the student is able to present the illusion of the simple, separate forms of which it is composed. Only through the study of anatomy may the student become familiar with all the unfamiliar forms of the body necessary for a successful drawing of the figure. There are a great number of these forms in the body that are of great importance to the artist, but the beginner will be totally unaware of their existence. And naturally if he is unaware of the existence of a form, he will be unable to present the illusion of its shape. In the beginning, when he starts to draw a model he will see only those bodily forms which up to that time have been brought to his attention. He will see only those forms that have an emotional significance to him, or forms that he has read or heard about. Beginners never fail to draw a woman's breasts. Yet few are conscious of the rib cage underneath—a form of greater size and therefore greater importance. Beginners will always draw the belly and buttocks, but they will never be able to give the illusion of the pelvic region until they have become aware of two other important forms that help shape that area—the tensor fascae latae and the gluteus medius.

These lectures will introduce the beginning student of anatomy to such forms as the strong cords on each side of the center line of the small of the back, features of great importance in creating the illusion of the strength of man. They will point out spiral forms like the external oblique that carry the flow of the body from one part to the other, and all the other essential forms that certainly do not exist in the mind of the beginner in anatomy.

Once the student has become aware that these forms exist, then it is our task to assist him in coming to a decision about the shape of each. For naturally, the student cannot communicate to others the exact shape of a form unless he has the exact shape in mind. He must realize too that this is a very personal decision based on the study of the simple, basic shapes of the cube, the cylinder, and the sphere and their many possible variations. Actually the forms of the body have no exact shape and never have had except in the mind of the individual artist. They have always varied according to the knowledge, the style, and the time of the artist. They have always been created by the artist to conform to his ultimate purpose.

These lectures will further explain to the student that the shape of a form may not be fully realized until the student is able to visualize it from all points of view, until he is aware of its direction (or aspect), until, in short, he has acquired the "feeling for form" that an accomplished artist possesses.

In these lectures we discuss the technical problems that have been faced by generations of artists and certain methods that have been used in solving them. Perhaps it can now be seen that in essence, the experienced artist sets his own conditions and adapts himself to them. He is by no means forced to accept conditions that are inimical to his purpose. He is in full control at all times because he himself creates the questions and in doing so he may frame them to his answer. What is the shape of the form? The shape he wishes. Where does the light come from? Wherever he wishes. What are the proportions of a form? Those he thinks fitting. What is the direction of the form? The direction he decides upon. Have I made it clear that drawing is not a mere act of copying, but a highly creative act controlled by the artist's expressive intent?

ROBERT BEVERLY HALE

THE RIB CAGE

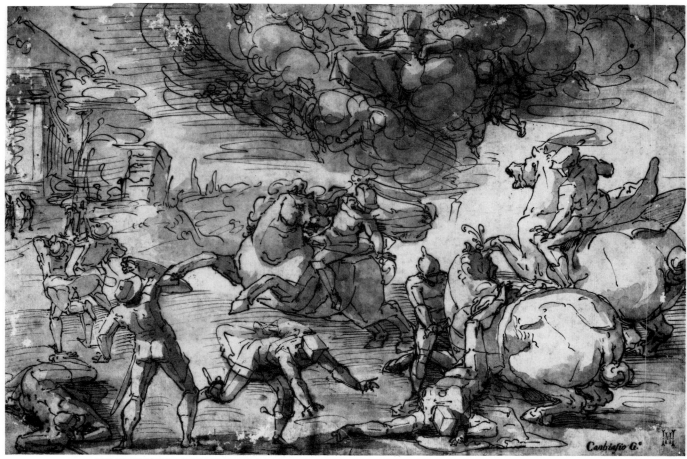

LUCA CAMBIASO (1527–1585), THE CONVERSION OF SAINT PAUL, *pen, brown ink, and brown wash on brownish paper,* 10¹⁵/₁₆" × 16" (27.7 × 40.7 cm)

MASSING
Back View

It is a pleasure to see that so many people are interested in anatomy. This, of course, is not exactly anatomy. It is what is known as artistic anatomy, which is very different from anatomy as we usually think of it. This is a course in anatomy and the elements of drawing. Actually I think it is much more drawing than it is anatomy. I suppose I never mention an idea in these lectures that is not of actual interest to the artist. I thought I would make a few general remarks on the problems that arise when you try to draw the figure.

The trained artist knows that everything in the universe is in motion, from the outer space beyond our solar system down to our own selves. He also knows that to draw an object, he has to

"still" it. In other words, he has to decide where it is—its position in space, and in which direction it is facing. He asks himself, "Is it above me or below me? Is it facing to the right or to the left?" When drawing the rib cage, the experienced artist doesn't start his drawing with a detail, such as the nipple or the navel, as a beginner usually does. Instead, he first visualizes the rib cage in the simplest form he can—a box. This is the only mass that gives him a full sense of direction. He has learned to visualize all complex forms in terms of very simple masses. He has found out, as did the great masters of the past, that all forms are modifications of the basic forms of the block or cube, the cylinder, the sphere, and sometimes the cone. We use these masses, not just for the fun of it, but to solve problems. One of our

first problems might be the general shape of the rib cage.

In this drawing by Cambiaso, we see how the artist conceived of the different parts of the body such as the rib cage (A) and the pelvis (B) as simple blocklike masses. Visualizing them in this way, he could clearly decide on the direction of each part of the body and compare its size to the other parts. It not only simplified his understanding of proportions, but also helped to clarify any problems with perspective. We find that perspective is a matter of blocks; therefore, blocks must always be in the artist's mind. The perspective concept teaches you to see things all at once—the front, side, and bottom of masses, as well as the direction they are facing. The artist uses perspective as a device to create the illusion of three dimensions.

"Drawing is like studying Greek and piano— you can't speak or play in your conscious, which is clumsy. You must get it into your subconscious, which is graceful. But that takes time."

MASSING
Front View

In a sense, I face the problem of a mystic trying to explain mystical experiences to people who have not had them. If you have drawn a lot, you understand what people say about drawing. But if you have not drawn very much, it is very hard to understand some concepts. If you are starting in, do not be discouraged. Just draw a little and the concepts will become clear to you.

I thought in this lecture I might go along on this tack: It seems to me that the beginning artist's mind is very, very different from what it becomes later on. When you first start to draw, you do not draw very well until you get all the artist's concepts into your mind. That is a very curious thing. The artist, you know, sees a lot of things that other people do not see, and he knows a lot of things that other people do not know. And it is our job, I suppose, as artists to find out how an artist thinks.

As far as I can see, beginners tend to think in a very literary way. They think largely in terms of what they have read about and what they have heard. They know that people have eyebrows, noses, mouths, and legs, and they get all these into the picture. On the other hand, they rarely read or hear about the rib cage, which is easily the largest form in the body—so they leave that out. They know people have knees. But they do not realize that "knee" to an artist is an extremely vague term—it does not mean very much. What we try to do as artists when we really study the human figure is to find out about things we do not know about: the bumps on the body, conceptions of mass, and things of that sort. They come as rather shocking surprises to some people.

Simple conceptions of mass such as the block, the cylinder, the sphere, and the egg readily flit through the mind of the experienced artist. In dealing with a single part of the body, he may change these forms instantly to solve problems that occur. In the

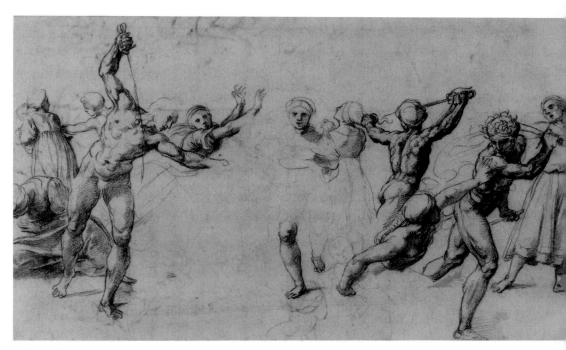

RAPHAEL SANZIO (1483–1520)
MASSACRE OF THE INNOCENTS
red chalk, 9³/₄" × 16³/₁₆" (24.8 × 41.1 cm)

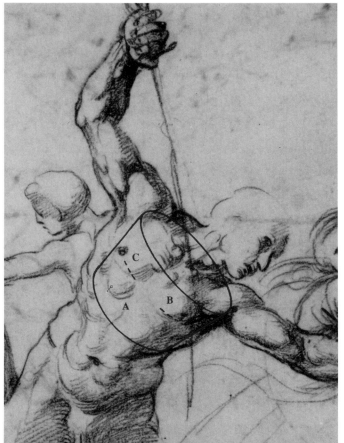

previous drawing, Cambiaso used the concept of the block to solve the problem of the direction of his masses. But the artist can visualize the rib cage as both a block and a cylinder, and sometimes uses one, sometimes the other. With the light coming from the side, Cambiaso decided to visualize the forms in his drawing as blocks. In this drawing by Raphael, the source of light comes a little more from the front, so he may have preferred to see the rib cage (A) as a cylinder slightly flattened from front to back. The lines (B) and (C) drawn at the base of the great pectoralis muscle reflect the cylindrical shape of the rib cage as well as the direction of the mass. In a side view of the body, the artist may think of the rib cage as an egg for purposes of light, line, and proportion. But if the rib cage is inclined toward him, as it is in this case, and he wishes to accentuate its direction, he may well think of a cylinder.

PLANES AND VALUES
Front View

Just as the trained artist is very
skilled at visualizing the forms of
the body in terms of simple
masses such as the cube, cylin-
der, egg, and sphere, he is also
very knowledgeable about the
planes of the body. Beginners just
draw outlines and details. Profes-
sionals know that the human body
is the most complex entity we
have yet discovered in the uni-
verse. It contains an enormous
assortment of diverse planes. No
wonder beginners become con-
fused and dismayed when they at-
tempt figure drawing. For, when
they start to draw, they can
scarcely offer the illusions of the
simplest forms known to man—
the box, the ball, and the cylinder.

Then why do life drawing when it
is so difficult? Because it teaches
you more about planes and values
than anything else.

Planes are the skin of mass. As
artists, we draw the planes that
we see on the model, but actually
we are drawing these different
planes on our flat pads. We imag-
ine our pads to be the picture
plane, on which we will create the
illusion of the planes we see on
the model. We have to imagine
other things: that we have one eye
in the middle of our forehead; that
we ourselves are still and not
moving—as if we were a tripod;
that the model is also not moving;
and finally that the light is not
moving. We can't work with a
moving light or with the 40 lights
we may find in a studio. So, for
the most part, we have to imagine
the dominant source of light and
keep it there. The professional
usually thinks of two lights, a di-
rect or dominant light (often 45
degrees to the picture plane and

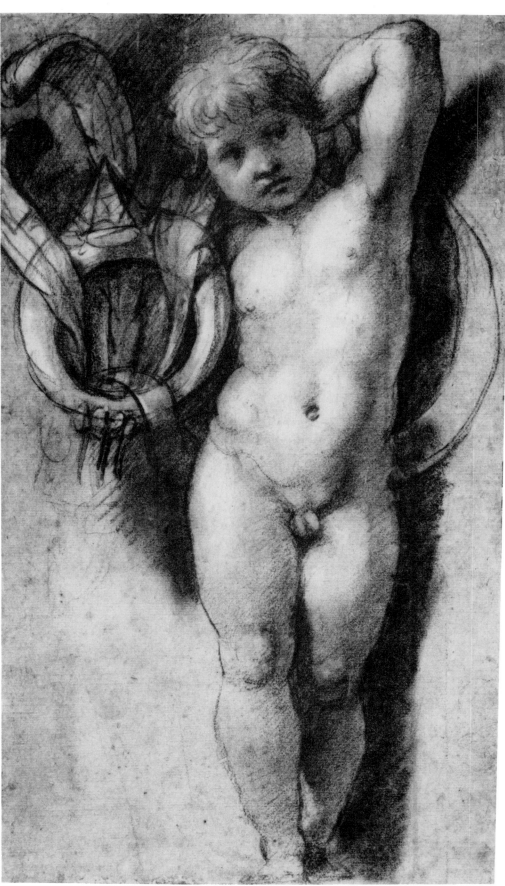

RAPHAEL SANZIO (1483–1520), PUTTO CARRYING THE MEDICI RING AND FEATHERS
black chalk heightened with white, 13¹⁵/₁₆" × 7⁵/₁₆" (33.9 × 18.6 cm)

from above) and a reflected light or a "light bounce" from the back.

In this drawing Raphael has visualized his dominant light source as coming from the model's left, above, and in front. He may have mentally massed the rib cage and visualized the dominant plane break in the upper half of the mass at the side of the pectoralis (A). He then could have imagined a well-known construction line (B) along the line where the rib cage changes direction as the ribs meet the cartilage and created his big plane break (C) of the lower half of the cage along this line.

PLANES AND VALUES
Back View

When first drawing the figure, the student, distracted by detail, is unable to see the large movement of values necessary for a successful rendering. In an effort to simplify values, it is well to first visualize the body in terms of simple, flat planes. Then you can be sure that the planes on which the light falls are of lighter value regardless of the values you see on the body. This helps you to draw what you know will create the illusion of form, rather than depicting cast

shadows, the edge of the model's sunburn, and similar distracting values that destroy the illusion. Later on, these big, simple, flat planes can be broken down into various smaller planes, both flat and curved.

Students soon discover that useful lines can be drawn to show where the planes meet. Often they may run an imaginary line over these invented planes breaks rather than over the form they actually see, and thus promote their illusions. By first thinking of the dominant plane break, you establish the concept of the controlling or dominant masses, which will

give strength of design and character to your drawing. You then create the strongest contrast of values between the front and side planes of these dominant masses.

In Dürer's sketch we might imagine a dominant plane break (A) to simplify the light (B) and dark (C) masses of the upper rib cage. The plane break (D) in the lower rib cage is at the well-known line of the angle of the ribs. Darks (E) on the side of the rib cage facing the light are kept generally subdued to emphasize the simplicity and unity of the controlling masses of the two big light and dark shapes.

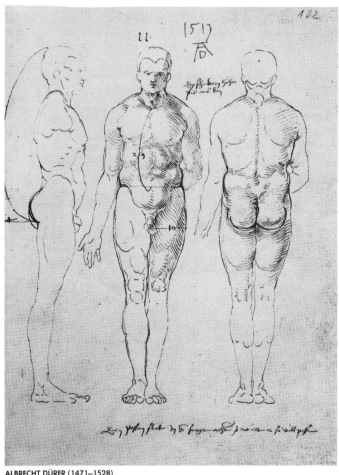

ALBRECHT DÜRER (1471–1528)
MAN OF EIGHT HEADLENGTHS
pen and ink
11⅛" × 8⅛" (28.3 × 20.6 cm)

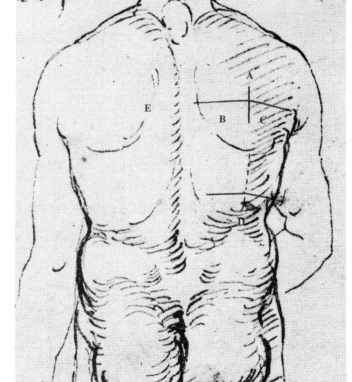

LANDMARKS
Front View

Landmarks are areas of particular interest on the body. For the trained artist, they often nicely indicate the shape, size, and direction of forms as well as bodily proportions. When landmarks are used to indicate proportion, they are preferably based on the skeleton rather than on the fleshy forms of the body. They can be as big as your thumb or as small as a point. The artist often prefers to indicate landmarks as geometrical points of position. For instance, the bottom of the tenth rib is about as big as your jaw, but the artist will make an agreement with himself and place a simple point on, say, the lowest part of this rib.

In this case, and for a special reason, instead of a point, Dürer has drawn a very strong curved line (A) to represent the low point of the tenth rib and the bottom of the rib cage in the front. Then he has placed a circle around this. It is believed that he sent this drawing to a doctor outside the town of Nuremberg, where he was living. He was asking for medical analysis and treatment for the pain in the area of his spleen. The inscription above reads: "There where the finger points is the yellow spot where it hurts me."

Dürer used even simpler lines to indicate the spiral curve of the clavicle (B) with the important landmark of the pit of the neck (C) at its inner end. The light vertical line (D) is the front of the sternum and the center line of the rib cage. It gives us both the horizontal and vertical aspects of direction of the mass of the rib cage. Is there any doubt that the rib cage is facing to our left and that the sternum faces upward?

ALBRECHT DÜRER (1471–1528)
SELF-PORTRAIT WITH LIVERSPOT
pen and watercolor
5" × 4⅝" (11.8 × 10.8 cm)

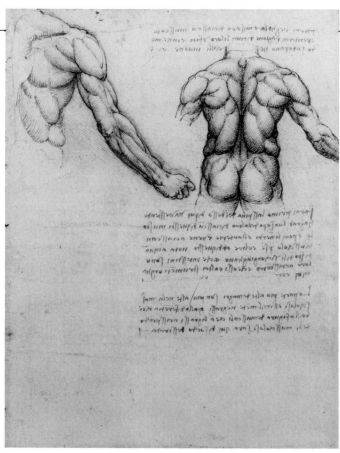

LEONARDO DA VINCI (1452–1519)
TWO VIEWS OF A MALE BACK
black chalk

LANDMARKS
Back View

Generally artists don't like the straight back view. The reason, of course, is that in this view, the line in the center of the rib cage appears straight, and a straight line suggests flat form. Well, everybody knows there's an awful lot of movement in the spine. We can see that the line of the spine in Leonardo's drawing runs from the important landmark of the seventh cervical vertebra (A) down to the sacral triangle (B) at the bottom.

Most artists would just hate to make that line straight. They would take that line and move it a little to the right or left so that it is moving. Of course, that's not so hard—all you have to do is look out of your right eye instead of your left eye, or vice versa, and the line begins to move right or left instead of being straight ahead as it is with two eyes. The line then begins to express the curve of the spine.

Pretty soon you realize that since you see out of one eye and then the other, perhaps the model is always moving. Try holding your fist up in front of your face. First squint with your right eye and then your left, and notice how it goes this way and that, this way and that. So then you realize you have to draw out of a convention, as if there were one eye in the middle of your head. You have to do this—otherwise the model moves, don't you see. Not very much, to be sure, but enough to destroy your accuracy when you don't want movement to the side.

If we have to take the straight-on back view, the only way we can suggest the movement is to darken the values on the side and down planes of the masses and lighten them on the front and up planes, as Leonardo has done in his drawing for more contrast and movement.

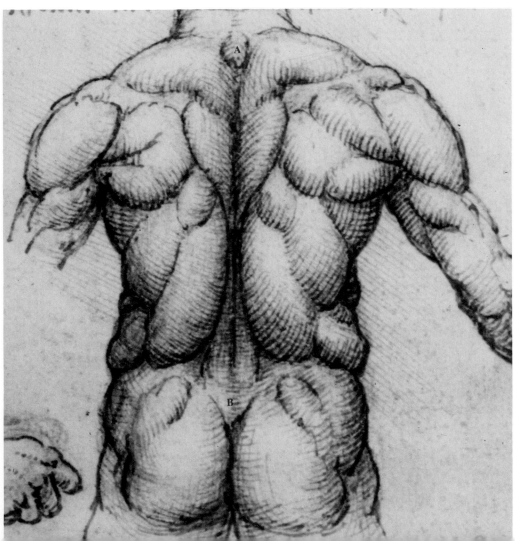

PETER PAUL RUBENS (1577–1640)
YOUNG MALE NUDE WITH ARMS BEHIND BODY
black chalk
18⁹/₁₆" × 8³/₄" (47.2 × 22.2 cm)

MUSCLES OF THE RIB CAGE
Front View

Now we are going to start in with
some very serious dissection. We
will take up the rib cage in great
detail.

I often get doctors in my
classes, who know a great deal
about anatomy, but they are not
very successful when they start to
draw because they know the
wrong kind of anatomy. The artist
knows a very different kind of
anatomy. He thinks differently
from the doctor. He does not
think in terms of details. Instead,
he thinks in terms of mass, thrust,
planes, values, line—all the things
we talk about in these lectures.

The rib cage is by far the largest
form in the body, and therefore
the most important, I would say.
The question is: What direction is
the rib cage going in Rubens'
drawing here? If I run the center
line (A) down the front in the di-
rection of the sternum under-
neath, I at least know how much it
is rotated.

The mass of the pectoralis ma-
jor (B) sits atop the front of the
upper half of the rib cage. Rubens
has placed the dominant plane
break (C) of the pectoralis at the
side and as far over as the nipple,
which falls into the dark side of
the plane. Note the fatty fold (D)
at the armpit, where the fibers of
the pectoralis go into the arm to
pull it forward.

If you imagine a construction
line (E) drawn directly down from
the nipple on a man, you will get
the front edge (F) of the slips of
the serratus muscle at the side of

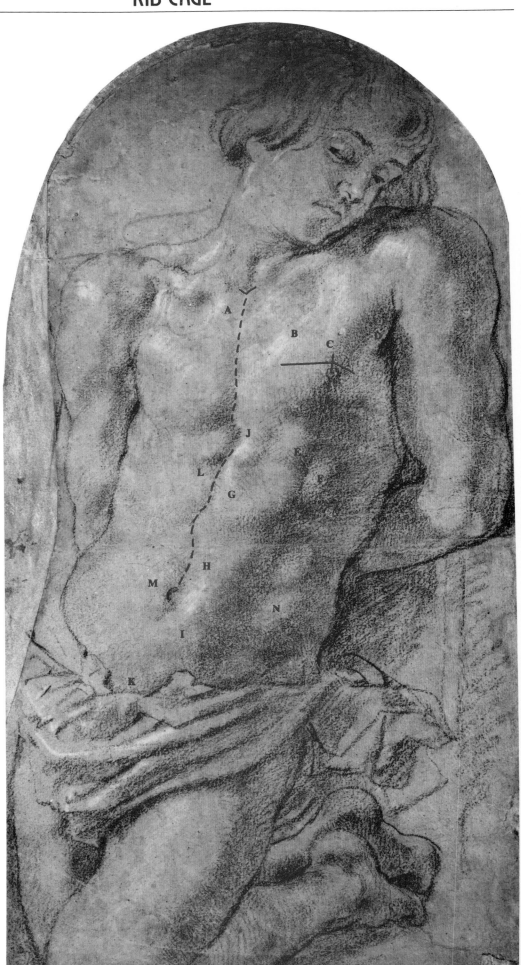

the rib cage. The three masses (G, H, and I) of the great rectus abdominus muscle run from just below the middle of the rib cage (J) down the front of the body to the front of the pelvis (K). Rubens has lightly indicated the line (L) of the linea alba, which divides the two sides of the rectus and stops at the navel (M).

Note the lit-up front plane (N) of the fatty portion of the external oblique. This muscle, which rotates the rib cage on the pelvis, generally has a teardrop shape, which most of you probably know. Certainly you have seen it strongly emphasized on antique statues when you have gone to museums.

MUSCLES OF THE BACK
Side View

We know that although the size of the skeleton varies from person to person, the proportion of bone to bone and of one mass of the skeleton to the other can be roughly estimated. The flesh, however, differs very much on everyone. It is at the mercy of age, environment, and the individual flutterings of human will. We can have the delicate muscles of a watchmaker or the bulging muscles of a weight lifter. We can be fat or thin. Nevertheless, in our fleshed secret figure, we may include certain known landmarks that clue us to proportions, to the meeting of bodily planes, and to other forms that result from the unchanging origin and insertion of muscles in the rigid bones.

In this side view of the figure by Rembrandt, you can easily feel the mass conception of the egglike form of the rib cage. It is an egg that is narrow at the top and wider at the bottom. You can take a ride over Rembrandt's variations on the surface of that egg. The line (A) of the vertebral column at the center of the rib cage overlaps the scapula (B) at the back. The mass of the latissimus dorsi (C) curving over the rib cage gives extra bulk. Note the dip (D) where the rib cage turns inward, and then the movement outward (E) for the mass of the strong cords or erectors of the spine. The hatching shapes define the masses of the external oblique (F) and the crest (G) of the pelvis.

In spite of the great masses of flesh on his model, Rembrandt was able to use his vast knowledge of bony landmarks and muscular shapes, sizes, and directions to accurately judge and render the proportions of this figure.

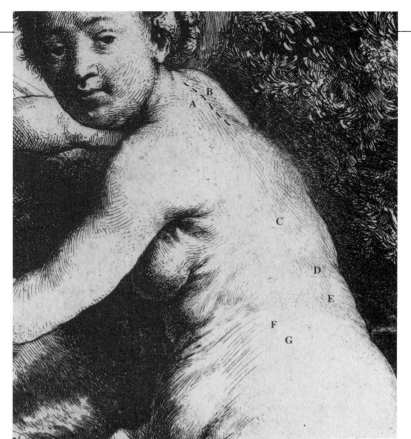

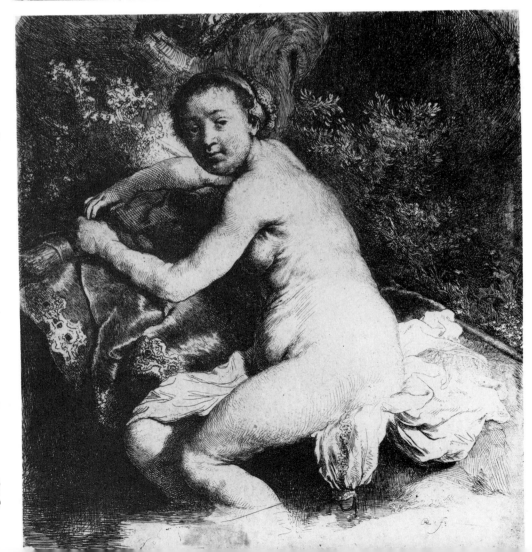

REMBRANDT VAN RIJN (1607-1669)
DIANA AT THE BATH
etching, 7" × 6¼" (17.8 × 15.9 cm)

PETER PAUL RUBENS (1577–1640), FOUR NUDE FEMALE FIGURES AROUND A BASIN, *pen and ink, 4½" × 8½" (11.4 × 21.6 cm)*

MUSCLES OF THE RIB CAGE
Back View

In these lectures I talk to a very varied audience. Some are people I know of old, who are very accomplished artists; a few are people who are absolute beginners; and there are grades in between. So the things I say may sometimes be very simple, or they may be very complicated. I am afraid you may not understand some of the things I say, but it will depend entirely on how much you have drawn or painted. If you have drawn or painted a good deal, I am sure you will understand everything I say.

When drawing the back, most skilled artists immediately decide on the placement of the line of the vertebral column (A) or backbone, as Rubens has clearly indicated in his drawing. He surely must have had this in mind so that he could decide on the direction of the rib cage. He made the watermelonlike mass of the latissimus dorsi larger in the near portion (B) and smaller on the far side (C). This diminishing of size is an

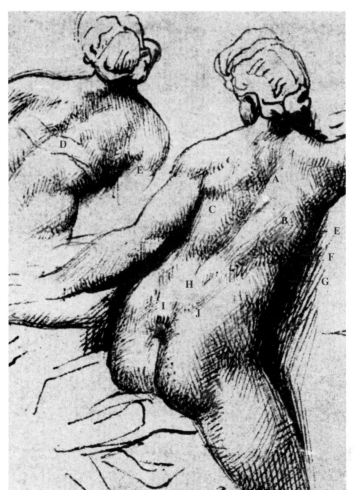

additional clue to the direction of the rib cage.

In the far left figure, Rubens has drawn two parallel curved lines (D) over the back of the rib cage, giving us the traditional concept of the shape of the back as a fluted cylinder. Of course, if you want to further clarify the back, you have to throw a little light on it. Notice that the darkest darks (E) in the two left figures are on the side of the flute furthest from the light source on the left.

The side plane darks (F) of the lower rib cage are connected to the side plane (G) of the external oblique. The ropelike strong cords (H) that move up from the sacrum (I) are part of the dominant light shape of the back. So that they won't jump out of place and become what we call "spotty," Rubens has subtly indicated them with a few light hatchings (J). He has been selective in his muscular definitions. And as an artist, he knew that if he threw on too many lights, he would destroy the form. He imagined and used simple lighting to give strength and unity to his design.

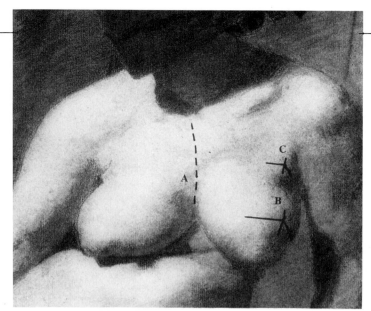

THE BREAST
Front View

When the artist draws the breast, he forgets for a moment that it is a breast, and thinks of it as a sphere. But you can't put the spherical form of the breasts on the rib cage until you have decided on the direction of the rib cage. The beginner often gives us a profile view of one breast and a front view of the other. It then appears that the rib cage is looking in two directions at once; in other words, it has a double aspect. You see, no form can look in two directions at once. That is, no solid form can do that. A piece of chewing gum can, but no form can really have two directions at once. So watch this thing particularly. You'll all be drawn to do it.

In this drawing done by Thomas Eakins in about 1875, the face of the model was covered to conform with the rules of modesty. You can immediately solve the problem of direction of the rib cage by visualizing the center line (A), which is really the bone of the sternum.

If there is one thing students know about, it is nipples. They put them in hard because they see them and probably read books about them. They always put them in the middle of the breast; you will find that is very usual. Putting the nipples in the middle of the breast and making the breasts look straight ahead is a very primitive mistake. The fibers of the breast hang off the sternum so the mass will hang a little to the side—especially if they are heavy. So you should always place the breasts so that they look this way and that way. This one is looking up at the Cathedral of St. John the Divine, and this one is looking to the police precinct on 58th Street. That's the way they ought to be placed—church and state. Do not let them look straight ahead.

The dominant plane break (B) of the breast in this drawing is on the side of the breast furthest from the upper left light source. Just above the breast is the plane break (C) on the skin fold of the pectoralis, moving to its insertion in the upper arm.

You should vary the size and shape of the breasts a little. They are never exactly the same, as beginners make them. To get more vitality and movement in their shapes, artists usually avoid exact symmetry of the parts of the body from side to side.

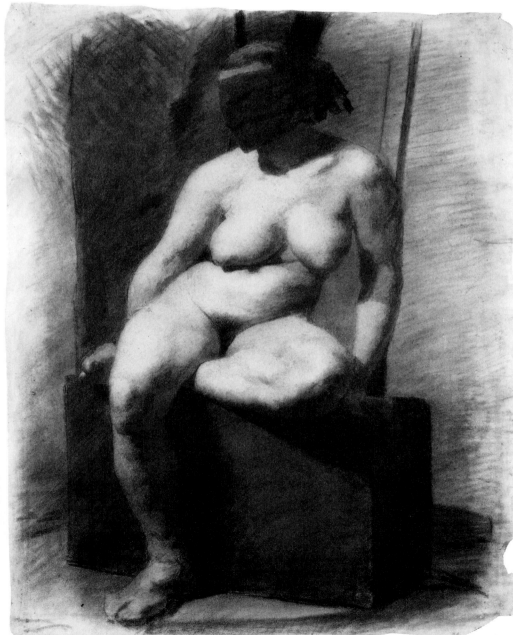

THOMAS EAKINS (1844–1916)
NUDE WOMAN SEATED WEARING A MASK
charcoal
24¼" × 18⅝" (61.6 × 47.3 cm)

DEEP MUSCLES OF THE BACK
Back View

As you progress in anatomy, always keep in mind that man holds himself erect, and that the muscles assigned to help him do this are strong and prominent. As a matter of fact, these important muscles are often accentuated and characterized by artists to promote a more human appearance and to differentiate man from the beasts. In order to hold this mechanism of the body erect, you have to have some very strong muscles between the rib cage and the pelvis so the rib cage won't fall forward. The anatomical engravings of the famous sixteenth-century anatomist Albinus, which are exceptional in

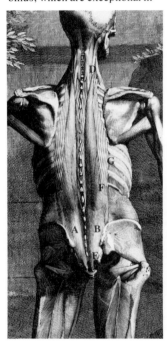

their clarity and accuracy, are excellent for studying these muscles in detail. The muscles that students call the strong cords of the back and doctors call the erectors of the spine can be seen on each side (A and B) of the center line (C) of the small of the back. They hold the rib cage erect above the pelvis. Similar cords buried in the back of the neck (D) hold the head erect above the rib cage.

You can think of the strong cords of the lower back as growing out of the sacrum (E) and into the rib cage (F). We feel, on each side of the center line (C), a very strong column that is as wide as the line of the angle of the ribs (G). Certainly, if you consult the drawings of the masters, you will almost always see these columns indicated, especially in the lower portion. Above, they are covered by the latissimus dorsi so they are not always shown in anatomy books.

BERNARD SIEGFRIED ALBINUS (1697–1770)
PLATE FROM *TABULAE SCELETI ET MUSCULORUM CORPORIS HUMANI*, 1747
engraving

BONES
Multiple Views

Undoubtedly, if you study the techniques of the old masters you know that one of the ways that they taught their students was by having them become familiar with the skeleton. You see, in the very early days, and pretty well on, dissection was frowned upon. People didn't dare to do dissections. But they didn't mind if you had a little collection of bones, and they were easy to come by. So if you got an apprenticeship with Leonardo or another great artist at the age of eight, which was when people started to study art, the old man would throw you a bone and say, ''Learn this.'' And by learning it, he simply meant to learn it so you could draw that bone out of your head in any direction. Now, if you knew all the bones, you knew the skele-

ton, and you knew where the muscles started and where they ended. Then you just drew a line from where they started to where they ended and you drew a beautiful figure. I'm trying to get you to draw bones out of your head.

While Leonardo's anatomical drawings were very advanced for his era, they do sometimes exhibit minor inaccuracies. This was due to the fact that he did not possess a complete skeleton; moreover, the parts that he did possess presented problems of accurate arrangement of the whole due to shrinking of the soft fibers. In this page from his sketchbook, the scapula (A) is positioned correctly, but we know that it really goes only halfway down the rib cage or just a little lower than half. In the front view, the sternum (B) should go about halfway down the rib cage.

If we want to make good figure drawings, we have to learn a good deal about the skeleton because in many places of the body the skeleton really comes right through. The hands are very hard when you tap them, and that must mean bone and a study of the bones. The knees are hard. Bones come through at the extremities. The head is pretty hard—study your skull. I feel that in order to make up figures beautifully and to draw well you really have to know your whole skeleton by heart so that you can draw it in any position out of your imagination.

The inscription at the top of Leonardo's page of studies reads: ''What are the parts of man where the flesh, no matter what the obesity, never increases? And what are the places where this flesh increases more than anywhere else?'' Artists know that bony

surfaces like the clavicle (C) and the pit of the neck (D) are visible on the fattest model. In the back, the seventh cervical vertebra (E), the spine (F), the inferior angle (G) of the scapula, and the point of the shoulder (H) are all visible as bony landmarks. We all know that the area (I) between the rib cage and the pelvis is often modified by an increase of flesh. You can make many other similar observations throughout the body.

It's terribly important to get a truly full sense of your rib cage in the figure. That's why I suggest to everybody that just in the beginning they draw the rib cage every now and then. Otherwise they just forget about it. But also, since it's the largest, the major form in the body, it's very important to get the feel of the rib cage and how it can modify the surface contours of the body.

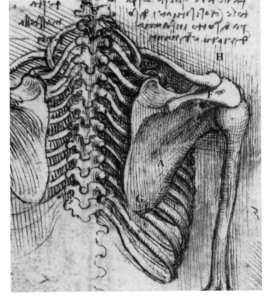

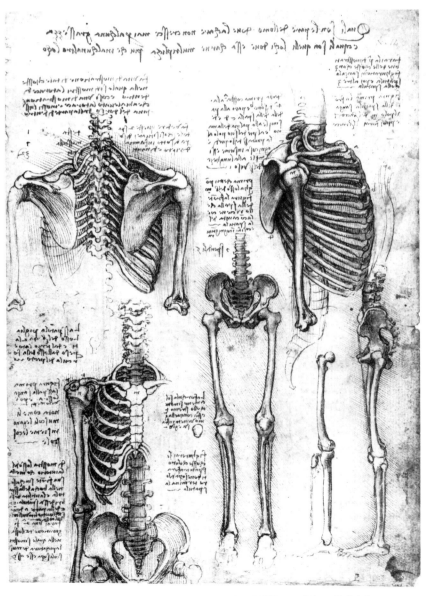

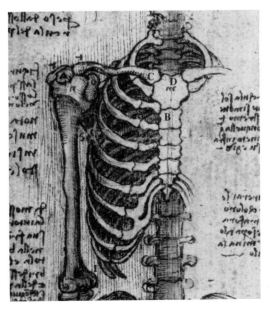

LEONARDO DA VINCI (1452–1519), STUDIES OF A RIB CAGE, PELVIS, AND LEGS, *pen and ink over black chalk*

BONES
Front and Back Views

There are many proportional systems, but beware of those that follow fleshy rather than skeletal landmarks. A lot of people like to measure the body in terms of the height of heads. They like to say it is one head from the bottom of the chin to the nipples, another to the navel, and one more to the bottom of the buttocks. But nipples, especially in women, vary greatly in position. The navel moves about like a traveling salesman, and the exact position of the buttocks is just about as predictable. Using bony points of reference is a much more accurate and sophisticated method.

We have already spoken of visualizing the mass of the rib cage as a simple box. Within that box, the rib cage might be seen as a

DR. PAUL RICHER (1849–1933)
PLATES FROM *ARTISTIC ANATOMY*, 1889
pen and ink

cylinder or an egg. It might be an egg that is narrow at the top and wide at the bottom. As we proceed, of course, this simple mass concept must be greatly refined. The best way to continue the refinement of the shape of a rib cage is to encase it, or partially encase it, in a rectangular solid or block. Though many different blocking systems are possible, for the present I freely offer you mine so that, at least, you can understand the procedure and benefits of blocking. Artists feel, you see, that some sort of block related to the rib cage is necessary, otherwise they cannot take advantage of its line systems when they wish to draw the rib cage in perspective. Dr. Paul Richer's drawings are incredibly accurate in proportion and can readily illustrate my system of blocking.

My rib cage block consists of four cubes of five eye widths each. Each of these four cubes is also the width of the ball of the head (A) and the length of the sternum (B). Hence we call them "sternum boxes" and "sternum lengths." Together these four sternum boxes produce a rectangular mass most convenient for the placing of many bony and muscular landmarks of the rib cage. In the front view, we can see that it is one sternum length from the base of the nose (C) to the pit of the neck (D). Another box or sternum length down and you get the bottom of the sternum (E), or the middle of the rib cage. One more down brings you to the bottom (F) of the rib cage and the level of the tip (G) of the tenth rib. You can locate the wide point of the rib cage by drawing a con-

struction line (H) through the rib cage at the level of the base of the ensiform cartilage (I).

In the back view, one sternum length down from the base of the skull (J) gives you the level of the pit of the neck (D)—the top of the rib cage in the front view. The rib cage is a little higher in the back and goes up to the base of the landmark of the seventh cervical vertebra (K). One more box down gives you the middle of the rib cage (E). Notice that the bottom (L) of the scapula comes down to this line. Sometimes it hangs just a little lower. One more box down and we have the bottom (F) of the rib cage.

You can easily locate the important line of the angle of the ribs (M) moving upward at about mid-box. It is along this line that the dominant plane break of the lower back takes place. The inner border of the scapula (N) lies along

the upper part of this line. The counterpart of this line on the front, and also a dominant plane break in the lower rib cage, is the line (O) where rib meets cartilage.

Once you have blocked up the rib cage, it then becomes an easy matter to throw this mass of boxes into perspective, and the rib cage and its landmarks with it.

THE VERTEBRAL COLUMN
Multiple Views

When man began to stand erect, the vertebral column—or the backbone as the layman calls it— had to adapt itself and produce new curves in its overall form, different from those of animals and characteristic of man and man alone. We can analyze the structure of the human backbone in these very accurate drawings by Leonardo.

In the side view (A), we can see that as the column moves downward, the seven cervical vertebrae of the neck area take on a C-curve (B). This curve is convex to the front of the body in order to get under and support the head that sits on top of it. Then the twelve dorsal or thoracic vertebrae of the rib cage area make a more pronounced C-curve (C) to the back. It is as if the column tried to go around and get under the rib cage that it supports. Then, suddenly, it forms still another C-curve (D), this time to the front, as if to support the pelvis.

This page from Leonardo's sketchbook also gives us his studies of a vertebral column from the front (E), from the back (F), and two detailed studies (G and H) from the back on a larger scale.

It is wise to learn by heart these curves of the column as they have a great influence on the shape of the figure. In the profile of the body, they force the forward curve of the cylinder of the neck. The front of the neck is nothing but a reflection of the movement of the cervical region (B) of the backbone. The belly is a reflection, you see, of the movement of the lowest portion (D) of the backbone. In the back of the body, the C-curves are responsible for the spirit of the outline from the head at the top, to the projection of the gluteus maximus at the back.

By studying the skeleton of the human figure, we gain a much clearer conception of how artists decide on the shapes they use in creating the illusion of the human figure. Most of all, we come to understand the movement of man's spinal column, which so greatly influences the gesture and form of his body.

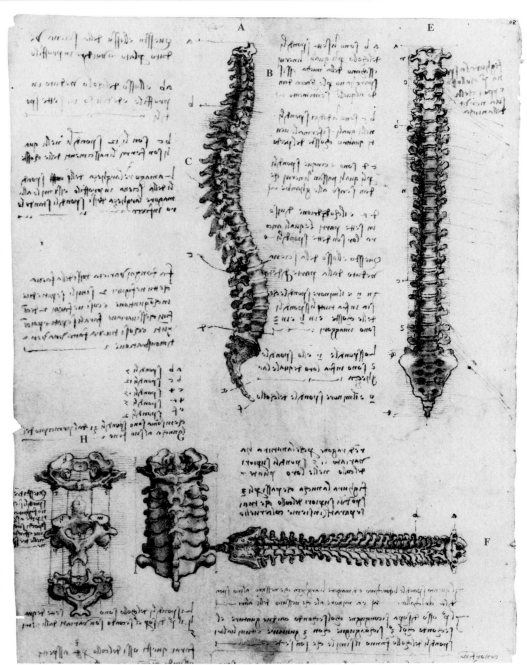

LEONARDO DA VINCI (1452–1519)
STUDIES OF THE SPINAL COLUMN
pen and ink over black chalk

THE PELVIS

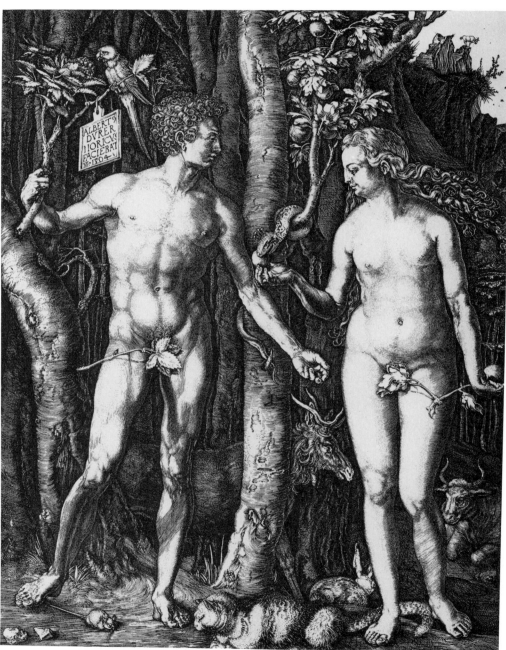

ALBRECHT DÜRER (1471–1528)
ADAM AND EVE
engraving

MASSING
Front View

Mass conceptions play a great part in solving not only problems of direction (or aspect) and perspective, but many difficulties of general shape and proportion. In this full-front view Dürer has achieved in the two beautifully rendered figures one of his finest expressions of a lifelong search for the ideal human proportions.

In analyzing the relationships of the rib cage and pelvis, we might visualize them as simple blocklike masses. In this way small differences become readily apparent. If you follow the side of the box of the rib cage (A) downward in the female figure, you run into the line (B) of the side of her pelvis. You can easily see how the pelvis is much wider than the rib cage in the female. If you look carefully, you will observe another anatomical fact known to artists: that the male is widest in the rib and shoulder area and that the side of his rib cage (C) is about the same width as the side of his pelvis (D).

In the female figure here, the weight of the body is on her right leg (E), which causes the right side of her pelvis (F) to tilt upward. Her rib cage has inclined to her right, and to create balance, the side (G) of her pelvis has dropped down a little.

We see right away that mass conceptions help to make these and other differences in the human figure readily apparent. So start drawing mass conceptions over and over until you can commit them to memory and readily visualize them. Then you can file them away on a most accessible shelf in your subconscious, ready to be taken out at any time to solve the problem at hand.

"Everything in the universe is in motion.
The only way we can still anything
is to relate it to something else."

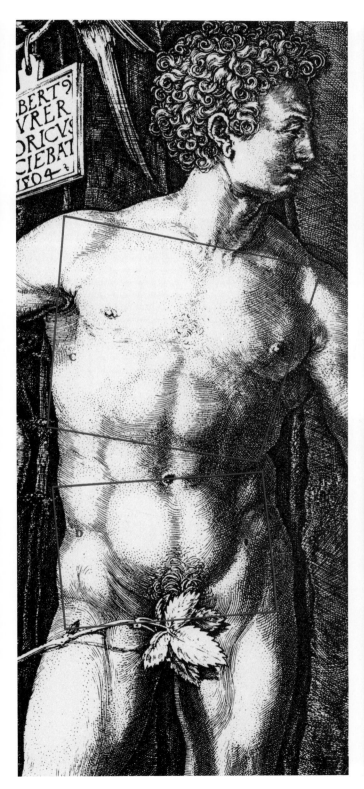
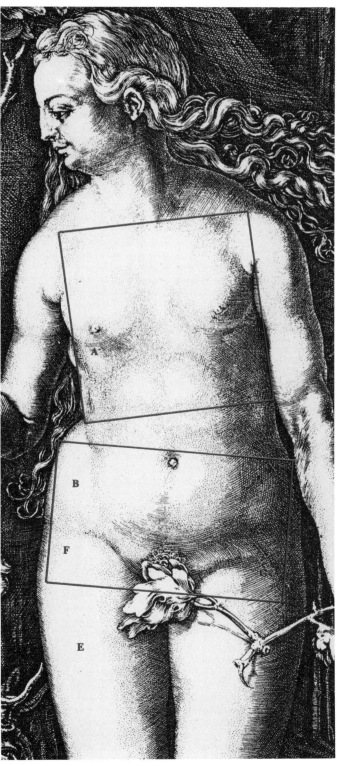

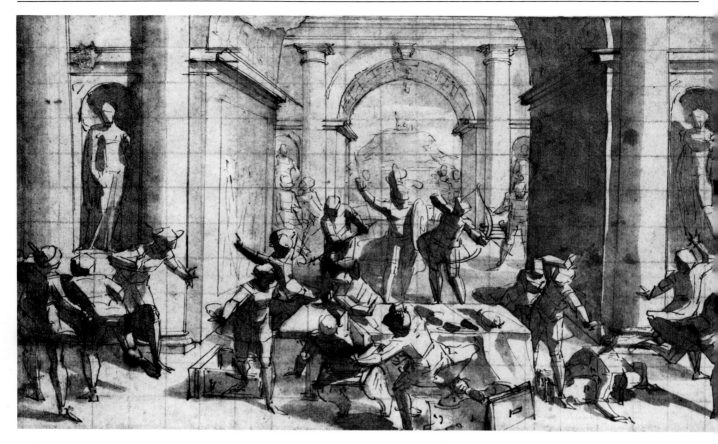

MASSING
Back View

Proportion is largely a matter of
the relationship of masses, one to
another, in a manner suitable to
the artist concerned. But through
the visualization of mass, the
thrust or direction of a complex
form in space may be more read-
ily felt, and relationships of
shape, size, and position are more
easily seen, felt, and evaluated. It
is easy to feel the exact direction,
size, and position of the pelvis if
such details as the sacrum, the
spine, and the muscular masses
are of secondary concern, and the
pelvis is thought of as a simple
box.

In this drawing, Cambiaso has
clearly first thought of the pelvis
as a block (A). He has accentu-
ated this mass concept by placing
a dark wash (B) on the side of the
pelvis away from the light. Proba-
bly as an afterthought, he added a
little textural indication of the
crest of the pelvis (C) and a brief
line (D) for the top of the sacrum—
both on the light side of the mass.
Throughout this drawing, in
which the architecture is in one-
point perspective, but in which
the line systems from the figures
go to many different vanishing
points, the artist has used the
block—the only mass that gives
him a full sense of direction.

LUCA CAMBIASO (1527–1585)
THE RETURN OF ULYSSES
*pen, brown ink, and brown wash
on brownish paper, squared in red chalk
7¹³/₁₆″ × 13⁵/₈″ (19.8 × 34.6 cm)*

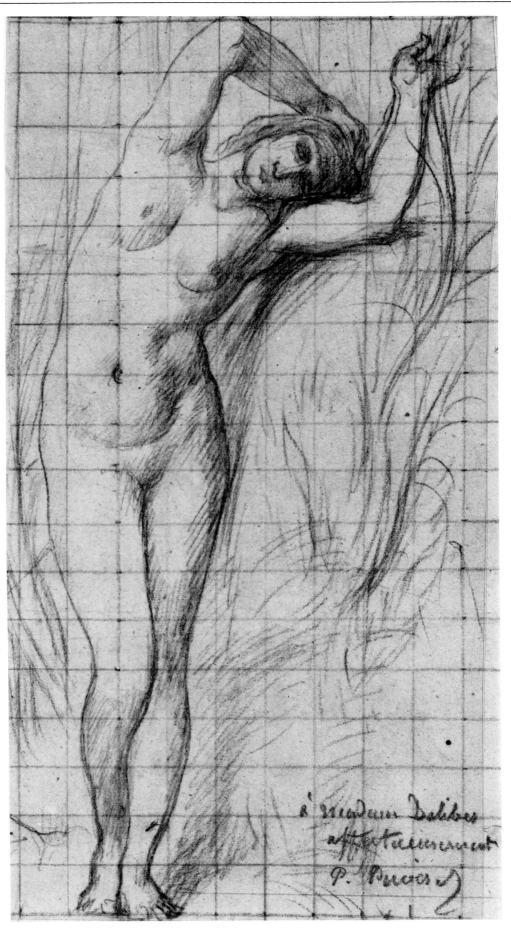

PLANES AND VALUES
Front View

Traditionally the lighting used in realistic drawing consists of a direct light from above, in front, and from one side, and a reflected light from the rear. If students learn to manage this traditional lighting with ease, they soon become familiar with all the other lighting conditions the illusion may require.

The first lesson in massing the body is to decide on opposing edges. Puvis de Chavannes placed his dominant plane break of the pelvic area (A) at the side of the lower and abdominal portion of the rectus abdominis. This is

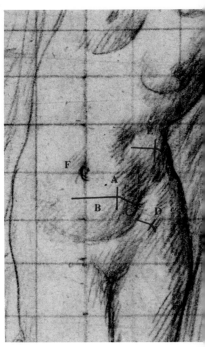

where the light front plane (B), which faces the upper left source of light, meets the dark side plane (C), which looks away from the light. A little secondary plane break (D) that we can imagine on the sartorius clues us to the front and side planes of that mass. The external oblique muscle is in the shadow area, but nevertheless, in describing its form, we can indicate a plane break (E) to divide its grayish light plane from its dark plane.

The vertical direction of the navel (F) on the mass of the abdomen suggests the direction of the pelvis even though we don't see it. As artists, we learn to use the elements of value and line to suggest and to emphasize form so that it suits our compositional and expressive needs.

PIERRE PUVIS DE CHAVANNES (1824–1898)
STUDY FOR *PERSONIFICATION OF THE SÂONE*
black chalk, squared with pencil, on tracing paper
9⁵/₁₆" × 4¹³/₁₆" (23.6 × 12.2 cm)

MICHELANGELO BUONARROTI (1475–1564)
TORSO OF A STATUE OF VENUS,
SEEN FROM BEHIND
black chalk
7¹⁵/16″ × 4⁵/16″ (20.2 × 11 cm)

PLANES AND VALUES
Back View

Most laymen, I think, know that the pelvis exists. But when they try to draw the pelvis, they seem to relate it to the dressmaker's word "hips" and then draw this shapeless word. A trained artist, however, has a most exact knowledge of the shape of the pelvis. For he knows that the pelvis strongly influences the shapes of the muscular forms that arise and fall from it. The back triangle of the sacrum (A) is strongly indicated in Michelangelo's drawing. It is at the base of the varying line (B) of the vertebral column, which curves through the center of the back of the figure, giving us a feel of the direction of the rib cage just as the sacrum clues us to the position and direction of the pelvis.

Mass concepts are a great help in conceiving planes. This is because all simple planes may be derived from our conceptions of the exterior or interior surfaces. A curved plane such as the spherical triangle of the sacrum is, then, but a triangle drawn on a sphere. The sacral triangle drawn on one surface of a sphere is different from one drawn on another side. The tilt of the sacral triangle indicates the direction of the mass of the pelvis of which it is a key part. Artists can make the sacrum point in the direction they wish, and this will suggest the full direction of the concealed bony mass.

The dominant light in Michelangelo's drawing is coming from the upper left as indicated by the downward direction of the cast shadow (C). Simple oblique and

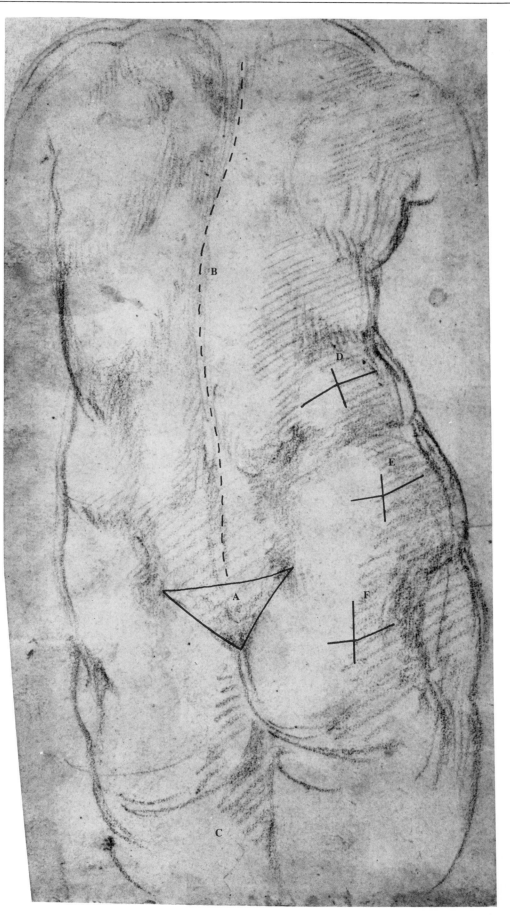

parallel hatching suggests plane breaks at the side of the external oblique (D), the gluteus medius (E), and the gluteus maximus (F). These side planes are tied together for unity and a concept of the boxlike, controlling mass of the pelvis.

PLANES AND VALUES
Side View

As artists, we know that there are certain spiral planes on the body. These may be learned and sensed by drawing a cylinder, and then drawing parallel spiral lines around the front and sides of that cylinder. The external oblique muscle (A) is such a plane. The sternomastoid (B) is another. You see this kind of spiral plane in a lock of hair. Almost any muscle that has the function of rotation has a spiral quality. The external oblique (A) spirals off the mass of the rib cage (C) directly above it. The anatomical waist (D) is where the down plane of the rib cage (C) meets the up plane of the external oblique (A). Here a strong, raking light hits the figure from the upper right, and the meeting of these two planes must be indicated by a change of value. But, since this is

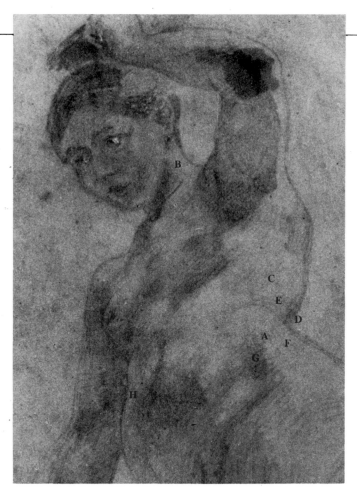

an interior plane in light, and part of the dominant light mass, Delacroix has softly indicated this plane change with a few curved lines at the base of the down plane (E). He did this in spite of the stronger dark that he may have seen. Had he darkened this plane as much as he saw it, he would have created an isolated, spotty, black hole much like a dark ink blot at the elbow.

You can also see how, by similar light hatchings, the down plane (F) of the external oblique (A) is kept as part of the dominant light area. The side plane (G) of the external oblique, which is away from the dominant source of light and part of the dominant dark mass of the body, is rendered with a strong gradation of dark to light, right to left. To keep the light moving, and create depth, Delacroix has taken a second light of lesser concentration from the back and cast it on the form as a vertical shape (H) of reflected light. Notice how this reflected light is not the kind of wormlike, attention-getting shape that fascinates beginners. It is a shape that is graded in size from one end to the other and harmoniously follows the form that it is on.

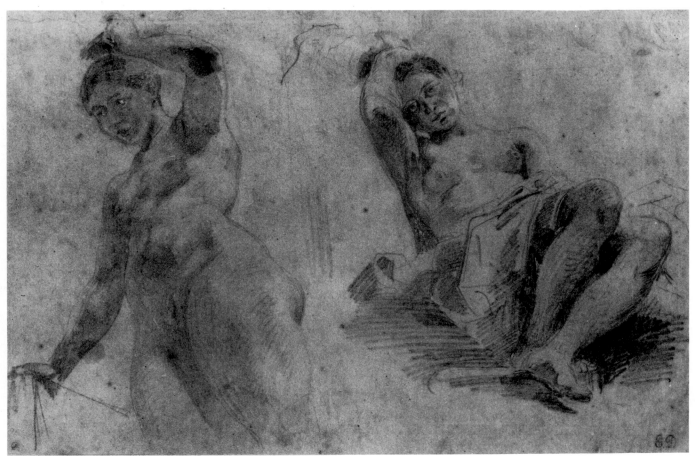

EUGÈNE DELACROIX (1798–1863), TWO STUDIES OF FEMALE NUDES, *black pencil,* 8⁹/₁₆" × 12¹³/₁₆" (21.8 × 32.5 cm)

LANDMARKS
Front View

Anyone who has begun to draw the human figure soon begins to realize that landmarks are of vital importance to the artist. They are his reference points for proportion. He can drive his construction lines through these points and compare the size, shape, and position of different parts of the body, one to another, as well as evaluate the degree of change in these relationships when the body moves.

In Dürer's drawing you can see how the rib cage and upper part of the body have moved to the left. He has drawn the line of gravity (A–B) so that he can measure how far the figure has moved to the left. This line passes through the erect figure from the pit of the neck (C) to just inside the ankle (D) of the weight-bearing leg.

A straight construction line is drawn across the points of the shoulder (E–F). A curved line (G) drawn to these same points represents the highline of the neck. The short curved lines (H and I) indicate the two clavicles or collar bones. With the sideway movement of the trunk, the pit of the neck has moved (from C to J). The construction lines help not only in placing the parts, but also in seeing the degree of change.

Another straight line is drawn through the tips of the tenth ribs (K–L) at the bottom of the rib cage. When you compare this line to the line through the points of the great trochanter (M–N), is there any doubt about the degree of tilt of the pelvis in the opposite direction to establish balance?

Using Dürer's study or similar drawings of your own, you can make many comparisons by combining landmarks and construction lines.

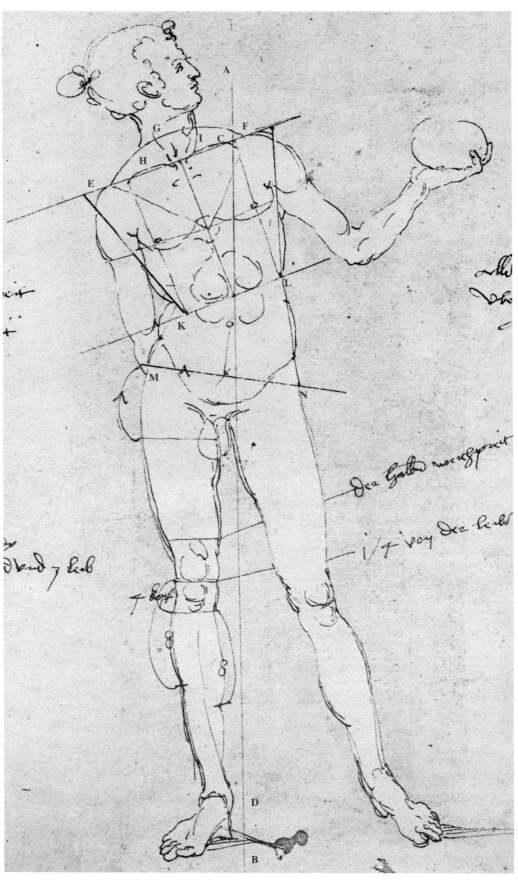

ALBRECHT DÜRER (1471–1528)
NUDE MAN HOLDING AN ORB (CONSTRUCTED)
pen and ink (27.9 × 20.3 cm)

MUSCLES
Back View

Let's look at the back of the pelvis. In this drawing by Signorelli we might first note the long line (A) of the vertebral column. It begins at the base of the ball (B) of the head and curves down and around the rib cage, and inward (C) at the base of the rib cage. It ends at the great triangular bone in the back called the sacrum (D). As you can see, this long center line of the backbone connects the three big masses of the head (E), the rib cage (F), and the pelvis

(G). Also, because it is in the center, it tells us which way the rib cage and the pelvis are facing.

A good way to start the back of the pelvis, perhaps, is to feel the sacrum (D) as a sort of keystone. I think our first shape concept of the sacrum is that it is a triangle built on a sphere—a triangle that curves in a little. Signorelli has drawn in the pelvic crest (H). We know that it is of tremendous importance because it shapes the form of the hips. The strong cords (I) of the back rise up from the sacrum (D) on either side of the backbone and help to keep your

body upright. The pelvic crest also helps to shape the form of the external oblique (J), which comes from the side (K) of the rib cage and goes into the side (L) of the pelvic crest. Since the flesh of these muscles has no particular form, it has to be forced by the bone.

If we look at the pelvis for a moment, we'll see that Signorelli has drawn curved lines at M and N off the outside of both pelvic crests, suggesting the gluteus medius muscle. The dip (O) in the outline is the gluteus medius inserting into the great trochanter of

the femur bone. We know also that this is the halfway point of the body.

Study the shape of the gluteus maximus (P) as it comes off the sides of the sacrum (Q) and moves down into the upper leg (R). Notice the shape and direction of the gluteal fold (S) that gives us the lower limit of the pelvic area.

Once you are aware that these forms exist, you can form shape concepts about them. Then, if you know a little something about light and shade, you can make the thing look something like what it is, and that's our ambition.

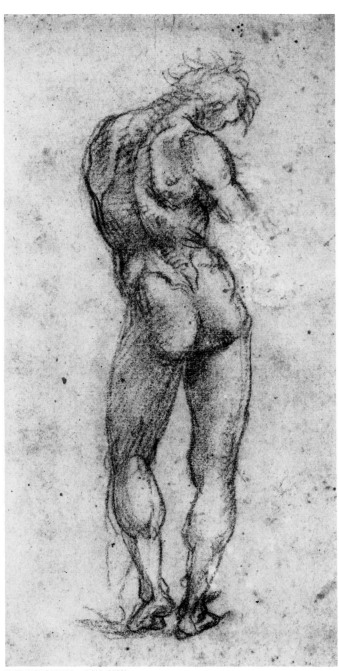

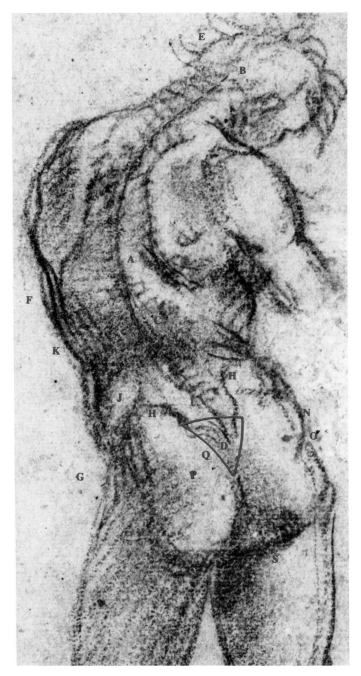

LUCA SIGNORELLI (ca. 1441–1523)
NUDE MAN
black chalk, 10⅝" × 5⅜" (27 × 13.6 cm)

MUSCLES
Front View

One of the best ways to look at the front of the pelvis is to feel the ball of the abdomen in the front. Michelangelo's drawing provides a good example of this concept. He has drawn the center line (A) of the body over the ball of the abdomen in a curving line from the navel (B) down to the line (C) of the groin. We feel the two masses (D and E) of the bottom portion of the rectus abdominis on either side of this center line.

The line of the groin (C) is the official dividing line between the trunk and the upper leg; it runs from the front point (F) of the pelvis on one side to the front point (G) on the opposite side. Medical people call this Poupart's ligament, named after Jean François Poupart, physician to Madame de Maintenon, mistress of Louis XIV. The body is full of the names of great men, men who have discovered these things, and Poupart's name is among them. This ligament is his monument.

The external oblique (H) bulges out between the side of the rib cage (I) and the top of the pelvis (J). The bulge (K) on the outline below the external oblique is that of the gluteus medius. This is the muscle that runs from the pelvic crest (J) down to the great trochanter (L) of the femur bone of the leg. Perhaps you can see what it does. It pulls the leg bone out to the side—abducts it from the center. The gluteus medius is one of those masses that the layman does not know about. The layman certainly knows about the breasts because he has read poems about them. He may have read, for instance, the poem, "O come, the maiden says, and rest your weary head upon this breast." But no poet would ever write, "O come, the maiden says, and rest your weary head upon this gluteus medius." He would get thrown out of the poetry society and everything else.

We never run into the word "gluteus medius" and so we do not know it exists. Yet this is one of the great masses of the body because its function is so important. It pulls the leg out to the side. So get into the artist's mind and forget the literary mind. Remember that every mass in the body has its own importance even though nobody has ever written a poem about it.

BONES
Front and Back Views

Let's use the very accurate drawings by Richer to study the bony structure and landmarks of the pelvis just as we did for the bones of the rib cage. The pelvis consists of two large innominate bones (A) and (B), each vaguely shaped like a propeller, and each the mirror opposite of the other. They join together in the front at the symphysis pubis (C). In the back they are each attached to a thick spherical triangle called the sacrum (D). The sacrum is actually part of the spinal column and consists of five vertebrae that have fused together during the course of evolution. At the bottom of the sacrum are three tiny vertebrae (E), which is all that remains of our animal tail.

Each innominate bone is made up of three separate bones, which fuse together in early life. On top is the ilium (F); below, the projecting pubis (G) in front and the ischium (H) in back.

Now we must come to a decision about the overall shape of the pelvis. To have in our mind a figure that contains a more definite and well-shaped pelvis, let us try to relate the proportions and important landmarks of the pelvis to

MICHELANGELO BUONARROTI (1475–1564)
RAPID SKETCHES OF A MALE TORSO AND HEAD
black chalk
13⁷/₁₆" × 10³/₈" (34.2 × 26.3 cm)

a known block. Then by connecting the landmarks with lines, we can create and memorize a pelvis good enough for any artist.

Richer has used a male skeleton. We know that a man's pelvis is usually no wider than his rib cage and that the female pelvis is a little wider than the rib cage and tilts a little forward. Otherwise, the variations are minor to the artist. We can conveniently use the same system of blocks that we used for the rib cage, and simply make adjustments within the boxes for individual differences. These sternum boxes are solid cubes of five eye widths or the length of a sternum (I). The length of the clavicle (J) is usually about the same length as a sternum box.

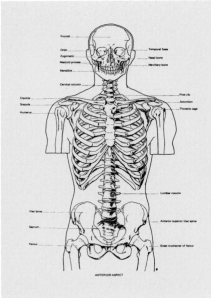

DR. PAUL RICHER (1849–1933)
PLATES FROM *ARTISTIC ANATOMY*, 1889
pen and ink

Now, basically, the artist derives the whole solid form of the pelvis from the triangle (D) of the sacrum in the back and the imagined pubic triangle (K) in the front, which we can indicate on the skeleton. In fact, it is said that if you give an artist two triangles, he'll give you back a pelvis. Certainly those two triangles are fixed: if you move one, you have to move the other.

Next we should locate the famous pelvic points—great landmarks for the artist. The information I am giving here is well known and has been known

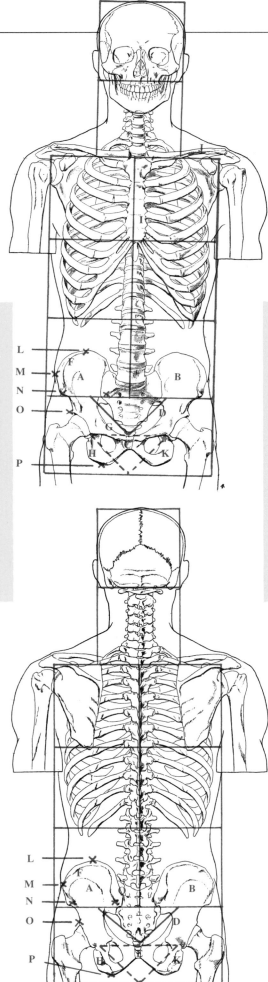

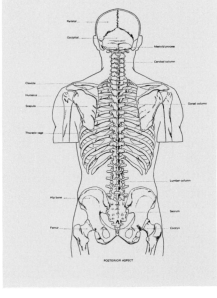

throughout the ages. The things I mention are really the common property of any good figure artist. We know that the pelvis has a high point (L), a wide point (M), and a front point (N). The front point is the great artist's landmark. You can easily feel it on yourself. Doctors call it the anterior superior iliac spine. They know that two finger widths below that is the secondary point (O) from which the leg bone springs. The point of the ischium (P) or the bottom of the pelvis, is the bone on which you sit. The back point (Q) is at the side of the sacrum. Of course all these points are repeated on the other side of the pelvis. In the back view we can identify all these same points.

Everybody, in drawing the model, should put in these landmarks. If you don't know exactly where they are on the model at first, try to put them in anyway. At least you know lots of places where they're not. They're not over in Jersey City. They're on your pad. You know that anyway. So try to put them in. As months go on, you'll get them nearer and nearer, and finally you'll put them right where they ought to be. But you have to start thinking about the pelvic points to guide you in your drawing of bones and muscles and in your massing and perspective.

THE UPPER LEG

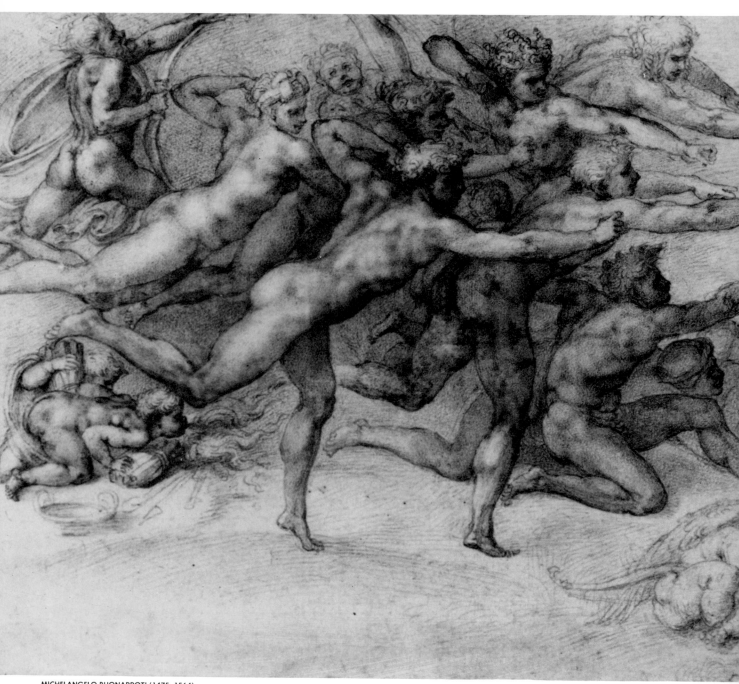

MICHELANGELO BUONARROTI (1475–1564)
ARCHERS SHOOTING AT A HERM
red chalk
8⁹/₁₆″ × 12¹¹/₁₆″ (21.7 × 32.3 cm)

"It is hard to exaggerate reality unless you know what reality is. If you are familiar with the norm, you can more easily see the deviation."

MASSING
Side View

If I get too fundamental for some of you, you will have to bear with me—I will get complicated enough as the lectures go on. I will probably talk a great deal about the problem of form and the massing of form. This is, of course, an anatomy class—fairly academic, I suppose. We become very interested in giving the illusion of form. That perhaps is our job in an anatomy class. I feel that perhaps most artists who deal with the problem of three-dimensional form work with very simple forms. Matisse, I believe, said that the artist never really uses anything other than the cube, cir-

cle, and cone. Artists know that we should keep our form symbols fairly simple, just the way we keep our palette simple.

I find that in practice the symbols of the cube, the cylinder (or, rather, something like a cylinder, which is a beer barrel or an egg), and the sphere (not a circle, but a sphere) are probably sufficient for any artist who is interested in three-dimensional form and figure drawing. These forms are a very great advantage to the artist. They solve almost all his problems. You will find that as soon as you can think in mass or think in form, you have solved your problems of foreshortening, your problems of value, your problems of perspective, and many others.

The upper leg can be massed first as a block (A), as Michelangelo may have first visualized it in this drawing in order to simplify problems of direction and the massing of darks and lights. As he continued to develop his drawing from a simple to a more complex shape, he had to change his mental image or mass conception. To refine the mass of the upper leg further toward the illusion of a slowly turning form, he may have imagined a cylinder (B) to help him grade the values.

You have the rest of your life to refine the simple mass concepts that we have been talking about. But it is very important that you become aware of them as a beginner.

PLANES AND VALUES
Front View

It is a convenience to the artist to
visualize both flat and curved
planes on the form in order to ac-
centuate values, to create and al-
ter line, to subordinate detail, and
to clarify thrust or direction.
Planes are visualized by the artist
at places he thinks best for his
composition and according to the
direction of light. These planes
may be flat or curved, large or
small.

Here Raphael portrays the
child's upper leg as a cylinder—a
series of slowly turning planes.
He has thrown a light on that cyl-
inder from the upper left, which
may have come from his imagina-
tion. The professional can create
light out of his own head—some-
thing the amateur can never do.

The amateur never gradates his
shade to give the illusion of form.
Raphael knew that the bigger the
cylinder, the wider the distance
between the lightest light and the
darkest dark. He has graded his
values in his hatching to give the
illusion of a slowly turning form.
But he has placed the greatest
concentration of crosshatching
(A) on his cylinder at the theoreti-
cal plane break (B) of the leg seen
as a block. This is often called the
plane change accent.

Notice how the darks of the
side plane (A) of the upper leg are
connected to the side plane darks
(C) of the egglike shape of the ab-
domen. We see these dark masses
of varying size, shape, and direc-
tion connected throughout the
side of the figure away from the
light source. You will see this in
all the great masters; it is in this
way that they create a larger,
more simplified and forceful state-
ment of mass.

RAPHAEL SANZIO (1483–1520), STUDIES FOR THE ALBA AND DELLA SEDI MADONNAS, *chalk, 8¹¹/₁₆″ × 10¹¹/₁₆″ (22.1 × 27.2 cm)*

PLANES AND VALUES
Back View

I believe the layman thinks of
planes only as simple, flat sur-
faces. The artist's idea of planes
may be simple or quite complex,
according to his needs and inten-
tions. For the artist, planes may
take on many shapes. They may
be convex or concave in one di-
rection and straight in another,
like the outside or inside, or part
of the outside or inside of a cylin-
der. But almost always on the
body they are convex to the out-
side in one direction and the same
in the other direction, like parts of
the outer surface of a sphere or an
egg.

As we observed in studying
mass concepts, planes are often
first visualized as blocks, and the
meeting of the front and side
planes of these blocks is thought
of as the dominant plane break of
the mass. With the dominant light
coming from the left in this draw-
ing, the upper leg might first be
visually simplified as a blocklike
form. The dominant plane break
(A) in the upper part would be on
the side of the vastus externus of
the quadriceps group. Here we
notice that the artist has blocked
the back of the lower part at the
side of the hamstring group (B).
The internal plane break (C) of
the line between the functions of
the great front and back muscular
groups of the upper leg is usually
copied by beginners as a stark,
isolated line that breaks up the big
masses. Here Giulio Romano
knowledgeably and subtly uses
his awareness of this line to break
up the monotony of the long edge
of the meeting of masses. He
treats it as a rhythmic interlock in
the edge line of separation be-
tween the light and dark sides of
the upper leg.

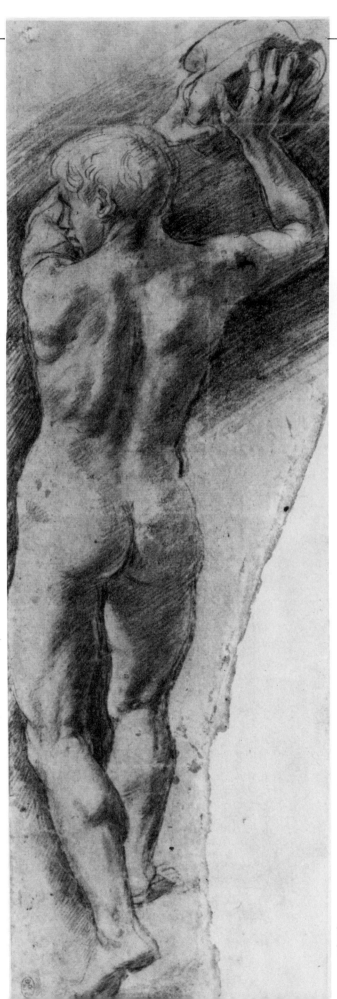

GIULIO ROMANO (1499–1546)
NUDE MAN CASTING A STONE
chalk
15³/₈″ × 4¹⁵/₁₆″ (39 × 12.4 cm)

PLANES AND VALUES
Side View

We can think of the entire mass of
the upper leg in Tintoretto's draw-
ing as a block or a cylinder, the
long axis of which moves in the
direction of the great femur bone
beneath. Frankly, since the whole
top end of the femur is buried in
the body, except for the outer sur-
face of the great trochanter, the
student doesn't have to refine the
top end of the upper leg unless he
wants to—the mass concept in-
volved nicely expresses the full
function of the top of the femur.
The cylindrical shaft of the femur,
you will soon notice, is convex to
the front. This is important be-
cause it influences the convexity
of the front of the thigh (A), as can
easily be seen in this drawing. Be-
ginners have a terrible habit of
drawing the front of the thigh as a
concave line, especially in the
seated figure.

The highlights of the body have
to be created by the student be-
cause they are hard to see or so
numerous as to be confusing. You
must first decide on the light
source so that you can give form
to the upper leg. If you are in a
large classroom, ignore the busy
effects of the 40 or more lights
shining on the model. Instead,
light the model from your mind
and eliminate all other light
sources.

Clearly, the light in Tintoretto's
drawing is from the left. The
curved outline (A) of the thigh re-
flects the curve of the femur bone
within. The highlight (B) is a re-
flection of the source of light, and
it runs parallel to the long axis of
our imagined cylinder (C). The
dominant plane break (D), which
simplifies the position and size of
the thigh's light and dark masses,
is placed well to the back. The
line (E) between the functions of
the quadriceps group (F) at the
front, and the hamstring group (G)
at the back, is kept very light as
part of the light mass to avoid
breaking up the unity of the big
front plane.

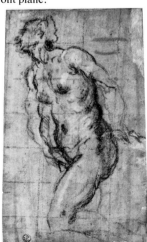

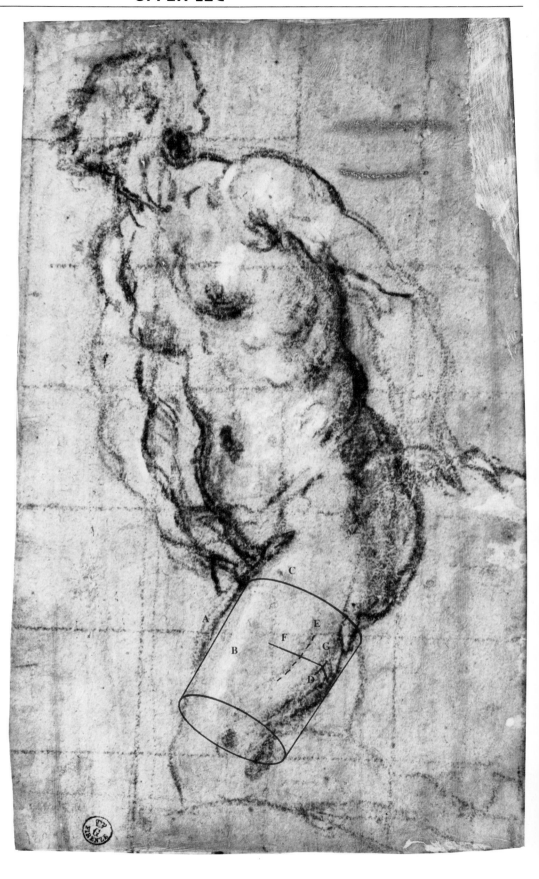

TINTORETTO (JACOPO ROBUSTI) (1518–1594)
TORSO STUDY
black chalk on blue paper
9⁷/₈" × 5¹³/₁₆" (25 × 14.8 cm)

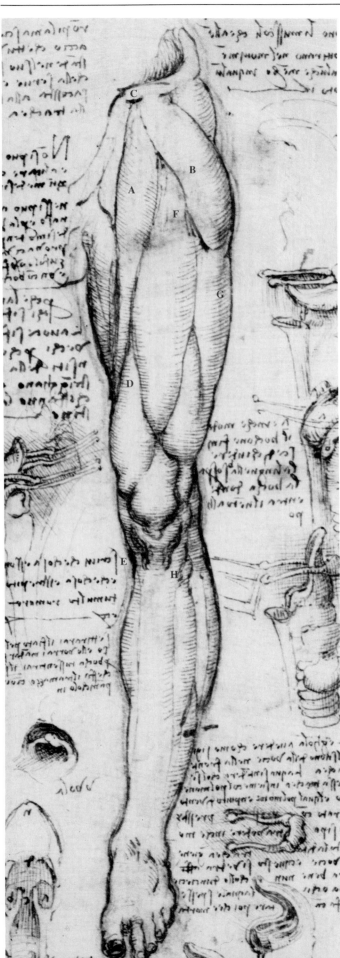

LANDMARKS
Front View

We must remember that the dot we make on the paper and call a point is usually nothing but a symbol of a mental concept of position. However, at times a point may be the symbol of the mental concept of a line seen on end. And at times, points are linked together to form a dotted construction line. Points are greatly used by artists in their training as well as afterwards because, if lightly indicated, they cannot mess up a drawing. You will notice that a trained artist often places points on his paper in advance of his actual drawing. He may do this to suggest the forthcoming proportions of his figure, but points are mostly used to indicate landmarks.

After a little study of artistic anatomy, you learn that a muscle originates at a certain point on the bone called the "origin" and ends at a point called the "insertion." Leonardo knew from his studies of the human figure that both the sartorius (A) and the tensor fasciae latae (B) muscles of the upper leg originate in the front point (C) of the pelvis. The sartorius moves down along the inside of the leg, around the side of the vastus internus (D) to insert in the side of the tibia (E) just below the knee. The movement of the tensor is easily followed from its origin in the front point (C). It travels over the side of the quadriceps (F), joins the iliotibial band (G), which follows down the side of the leg to insert at the outside of the tibia bone (H) of the lower leg. You can see now how landmarks can simplify your drawing of the muscular details of the body.

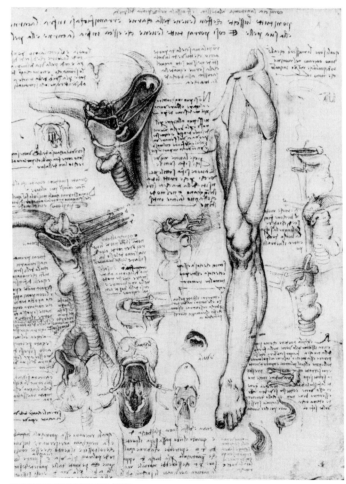

LEONARDO DA VINCI (1452–1519)
SKETCH OF A LEFT LEG WITH STUDIES OF A TONGUE, MOUTH, LARYNX, TRACHEA, AND PHARYNX
pen and ink over black chalk

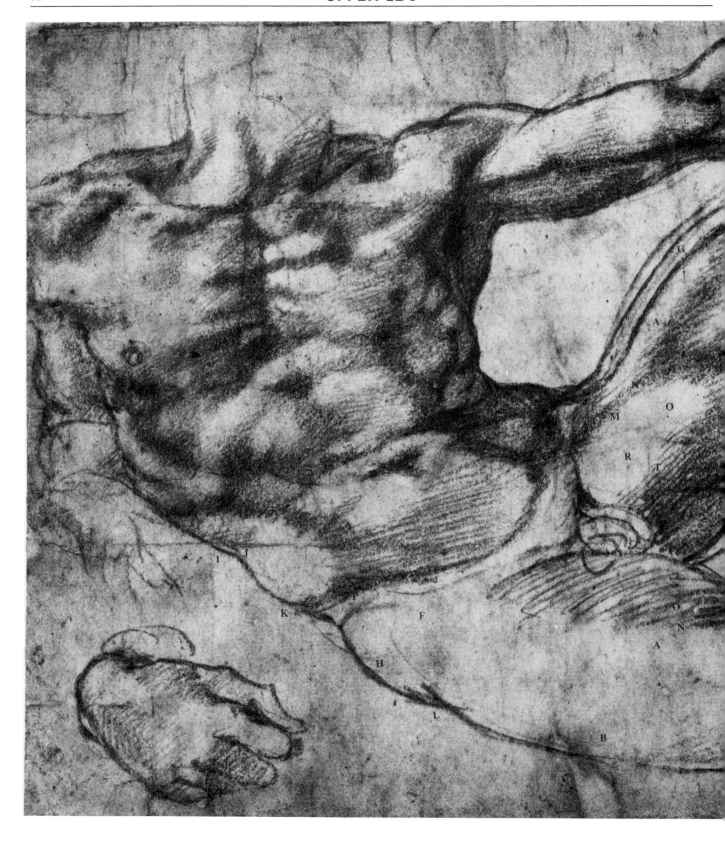

MUSCLES
Front and Inside Views

There is a great deal of material to cover in this lecture so I am going to give you the large ideas first. The little ideas, the details, are all in the anatomy books and you can certainly find them there. The large ideas in the function of these muscles are extremely important and, I think, the key to drawing this part of the body.

Let's look at Michelangelo's drawing and think about the upper leg. What makes this leg move? The rectus femoris (A) of the quadriceps group in the front lifts the leg of the model up against the pelvis. Together with the vastus externus (B) and vastus internus (C), it passes into the patella (D) and the lower leg (E) to straighten out the bent leg. The rectus femoris originates in the secondary point (F) of the pelvis and forms the front mass of the upper leg down to the patella (D). In the inside view we can observe the convex curve (G) of the rectus reflecting the convex curve of the femur bone beneath. Beginners usually make this line concave. But if you look closely, you'll find very few concave planes in the body.

If the model wanted to pull his leg out to the side, then he would call on the gluteus medius (H). In this drawing it is part of the rhythmic outline of the near side of the figure. Notice the anatomically revealing breaks in that outline where the curve of the rib cage stops (I) and is overlapped by the external oblique (J). The external oblique dips in (K) to the side of the unseen pelvis and the gluteus

medius reaches in (L) at the halfway point of the body to the great trochanter of the femur bone.

Once you get the leg out, you have to get it back—otherwise it would be terribly awkward, you know. You have to get it back, so you have muscles that pull it back inward. They're called adductors, while the ones that pull it out, like the gluteus medius, are called abductors or kidnappers. They move it away from the center line of the body. You can think of the ones that bring it back, the adductors, as the FBI.

Artists love to use the beautiful rhythm line of the sartorius (M) or tailor's muscle. This line spirals along the hollow (N) of the line between the functions of the adductor mass (O) on the inside and the quadriceps group (C, A and B) in the front. It is the longest muscle in the body and moves from the front point (P) of the pelvis to the inside of the lower leg (Q) just below the knee.

Drawing, of course, is a language, a method of communication. As far as we are concerned in an anatomy and drawing course, it is a matter of communication of form. When I draw the sartorius or the adductor, I am expressing a rhythm line, or the shape of a form. Perhaps an oval might suggest the adductor mass. If I throw a light on the oval as Michelangelo has done, I get the feeling of a light front plane (R) and a dark side plane (S). I grade the values (T) to give the illusion of roundness and the oval form becomes clearer. I am using a language, a language of expression.

MICHELANGELO BUONARROTI (1475–1564)
NUDE FIGURE: STUDY OF ADAM
blue chalk
7⅝" × 10³/₁₆" (19.3 × 25.9 cm)

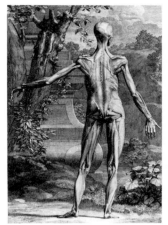

BERNARD SIEGFRIED ALBINUS (1697–1770)
PLATE FROM *TABULAE SCELETI ET*
MUSCULORUM CORPORIS HUMANI, 1747
engraving

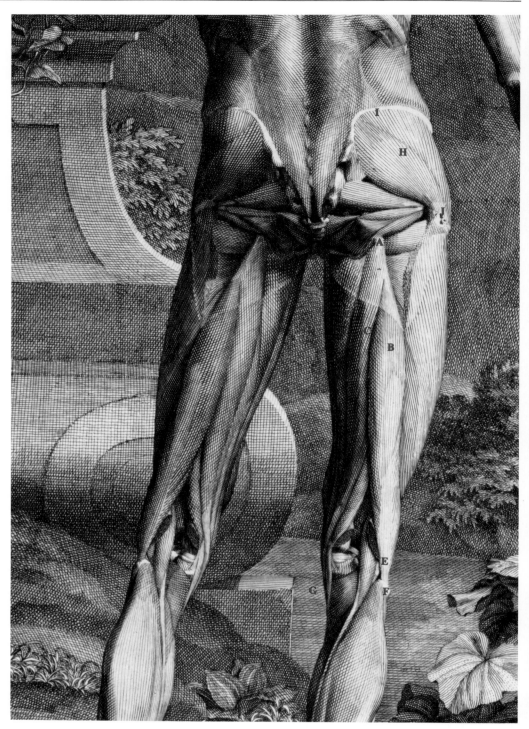

MUSCLES
Back View

Well, I think now we can just touch a little more on function because certainly it is function that clarifies all the forms between the top of the pelvis and the knee. What I mean to say is that if you know what this mechanism does, you just have to put the muscles in the places where they belong. Now what do we do with the upper leg? We move it forward and back, we move it out and in. There are four great groups of muscles that do that for us.

We already talked about the quadriceps group in the front of the leg, which moves it forward. In this most accurate and finely detailed flayed figure by Albinus, we can easily identify the muscles in the back that move the leg. Let's go into the muscles that pull the leg to the back. There are three muscles that come off the back of the ischium (A) of the pelvis. They have terrible names: the biceps femoris (B), the semitendinosus (C), and the semimembranosus (D). Of course, you do not see the big split down the middle on a real model if he is adequately nourished. And here we get a principle, which is: If two or more muscles have the same general function, we as artists can mass them into one mass. So, for the most part, we forget about the details and think about the three muscles as a mass with a simple function of moving the leg back. Of course, these muscles extend all the way down into the lower leg so they have the function of bending the lower limb. One of these muscles sends a strong piece of stringlike tendon (E) down on the outside into the little bump (F) of the head of the fibula. This is the famous outer hamstring. The inner hamstring is a little different. It spirals around the inside (G) and is fuller and more

rounded out than the outer hamstring.

How do you move the leg out to the side? Well, we know that the gluteus medius (H) comes off the crest (I) of the pelvis and goes into the great trochanter (J) of the femur bone and pulls the leg outward. Abducting the leg, as the artists say. If you take someone away from home, you call it abduction. You often hear of the traveling salesman going to the country and abducting the farmer's daughter!

Unfortunately we do not often

hear the opposite word, "adduction," but the anatomists use it very often. A group of five muscles of the adductor mass (K) comes off the wheel of the ischium on the bottom of the pelvis. The function of these five muscles is to pull the leg back inward. But you don't have to learn all their names because the functions are all similar. They are all engaged in bringing back the farmer's daughter—I mean, the leg. You don't have to learn the horrible names unless you want to get up and give a lecture. All you have to do is

just feel them doing the same thing and group them as one big mass.

Now remember that all that an individual muscle can do is contract or get shorter, so that's why the muscles of the body come in pairs or groups. One to pull the bone one way, and one to pull it the other way. You see, the artist takes the body apart, into pieces, so to speak, and he tries to feel the function and character of the pieces. He thinks a great deal about it. I can only perhaps hint at the direction you have to take.

BONES
Front and Back Views

If you ask a layman to draw a skeleton, he will produce a primitive, most peculiar, and frequently very funny illusion. But, I assure you, any well-trained artist will be able to offer you an excellent illusion of the skeleton. This is because the trained artist is not only aware of the existence of the individual bones, but has long since come to a conclusion about the shape of each bone and especially of the parts that affect the surface form.

The layman, in drawing the skeleton, will present each of the long bones of the arms and legs as a long stick with "something" on one end and "something" on the other. The layman knows that there is something at the end of each bone and, as far as I can see, tries to draw the word "something." This, of course, is impossible. Artists are visual, not verbal. They draw shapes, not words. I have noticed that the word "something" that the layman always draws on the top and bottom of the long bones seems to resemble an individual brussel sprout. And that's not what's there at all. On the other hand, the

artist, because of his training, proceeds very differently. For example, in his training he has examined the actual femur bone and looked at its every aspect. And he has consulted the best pictures of the femur he could find.

Now let's look at these drawings by Richer of the leg. The pelvis must have a hole for the leg bone. Where is that hole? That's always the question. Where are these things in relation to the other things we know? There's a beautiful trick, a nice three-dimensional construction line. If you draw a line from the tubercle (A) of the widest point of the pelvis to the bottom point (B) of the ischium, you'll find that at about the halfway point (C) of that line you have just enclosed a hole for the leg bone. You also get a feeling of the way that hole looks. It looks down and to the outside. The acetabulum, or little vinegar cup, is the name of that hole for the leg bone.

Now, if we look at the femur bone in this drawing, we'll find that at its top there is a head (D) which fits into the hole of the acetabulum (C). This head connects with the neck of the bone (E), which connects with the great trochanter (F). The student is after

general shape in the beginning, so he turns to mass conceptions. He translates the head into a sphere, the neck into a cylinder, and the somewhat amorphous great trochanter into a cube. He then sees the shaft (G) of the bone as an elongated cylinder moving down and inward. This ends, not in a brussel sprout, but in the condyle (H), which can be conceived as the mass of a spool. These mass conceptions, if set down, will create a most adequate illusion of the general shape of the femur.

The measurement of the femur bone from the top (I) of the head to the bottom (J) of the condyle is generally about two heads, or two times the height of the pelvis. We might also say that the femur bone measures about three sternum lengths. Of course the artist always allows for individual variations.

The body is full of things that you don't know exist in the beginning. But with a little study you realize they do exist. Then you arrive at shape concepts about these forms and you decide in which direction they are going. Finally, you know exactly how your body is put together. You then throw a little light on these forms, and your drawings come to life.

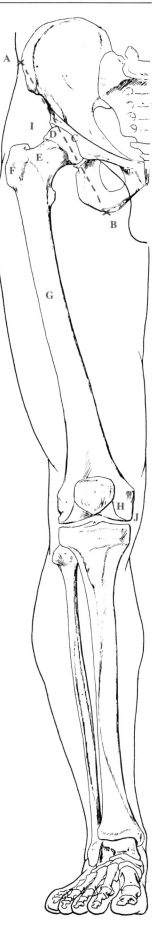

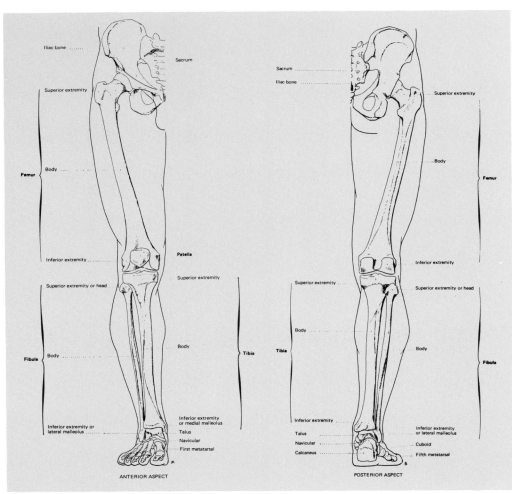

DR. PAUL RICHER (1849–1933), PLATES FROM *ARTISTIC ANATOMY*, 1889, *pen and ink*

THE KNEE

"First we draw what we see; then we draw what we know; finally we see what we know."

MASSING
Front View

As a student, you will have to clutter up your precious drawings with construction blocks until the process becomes instinctive and you are able to imagine them. When you study the works of the great masters, you will sometimes see these construction blocks or other basic shapes. But, more often, they are not visible because the artist has learned to imagine them for himself as he draws and doesn't have to put them down. In order to learn to draw you must use them. Continue right through the body with them, massing the upper leg, the knee, the lower leg, the foot, and even the individual toes. In this way you will eventually solve problems of position, aspect, and perspective.

Guercino has given the upper leg (A) a blocklike form. The artist knows that the knee is mostly formed by the bony masses of the condyles of the femur and tibia and the patella in the front. But he also knows that the knee is best expressed by the concept of a block (B) that is narrow in front and wide in the back. By first drawing in the simple mass, you can be sure of the direction, size, and relative proportion of the knee. You will be able to capture the controlling or dominant shape of the knee, in which much of the strength and character of the drawing lies.

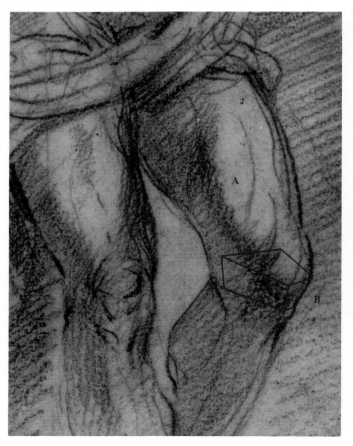

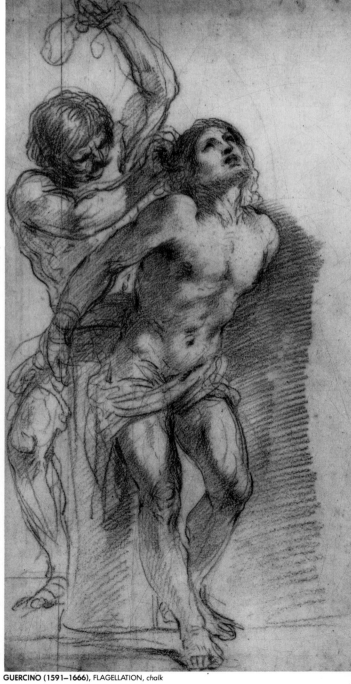

GUERCINO (1591–1666), FLAGELLATION, *chalk*

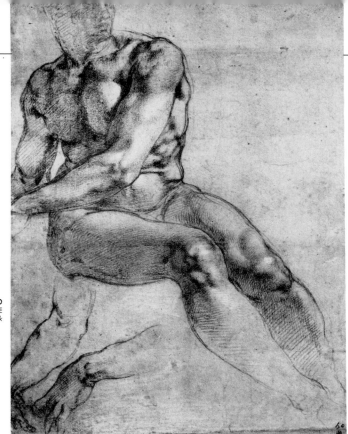

FOLLOWER OF MICHELANGELO
SEATED NUDE FIGURE
black chalk

PLANES AND VALUES
¾-Front View

Perhaps at this point in these lectures you can begin to understand that you cannot hope to create convincing illusions of the figure unless you have an idea of the shapes you intend to give these forms. Once you decide, you can then convey your idea of a shape, or a pattern of shapes to others. Drawing, which is much like a language, is the art of communication to others through shape illusions. So, you can see that you learn to draw by coming to conclusions about shape.

The bent knee in this drawing is best visualized as a boxlike shape. The light is from the side and above. The artist has saved his greatest value contrasts for the meeting of planes nearest to him and for places where he wanted the greatest attention. Here, the strong plane break (A) is on the prominent mass of the patella (B) of the near knee. To create variety and rhythm, the overall light shape in this area does not move very far in a straight line. From the dominant light on the patella (B), the light hatch marks carry the eye down across the patella ligament (C). The shape of light then shifts to the left over onto the prominent mass of the tibialis anterior muscle (D). We can visualize another plane break (E) here. The head (F) of the fibula provides a little shape variation at the side. Notice that the light shapes are not of the same width or parallel side to side; the-in-and-out shifting of their edges gives them variety, yet they are all connected and read as a light mass. Notice also how the parts of the big light plane are graded in intensity of light. This creates the illusion of moving form.

The values in both the light and dark areas of the body were not copied exactly as this artist saw them on the model. He invented a direct and reflected light, imagined the value gradations in his mental image of the box of the knee, and then transferred these values to his drawing with variations for design and anatomy.

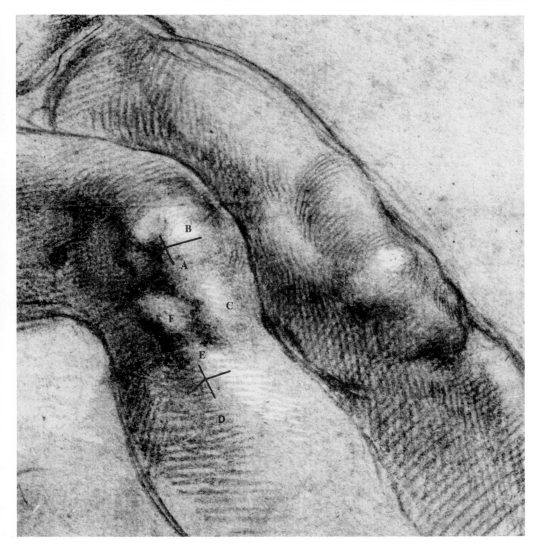

PLANES AND VALUES
Front View

As students of artistic anatomy, we learn that in a bent knee the bony mass of the condyle at the base of the long femur bone of the thigh moves forward and adds to the boxlike effect of the knee. This simple concept, I assure you, is most valuable in analyzing the planes and values of the foreshortened knee.

Parmigianino has placed the dominant plane break (A) of the knee on the patella (B). He has moved the lightest light and darkest dark closer together to accentuate the sharp angle where the front plane (B) meets the side plane (C) of the patella. In the upper leg, the highlight (D) and the darks (E) are moved far apart, and the value movements between them are changed gradually for the illusion of roundness. The line (F) that overlaps the adductor mass (G) at the back adds to the illusion of foreshortening.

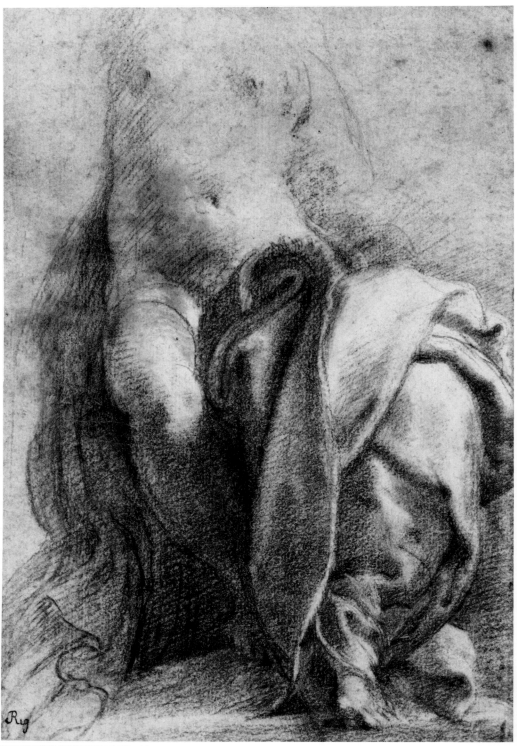

PARMIGIANINO (FRANCESCO MAZZOLA) (1503–1540)
STUDY OF DRAPERY (RECTO)
black and white chalk

LANDMARKS
Front View

Leonardo knew that the masses of the knee are largely formed by bone. The bone of the patella (A), the largest of the sesamoid bones in the body, protects the knee joint at the front. It connects the three visible parts of the quadriceps—the vastus internus (B), the rectus femoris (C), and the vastus externus (D)—to the kneeling point (E) of the lower leg. It helps provide a functional link between the upper and lower legs in the front.

Leonardo drew the knee flatter on the outside (F), where he knew that the condyles are close to the surface. On the inside (G), he made the line more curved and the knee fuller, as he was aware of the tendons of four leg muscles passing over the bone at this point and filling out the mass. Here we see how bony landmarks can become clues to shape as well as to size.

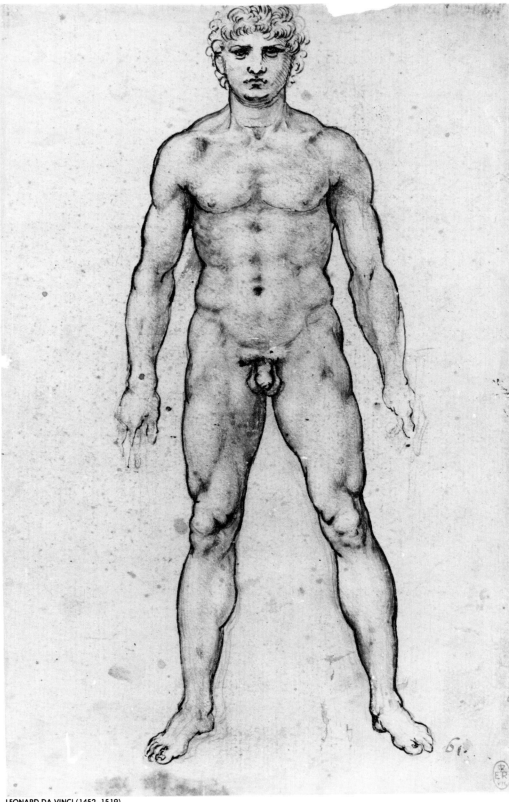

LEONARD DA VINCI (1452–1519)
NUDE MAN STANDING FACING THE SPECTATOR
red chalk on red paper
9⁵/₁₆" × 5³/₄" (23.6 × 14.6 cm)

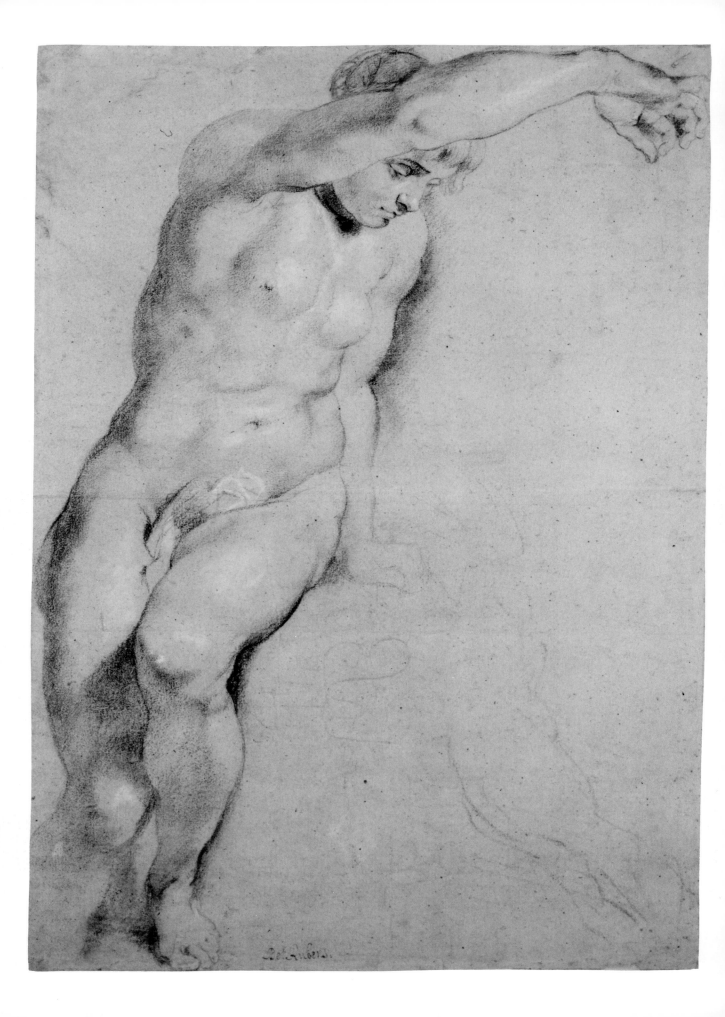

MUSCLES
Front View

I thought I might start this lecture by talking about the way one of my very newest students might draw the figure and perhaps explain some of his confusion about drawing. When you first come to an art class, you walk in and look at the model. There she is sitting up there. So beginners may start off with the left eye. Then the model may throw her head up a little, so they put the other eye a little too high—that happens very often. The model possibly turns to the side a little, and when they put in the nose that is out of place. There is something wrong with the fundamental thinking here evidently. They are copying exactly every detail they see. It is very possible that the school's cat is sleeping on the skylight with per-

haps a couple of kittens, and that is casting a shadow across the model's rib cage. That black shape is dutifully recorded by beginners. They may see an appendicitis scar that the model got some years ago and that goes into the drawing. And the sunburn on the top of the legs goes in.

They look at their picture and say, "Do you think I have any talent?" I do not know what to say to that because they may have talent, but it is rather disguised—disguised by lack of efficiency.

The mistakes in the drawing are not very grave. You can call attention to them in a short time and explain why the result came out badly. So, I suppose, these lectures to a certain extent concern rectifying some of these mistakes. The artist studies anatomy so that he can select and simplify forms and doesn't always have to copy

them. He can design the shapes, sizes, values, and lines on the figure to create convincing and visually interesting illusions.

Artists can draw the knee in many different ways. What they actually do is to pick and choose from the known facts when they draw a knee. Let's see what Rubens has done. First of all he brings the great quadriceps mass (A) down the front of the leg. The strength of the muscle goes through the patella (B) and then through the patella ligament (C) into the kneeling point (D) of the lower leg.

The secret of the knee is round, soft, and low on the inside; straighter and bony on the outside; narrow in front; and wide behind. Almost every artist puts in the sloping over of the vastus internus (E) on the inside. Rubens has placed a little accent (F) for

the outer hamstring, and a little indication of the head (G) of the fibula. He comes down the side of the leg and gets a sort of a nervous twitch in there. So you look for little nervous evidences of anatomical knowledge in his work. Most artists put in some indication of the edge of this platform (H) of the patella. Then, exactly how you mass or break up the other details of the knee is a personal question. I leave it to you. You will have to pick and choose and create. That is why I suggest that you get some sort of image in your mind about what happens in there by studying the bones that give much of the form to the knee. You'll then see how function makes form. And you will be able to pick and choose from among the details as an interpreter and designer, not a reporter.

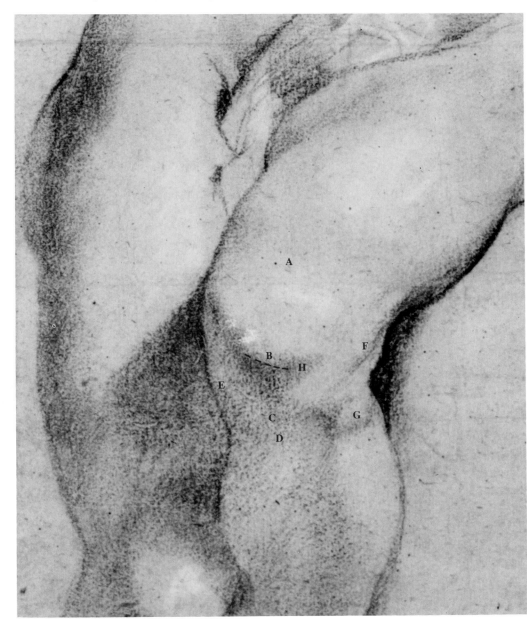

PETER PAUL RUBENS (1577–1640)
NUDE FEMALE
black chalk heightened with white
22¾" × 15¹⁵/₁₆" (57.7 × 40.5 cm)

MUSCLES
Back View

We might begin the back of the knee by looking at Albinus' flayed figure and thinking of what a knee really is. A knee is simply the flowing of the quadriceps group across the front of the bone, and the flowing of the two sides (A and B) of the hamstring mass across the back. That is all a knee is. When you know the function, you can draw these very well. Look how straight the knee is on

the outside and how sloping it is on the inside due to the shape and direction of the outer (C) and inner (D) hamstring tendons.

About all you have to think of with regard to the hamstrings in the back is getting the difference between the upper hamstring masses (A and B), which are made up of three muscles with similar functions, and the actual hamstring or tendons (C and D), which form the back of the knee. Think of the function and you will get it. You have to straighten out

the outside line of the knee, and curve around low on the inside because those hamstrings are telling the whole story in the back of the knee. Remember the quality of the inner (D) hamstring, which is like a big spiral piece of rope that inserts into the tibia bone (E) well below the knee. It is pretty rounded as it moves from the back to the front. Look how much lower it is than the outer hamstring (C).

We have to remember, too, that the knee is wider in the back be-

cause of these hamstrings, and very narrow in the front. And there is that little diamond-like popliteal space (F) between the hamstrings. It is not really as hollow and black as it appears in this flayed figure because there's a little mound of the popliteus muscle that fills up this space in the living figure.

Well, you see what the back of the knee is now. It is nothing but a very clear idea of the hamstring masses flowing across the back of the leg.

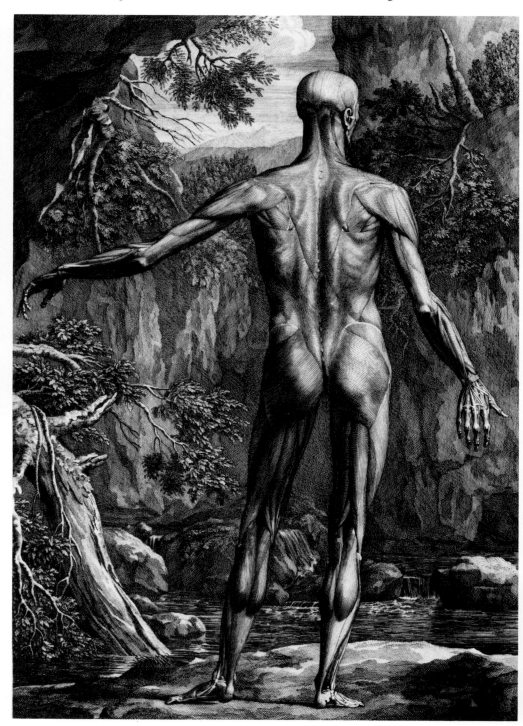

BERNARD SIEGFRIED ALBINUS (1697–1770)
PLATE FROM *TABULAE SCELETI ET MUSCULORUM CORPORIS HUMANI*, 1747
engraving

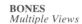

BONES
Multiple Views

The knee joint is a masterpiece of anatomical engineering. This hinge joint, the largest and most complex of all the joints, combines the functions of weight bearing and locomotion. Look at the huge condyles of the femur (A) and of the tibia (B) in Richer's very precise drawings. They are built to accommodate the enormous weight of the body. The strong ligaments (C and D) at the sides of the knee reinforce the great lever effect of the long femur bone above and the tibia bone below. These powerful ligaments combat the downward pull of gravity to meet the demands of walking, running, and jumping.

When you look at the front of the knee, you may have the feeling that the knee is held in a sling, with the tendinous mass (E) of the sartorius and inner hamstring on one side, and the mass (F) of the tendon of the biceps femoris on the other. That is the feeling you get when you draw the knee. Incidentally, the artist rather likes to make the movement (E) around the inner knee quite a big bump. I think if you run down to Rockefeller Center and look at the statue of the fellow who is holding up the world, you will find the artist has thought a lot of that thing and made something out of it.

The patella (G) in the front is a sesamoid bone. You sometimes have sesamoid bones in places where the ligaments run across bony points. The patella is called "the prince of the sesamoid bones" because it is the largest of the lot. Some people can make the patella go up and down. They can pull it up and down, and it gets high and low. This is one of the ways horses keep off flies. Practice it on yourself and look at that patella and get familiar with it.

Now, of course, that patella rubs across the knee a great deal and you get a lot of friction there. In fact, I think you might almost get sparks if the things weren't pretty well lubricated. The lubrication system is what gives artists trouble. In order to lubricate and cushion the knee we have a bag of fat called the bursa (H)—sometimes known as the water bag. At times it has a very full shape, but sometimes it is not too obvious. Knees change their shape a lot from person to person and confuse the artist. That bursa is tucked in behind the patella (G) and the patellar ligament (I), and sometimes it swells out beyond the patella. It's pretty hard to say exactly what the size of the bursa will be. Usually the artist uses this and all the other details of the knee as rhythmic variations in his overall design of the area.

DR. PAUL RICHER (1848–1933), PLATES FROM *ARTISTIC ANATOMY,* 1889, *pen and ink*

THE LOWER LEG

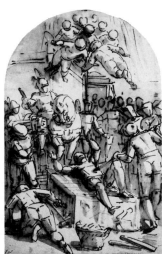

LUCA CAMBIASO (1527–1585)
MARTYRDOM OF ST. LAWRENCE
pen and brown ink wash
15¼″ × 9⅝″ (38.8 × 24.4 cm)

MASSING
Front View

The multiple mistakes that beginners make because of their unawareness of the principles of perspective usually have to do with the illusion of shape, aspect, proportion and, of course, foreshortening. The extent of a beginner's knowledge is revealed at once by the way he draws the stand on which the model is posed. The model stand is usually a simple rectangular block resting on the ground plane or floor, and is thus necessarily in one- or two-point perspective. It should not look like a lopsided ski slope. This can be remedied by persuading the beginner to imagine his pad as his picture plane and his face as parallel to the picture plane, which is just in front of his face. Then, before long, you can coax him to drive the line systems (A, B, and C) of the model stand to the appropriate vanishing point of these depth lines on the horizon line or eye level, as Cambiaso has done in this drawing. He can also indicate the height lines (D) and the width lines (E) of each side of the model stand. An important reason for drawing these lines is so that the beginner will have an exact idea of what is above or below his eye level or to the right or left of where he is standing. In perspective, the slightest change in the position of a form will change the illusion of its aspect. To avoid

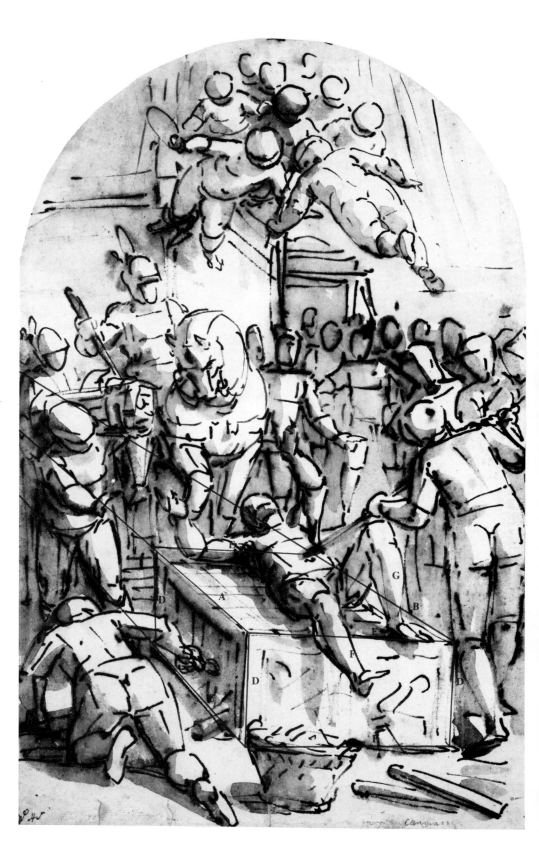

"Shape and function is our interest rather than words."

drawing the different parts of the same mass going in different directions at once (called double aspect), the beginner must learn to first place the big mass in space. He can then relate all the secondary masses, lines, and textures to this controlling mass.

The sharp edges of Cambiaso's washes strengthen the block concept of the right (F) and left (G) legs of the reclining figure. Just like the model stand, each of these blocklike masses has its own line systems.

MASSING
Front View

Raphael was a master of anatomy and perspective, as is evident in this beautiful silverpoint drawing. The blocklike form of the upper leg (A) and the continued blocking at the knees (B and C) and on down the leg (D) assure us that he thought of mass before detail. In his drawing the masses stand out more than the details.

Let us try to understand the relationship between anatomy and the construction blocks used in perspective. We know that a trained artist can imagine the whole body itself and each of its separate forms as encased or partially encased in such solids. Of course, the rectangular solid or block solves the major problems of direction and perspective. The other solids—the cylinder, the sphere, and their variations—are often used for specific problems. The cylinder, for instance, is used for the accentuation of tilt; the sphere and the ovoid, for the comprehension of general shape, etc. But the rectangular solid is much favored by artists because of its three line systems of height, width, and depth and how they clarify perspective. As artists say, perspective drawing is mostly a matter of taking a ride on a line system.

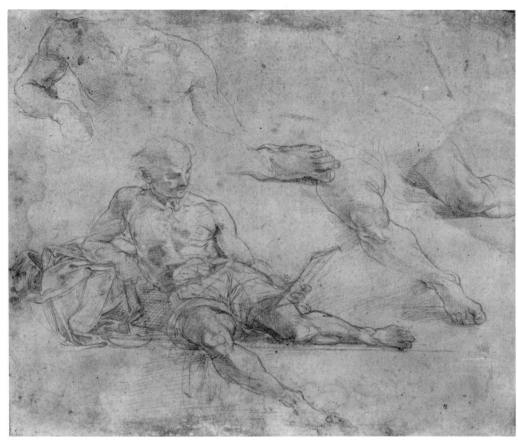

RAPHAEL SANZIO (1483–1520), STUDY OF DIOGENES FROM *THE SCHOOL OF ATHENS*, silverpoint, 9⅝" × 11³/₁₆" (24.4 × 28.4 cm)

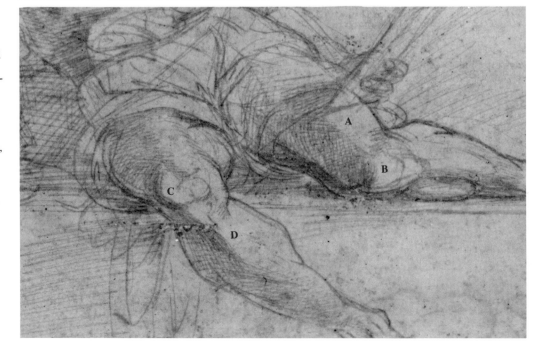

PLANES AND VALUES
Side View

Beginners start out by concerning themselves with such things as little details and inside planes. Professionals at once put in the big outside planes. They think about plane breaks and the values that define the planes. They reserve their value contrasts for where the great planes meet. They keep their lights near their darks when they want more of the contrast that will give vitality to the drawing. Sensitivity to movement of values is developed through practice. If values don't move, you lose the form. Of course, you won't always see them on the model—you have to create them. This is called gradation, or modeling in the movement.

Here Domenichino lights his figure from the right. There is a strong plane break (A) at the outer hamstring as it moves to the head of the fibula (B). The blocklike rendering of this area near the knee contrasts sharply with the cylindrical feel of the calf (C). Here the values are graded more subtly. They move gradually up to the strongest light (D), to the dark (E), and back to reflected light (F).

For simplicity and ease in learning, work first in three values. Later, with more experience, try six or seven values, according to your artistic needs.

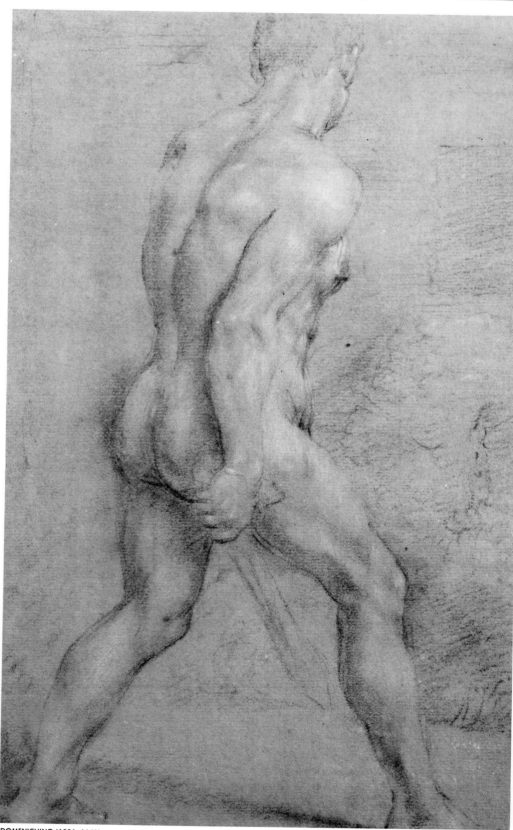

DOMENICHINO (1581–1641)
MALE NUDE FACING RIGHT
black chalk

PLANES AND VALUES
Inside View

Almost every beginner shades behind the form. The experienced artist shades on each form separately and then ties them together. The meeting of planes within the form must be indicated by a change of value—even if we have to stretch things a little. This method gives the best illusion of reality.

It is difficult for beginners to realize that you don't just copy values that you see on the body. You soon learn that these darks and lights are almost always moving incorrectly for the purposes of illusion, that for the most part you have to take the dominant source of light and the movement and shapes of values out of your head. In other words, the artist is a designer and a creator of illusions.

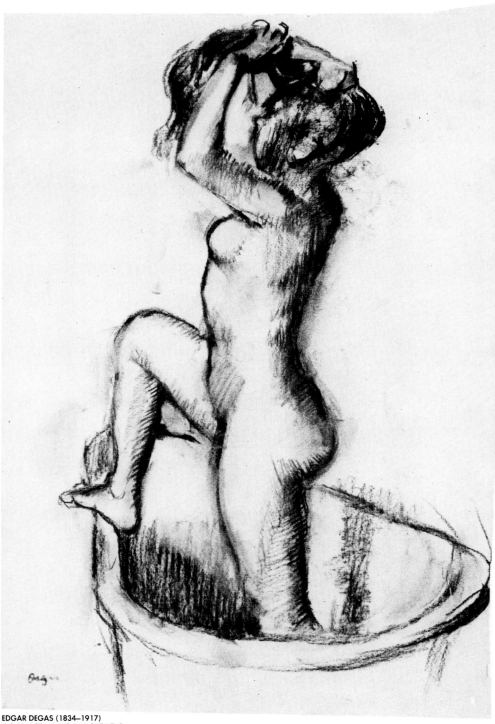

EDGAR DEGAS (1834–1917)
WOMAN STANDING IN A BATH TUB
charcoal on yellow tracing paper
17¼" × 12" (43.8 × 30.5 cm)

He does not copy like a camera. First we draw what we see, then we draw what we know, and finally we see what we know.

Much of the vitality of Degas' drawing is achieved by variety in the handling of his line and values. The strong dark (A) of the side plane of the lower leg is hatched in with the end of his chalk. The oblique direction of his strokes suggests the back of an imagined block (B). In the next plane (C) moving toward the light, and from the strong dark (A) to this low midtone, Degas changed his method of using the chalk. He used the side of the chalk instead of the point and pressed more gently as he stroked to get a lighter value. This flat surface suggests one of the slowly turning planes of a cylinder (D). Can you feel the vivid and sculptural movement of planes in Degas' drawing of the lower leg? You can find examples of this planar massing in the upraised arm and throughout the body.

LANDMARKS
Side View

Most basically, the act of traditional drawing is to create the illusion of three-dimensional volume on a working surface. This is mostly done with points, lines, planes, and rubbing the chalk, and occasionally even a finger, over the surface. Knowing the landmarks of the body gives us points of reference, which make the drawing of these volumes easier. And by drawing lines over these forms, we can visualize the direction of the different parts of the mass.

The lower leg is cylindrical in form. We might visualize a contour line (A) drawn over the leg of Rubens' model so that we can observe the changing directions of the different forms in relation to the light from the upper right. The gastrocnemius (B) and the side mass of the peroneus longus (C) are facing up into this light and are strongly lit. The dark side plane (D) of the peroneus longus, away from the light source, is indicated by a long shape of dark that follows the long axis of the cylinder of the leg.

Short little contour lines (E) are sketched in at the ankle where the down plane (F) of the leg meets the up plane (G) of the instep of the foot. These lines suggest the curving of form at the ankle and represent the flexion folds caused by the upward movement of the foot against the ankle.

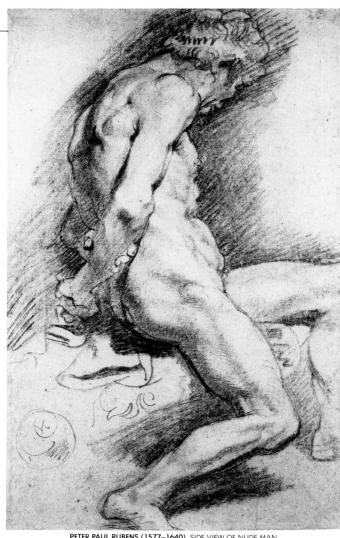

PETER PAUL RUBENS (1577–1640), SIDE VIEW OF NUDE MAN
black chalk, 16⁹/₁₆″ × 10¹/₈″ (42.1 × 25.8 cm)

MUSCLES
Front View

The form of the lower leg in the front is dictated by the bone, and I do not believe that anything but study of bone will clarify it. Certainly, in this anatomical plate by Vesalius, you are very conscious of the knife edge (A) and the long flat plane (B) of the tibia bone. We see this plane lit up all the way down to the inner ankle (C). You can feel that whole plane of bone down there very strongly and it is often drawn by the artist very clearly.

There are rhythm tricks that take advantage of that long line of the front of the tibia bone. Artists will emphasize the long rhythm line of the sartorius (D) coming down the leg, around the knee (E), and continuing on down the edge (F) of the tibia into the side of the ankle (G). This was an old rhythmic device of Michelangelo.

The tibialis anterior (H) on the front is often felt quite strongly by the artist. It fits very nicely into that slight curve (I) in the tibia bone. It sends a tendon down into the foot at the side (J) and moves forward to the base of the metatarsal of the big toe. Well, when that muscle contracts and its tendon pulls on the front of your foot, then it lifts the foot and puts you up on your heels. At the ankle (K), the tibialis anterior tendon fills in the angle between the front of the tibia and the top of the foot and carries the flow across the forms.

Tucked in behind the tibialis anterior is a little muscle that lifts your big toe—the special extensor of the big toe (L). It sends a tendon (M) all the way to the end of the big toe. You can see it on yourself if you wiggle your big toe before you go to bed tonight. Then, there is a muscle (N) called the common extensor of all the toes. As you can see, if you follow it down, it sends tendons to all the toes except the big toe. That toe already has a tendon to wiggle it and doesn't need another. Certainly you can see these tendons on the model if you are near enough. You can see or imagine the strings. These tendons are used by artists to decorate the back of the foot and to start the flow of line toward the toes.

There are altogether six muscles packed together in the lower leg from the tibia bone in front to the calf group in the back. They can be called the peroneal group. Most prominent in the front is the tibialis anterior (H). In the other leg of this flayed figure, that muscle has been removed, but we can see the most prominent muscle of the side of the leg, the peroneus longus (O). That muscle sends a tendon under the foot at the out-

side (P) and helps put you up on your toes. It is much more important to go up on your toes than on your heels, or it is more important to drive yourself forward, so the mass in the back, the calf group (Q), is tremendous in size. This mass breaks (R) at about the upper third of the leg.

I always feel that you can get much of the detail by yourself. My job, of course, should be to give you principles. Well, the first principle is that you are never going to see to much difference between any of those muscles. They are all going to form a mass there. Contour lines (S and T) are going to extend very simply around the leg. You are really going to run into very simple cylindrical shapes there. If you get a model in fast action like a running man, you begin to see these separate muscles stand out, and then you can make subtle and expressive variations in the big, simple masses.

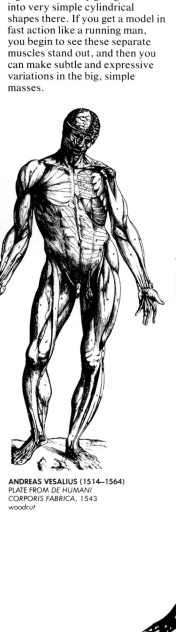

ANDREAS VESALIUS (1514–1564)
PLATE FROM *DE HUMANI
CORPORIS FABRICA*, 1543
woodcut

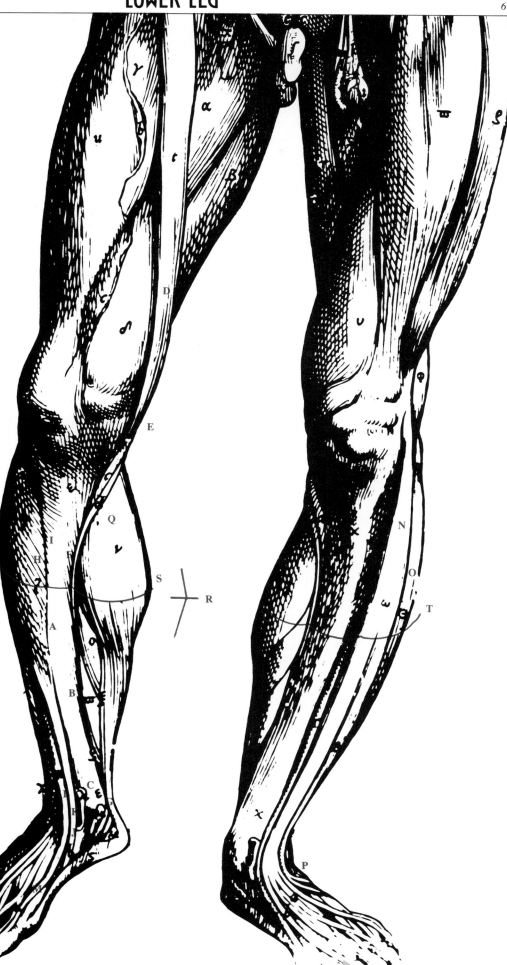

MUSCLES
Side View

When beginners draw the back of the leg, they generally know about the calf, as everyone does, and they are aware of the ankle because poets have been pretty busy writing about calves and ankles. And they know about heels because poets have talked about silver heels. But they never know about the base of the metatarsal of the big toe because that would be the ruination of a poet. Of course, they know about the big toe. So you see perhaps what your problem is—to investigate what you do not know and find out about it. That is all it is.

Let's look into the calf mass and examine it in this plate by Vesalius. You can see how it puts you up on your toes. Let's dissect it, as we say. It is made up of two muscles and a tendon. The two muscles have rather curious names: the soleus (A) and the gastrocnemius (B). Both have the same function: they lift up the back of your foot. The soleus throws out a little mass to the side and looks a good deal like a sole fish. It is a very smooth and beautiful muscle that covers the bone and gives grace to the leg. It comes down the side and goes into the Achilles' tendon (C).

On top of the soleus muscle, we have the gastrocnemius (B). That means frog belly in Latin. This muscle comes out of the two knobs at the back (D) of the upper leg. It moves out from behind the two string (E and F) of the hamstring. It bellies out to about one-third (G) down the leg, and then continues down to connect (H) to the Achilles' tendon (C).

ANDREAS VESALIUS (1514–1564)
PLATE FROM *DE HUMANI CORPORIS FABRICA*, 1543
woodcut

At the base of the gastrocnemius, where it goes into the Achilles' tendon, you get these two half-moons (I), which show a little on the near leg. When the model goes up on his toes, you will see them very clearly on the back. Everybody has these landmarks, even the most beautiful girl. If you follow her upstairs, you will see this little depression there right on top of the Achilles' tendon.

Those are the two muscles that make up the calf group. I think their form and function are pretty simple. They pull up the back of your heel by their connection to the Achilles' tendon. The Achilles' tendon rises from the back of the calcaneus (J) or heel bone, and ends in the little depression or half-moon (I) at the base of the gastrocnemius. That is your famous Achilles' tendon.

On the average model you probably will not see the line (K) between the soleus and the gastrocnemius. But when the model goes up on his toes and there is muscular tension, then you can catch it for an instant. It begins to show here as the figure moves forward onto the left foot. Certainly you would have a terrible time seeing it on a female model, where the details are much less pronounced.

Once again, you should think of the bone and of the function. It will clarify the whole thing. There is the tibia (L) on the front, and the big calf mass (M) behind. You can all grab your own leg on the inside and get your fingers in there behind the bone and feel that mass very clearly.

There are so many approaches to understanding the figure and to the drawing problems that arise after you think a little about the anatomy of this area that I suppose I could talk all day about it. I think the simplest thing to remind you of is that you can give strength to your drawings and paintings by stating these anatomical forms as big, simple masses and reserve the details for expressive variations.

BONES
Front and Back Views

Now let's take a look at the bones of the lower leg in Richer's drawing. You should know that understanding the size, shape, relative position, and landmarks of the two bones of the lower leg is one of the secrets of drawing that part of the body.

The enlarged condyle (A) of the tibia fits neatly into the condyle (B) of the femur bone above. Below the kneeling point (C) or anterior tuberosity of the tibia, we can easily follow the line (D) of the knifelike edge of the shinbone or tibia. Even on the model the surface (E) of the tibia is visible under the skin—that is, subcutaneous—all the way down to the inner ankle (F). The tibia changes from the three-sided shape of a prism in its upper portion (G) to a four-sided block at the ankle (F).

Note that the head (H) of the fibula is a little lower than the top (I) of the tibia. And the lower end (J) of the fibula, known as the outer ankle, ends lower than the inner ankle (F). So artists say that the fibula starts lower and ends lower. Sometimes they draw a construction line (K) across the points of the ankle to emphasize this difference.

The fibula bone carries no weight, but it serves as a base for the origin and insertion of muscles. It also helps prevent lateral displacement of the bones at the ankle. Function is the secret of the form of the lower leg as it is for much of the body. Just think of what the foot has to do. Think of how the tibia bone provides a sturdy compression member against which muscle and tendon tense and pull to move your foot. The Lord was very careful to place the bulk of the muscular masses that move the foot in the upper half of the lower leg for good leverage and to spare the foot any excess weight. As soon as you think of function, you begin to become more aware of the forms, where they are connected, what they are doing, and how their shapes reflect what they can do. In other words, function makes form. When these ideas become clear, you begin to draw more easily.

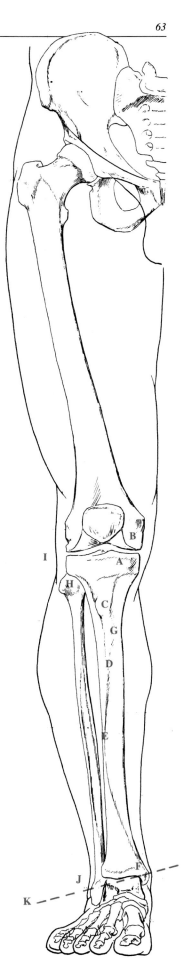

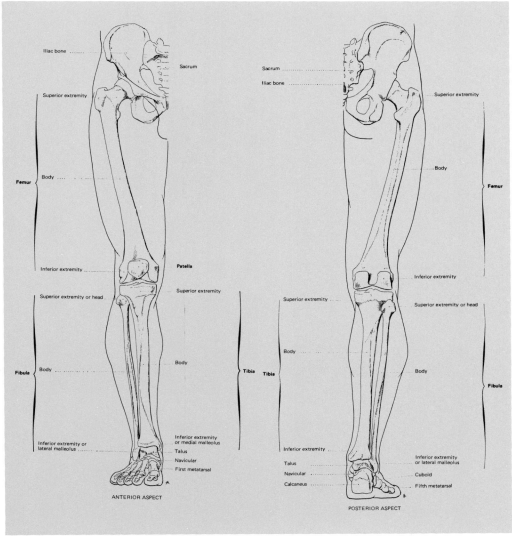

DR. PAUL RICHER (1849–1933), PLATES FROM *ARTISTIC ANATOMY*, 1889, *pen and ink*

THE FOOT

ALBRECHT DÜRER (1471–1528)
STEREOMETRIC MAN
pen and ink
11³/8″ × 8″ (28.9 × 20.3 cm)

ALBRECHT DÜRER (1471–1528)
pen and ink
8³/8″ × 5¹/4″ (21.3 × 13.3 cm)

MASSING
Side View

Dürer experimented constantly, throughout his life, with different conceptions of the human figure. His sketch pads are full of drawings such as these, which provide an excellent opportunity to observe how a great draftsman conceived of the side view of the foot. Dürer saw it here as a simple rectangular block (A). In the partially raised foot on the left, he broke his block into two parts: the larger upper portion (B), containing the tarsals and the metatarsals, and the smaller section at the front (C), which is made up of the phalanges or toes. Now can you see how an artist arrives at a conception of the shapes of his forms? He first thinks of them in terms of mass, or at times in terms of the planes or parts of planes that lie on the surface of the mass. Then, through continued observation and increasing knowledge, he refines these mass concepts over the years according to the changing requirements of his style. Can't you see that the artist must have some basic shape in mind before he can draw anything at all?

MASSING
³/4-Front View

Here's another Dürer sketch in which we can analyze his way of thinking about mass. He has moved from the simple massing of a flat profile view of the foot in the last drawing to the slightly more complex blocking of a three-quarter view (A). In this construction drawing Dürer has begun to experiment with the shapes. He has also turned the lower leg (B), upper leg (C), rib cage (D), neck (E), head (F), and arm (G) into a three-quarter view.

The box shape of the foot (A) clues us to the direction in which the foot is facing. The beginner would do well to box up the foot at first. Later on, even if he doesn't actually draw the boxes, he will have developed the habit of visualizing them in his mind.

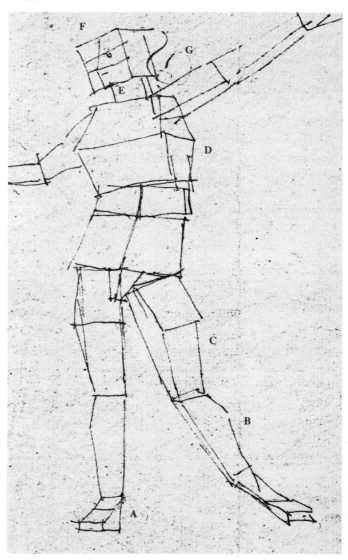

"Function makes form."

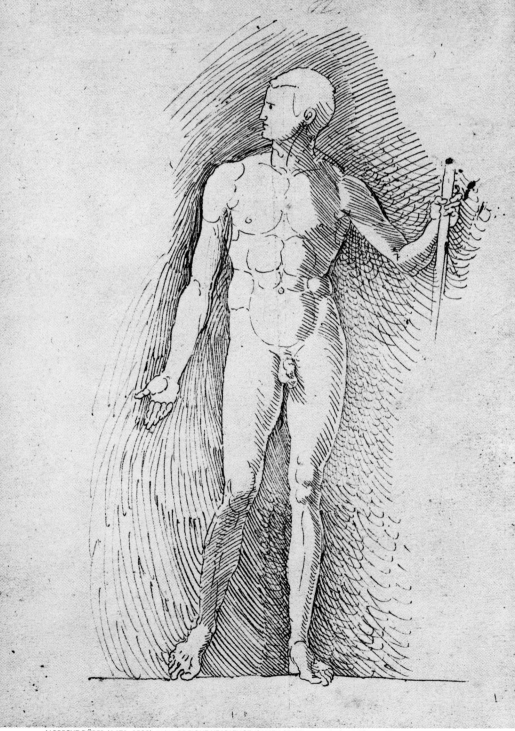

ALBRECHT DÜRER (1471–1528), MAN OF EIGHT HEADLENGTHS WITH STAFF, *pen and ink,* 10⅞" × 7⅞" *(27.6 × 20 cm)*

PLANES AND VALUES
Front View

The "highline" of the foot is always of enormous interest to artists. They know that it is the key to successfully massing and shading the foot. In this simplified sketch by Dürer, we can clearly see that the edge line (A) of the dominant plane break of the top of the foot is a continuation of the long plane break of the upper leg (B). The plane break at the side of the tibialis anterior (C), and along the knife edge of the tibia bone below (D), establishes the direction of light with the front planes light and the side planes dark. The extensor tendon (A) of the big toe creates the so-called highline of the foot. It is the big plane division of the top of the foot. The visible portion of this tendon starts at the ankle (E) and rides down over the upper bones of the foot to the big toe (F). It creates what is called a "trace line"—a line where one plane meets the other. It separates the light side of the foot from the dark. When we throw a light from the left, as in this drawing, the plane to the right of the highline is in shade. If the source of light were from the right, the plane to the left would be in shade. This is a good example of how a little knowledge of anatomy can vastly simplify problems of light and shade.

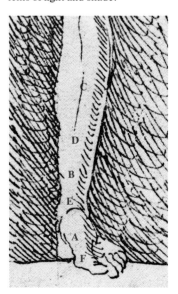

LANDMARKS
Multiple Views

As you pursue your studies of artistic anatomy, you begin to see how different the artist is from the layman. You begin to look at things differently. The layman, for instance, invariably draws five toes in his picture, but he certainly doesn't know about the flexors and extensors that wiggle his toes or about many other things that artists know.

Dürer spent much of his life analyzing the body. In these sketches we can see how he used construction blocks and lines to divide the foot into three equal parts (A, B, and C). He lightly sketched in the landmarks of the joints at the base of the toes and drew a curved construction line (D) across these points. He drew another construction line (E) across the base of the opening between the toes. The line at the end of the big toe (F) allows him to compare its size to the length of the long second toe (G).

Students can benefit greatly from doing studies like this. The knowledge that Dürer gained about proportional relationships and landmarks from these sketches led to the sureness and authority of handling in his more finished drawings, woodcuts, engravings, etchings, and paintings.

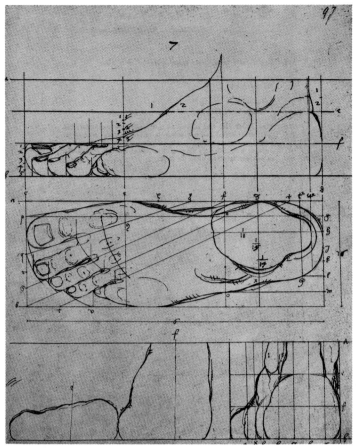

ALBRECHT DÜRER (1471–1528)
LEFT FOOT (CONSTRUCTED):
PROFILE, TOP, AND BACK
pen and ink
11½" × 8⅛" (29.3 × 20.6 cm)

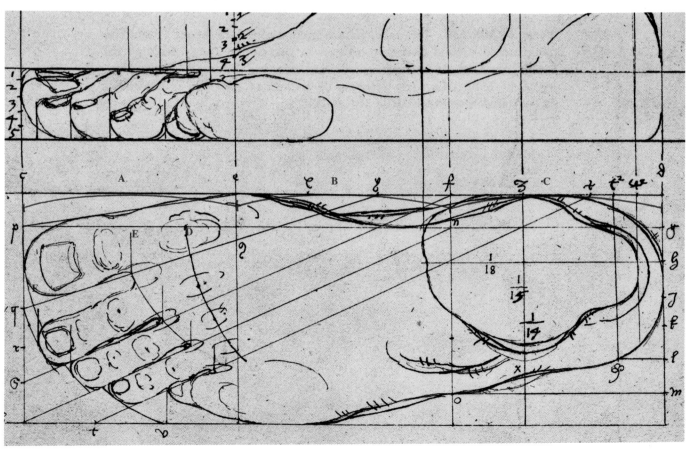

LANDMARKS
Multiple Views

Beginners soon learn from their study of artistic anatomy that certain forms on the body exist. They also find out about the shapes of some of these forms. Then they face the problem of relating these forms to the other parts of the body. In other words, you have to think a lot about proportions, which means relationships. Of course, the easiest way to do this is to create your own mental image of a figure, which you estimate to have average human proportions. Nobody really knows what the average human figure is. But, as an artist, you can create a personal image or secret figure that you believe to be about average. Eventually, with experience, you will be able to draw this secret figure out of your imagination at any time. When you are in front of the model, you can use your secret figure as a reference from which the actual model varies. You can make changes here and there according to this model's individual variations from your personal image. So, you see, in order to accurately observe and measure the unique characteristics of a model, you must have a comparison.

Of course, nobody is average. You are always drawing a personality. Some people are eight heads high, and some people are four heads high. Dürer drew figures from seven to ten heads high. Michelangelo drew figures eight heads high, and Leonardo drew them seven and a half heads high. It all depends on you; you are the artist.

Dürer often drew many construction lines and points throughout the body in order to compare proportional relationships within the body. Notice how the foot on the far left figure here has been divided into three equal parts. With the line (A) just below this foot, Dürer could compare the length of the foot to the thickness of the ankle (B) and the other parts of the leg—at the calf (C), the kneeling point (D) of the tibia bone, the base of the patella (E), a point just above the patella (F), and the mid-thigh (G).

You can continue these size comparisons throughout the body in this sketch as well as in the front view of the figure. Proportional comparisons like these were also made by Michelangelo and many of the great masters.

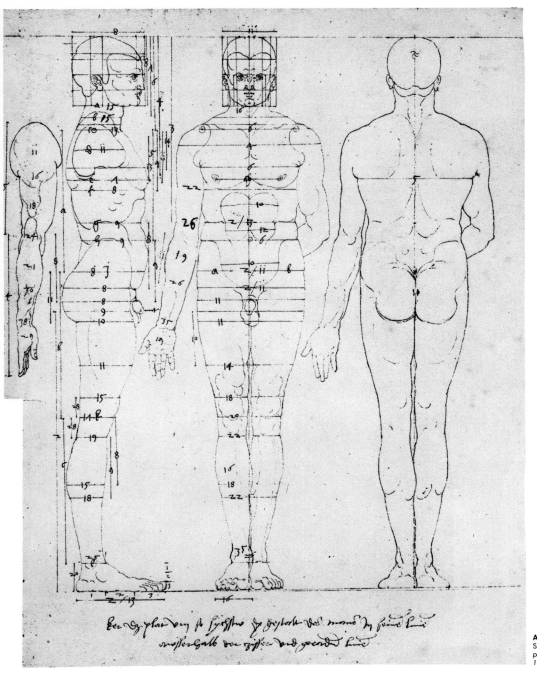

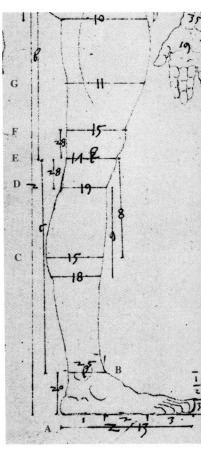

ALBRECHT DÜRER (1471–1528)
STRONG MAN OF EIGHT HEADLENGTHS
pen and ink
11½" × 8⅛" (29.3 × 20.6 cm)

MUSCLES
Front View

What do you see when you look at the foot? More than anything else, you see a triangular form—a triangular block. This is because the artist thinks first of mass and of detail last. The beginner draws exactly what he sees and gets terrible results. He zeroes right in on the details like the toes and the toenails. He prides himself on his sharp eye and reports all he sees. But we are not journalists. We are artists. And if we start with the details, we will end up with nothing on our pad but a spotty and disconnected assortment of lines and shapes. The experienced landscape artist doesn't put in the individual leaves of the tree before he indicates the large mass of the tree. As figure artists, we also think first of big shapes. First the dominant mass, then the secondary masses, and finally decorate with the details.

Look at the feet in this figure by Vesalius. Squint a little, and you will feel the mass. You can easily imagine or draw in triangular blocks on both the side (A) and front (B) views of the foot. The feel of the foot is triangular.

What else does the artist see? More than anything else, he sees the feeling of the longitudinal arch (C), as they call it. That is the arch that has to be kept in place by muscles and ligaments or else you have flat feet. Of course, the main reason people have flat feet is because they are taught to walk with their feet out at 45 degrees. Certainly, at the end of the nineteenth century, no woman was a lady unless she pointed her feet out at 45 degrees. That brings an unbearable weight on the bones of the foot, and the whole foot collapses. It is a very unnatural thing

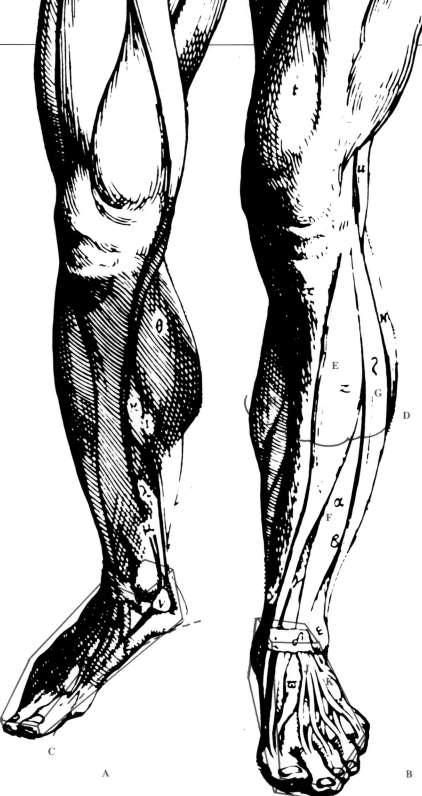

to do. Even at West Point they still stand at attention with their feet out. I happen to have been in the army for some years, and we had to do it then. We can take a lesson from the Indians who walk with one foot right in front of the other. Nobody ever told them to be polite. They just walk naturally.

When you draw the foot, don't isolate it. Learn to relate it to the size of the head and to the other parts of the body so you can

check your proportions. There are evidently two types of students—beginners, that is—those who get larger as they go down the body and those who get smaller as they go down. You see students coming down, getting larger, and drawing enormous feet, with a big toe, because they have all read about the big toe.

It's a good idea to also see the lower leg as a simple mass. It has the feel of a cylinder. You can draw a contour line (D) around

the muscles that move the foot: the tibialis anterior (E), the common extensor of the toes (F), and the peroneus longus (G) in the front, as well as the gastrocnemius (H) and soleus (I) in the back. The tendons (J) of the common extensor of the toes travel over an egglike form (K) called the short extensors. Think of these muscles, tendons, and small details as decorations or variations on the big mass concept of the foot as a block.

MUSCLES
Side View

Most students do not draw feet very well because they start off drawing the model in the classroom and by the time they get about down to the knees, the bell rings—they never get to the feet. That is rather sad as the feet are very beautiful. Also, a good knowledge of the foot gives you a good knowledge of the hand.

This beautiful anatomical engraving from Albinus' famous study of the forms of the human body clarifies much of the detail of the muscles that move the foot. The great mass of the quadriceps (A) passes down over the patella (B) at the knee to straighten out the lower leg. In the back we pick up the hamstring mass (C) and the outer hamstring (D) at the side of the knee moving down to the head (E) of the fibula. We can feel it

pulling up the entire leg. The line of the calf mass flows out (F) from the back of the upper leg. Let's get that flow of line. Let's feel that form. Here (G) is your break in the calf about one-third down the leg. You can feel the tension in the huge mass of the calf muscle as it contracts and pulls on the Achilles' tendon (H) and its insertion at the heel (I) of the foot. It puts Albinus' figure up on his toes.

You can easily locate the prominent peroneus longus (J). It moves from the head (E) of the fibula, down along the side of the leg, behind the ankle (K), and under the foot. We know that this muscle helps the calf group lift up the heel of the foot; at the same time it can pull the foot to the side, as it is doing here.

Here is an interesting proportional trick for getting the length of the foot. Start at the little bump (L) of the anterior tuberosity or

"kneeling point" of the tibia below the knee. Come halfway down (M) the distance to the ankle (N). Go out from the ankle the same distance (O) and you get the front end of your foot.

Well, there is a muscle on the foot that pulls out the little toe, takes it away from home—abducts it. Of course it is called the abductor of the little toe. It lies along the outside of the foot. Strange enough, it is a muscle of two bellies (P and Q). That is why you get a strong feeling of two divisions on the outside of the foot.

The big toe also has a long abductor mass (R), which softens the curve of the longitudinal arch and the base of the instep of the foot. Otherwise the instep would be very bony. Albinus has made the tendinous and muscular landmarks of the foot easy to identify and follow. But when you can find these landmarks on your own

body, it is even easier to learn about them. When I start my classes in the autumn, I say to my students, "I want you to feel yourself. The pelvic crest is right here; feel it on yourself." And a lot of people are so shy they don't dare feel themselves. Some of the women say, "Oh, Mr. Hale, I just couldn't feel my pelvic crest." Well, you have to break down that resistance and become very familiar with the landmarks of your own body—a most convenient model. When you study the foot, look carefully at your own foot and feel its masses and landmarks.

I am sure that you cannot learn all the details of the foot just from these lectures. You will have to continue your studies further. But in these lectures you can get a very good idea of them and of how to use them in your figure drawings.

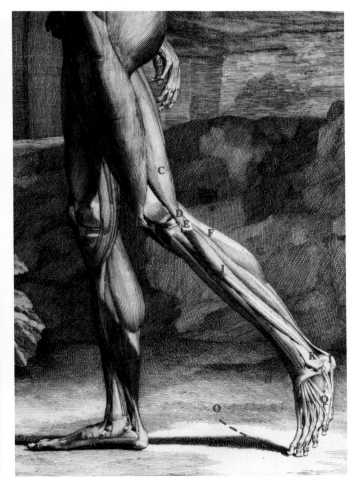

BERNARD SIEGFRIED ALBINUS (1697–1770)
PLATE FROM *TABULAE SCELETI ET MUSCULORUM CORPORIS HUMANI,* 1747
engraving

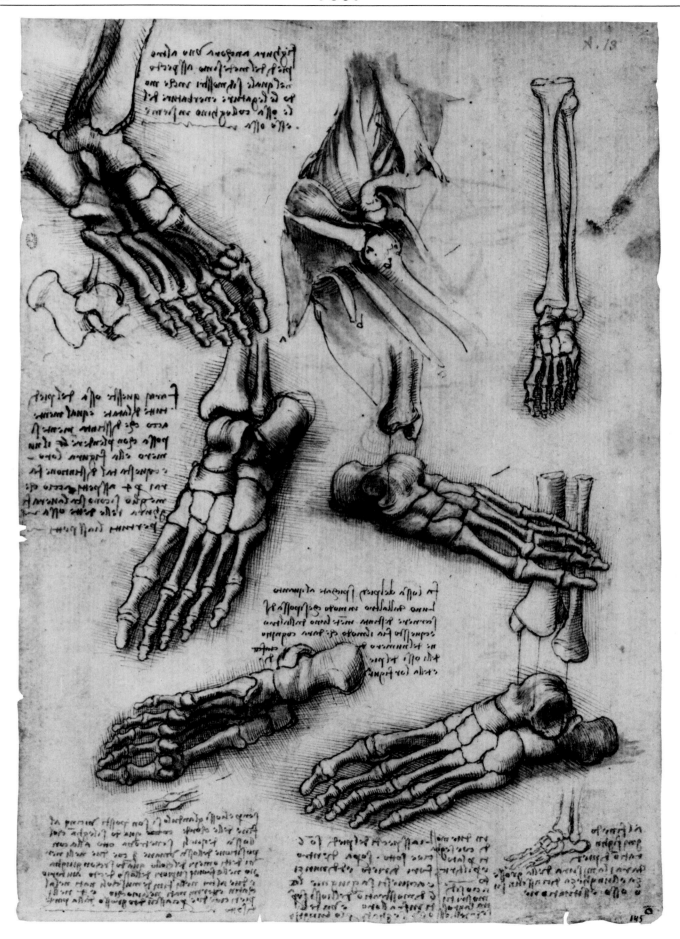

BONES
Multiple Views

You will find, as you go on, that the foot is the introduction to the hand. And if you can really grasp the bones of the foot, the short muscles within the foot, and the long muscles in the lower leg that move the foot, then you will have gone a long way toward understanding the hand. Although the artist thinks first of mass and then of detail, a good knowledge of bones will give you a feel for proportions, landmarks, and the placement and function of muscles as well as a bony basis for the feel of mass.

This is one of the many beautiful drawings that Leonardo did of the foot. Let's use it to analyze the structure of the foot. The foot is made up of a package of seven bones called the tarsals (A), five metatarsal bones (B), and finally the phalanges (C) or toes. I am not sure, though, if that is the way the artist ought to think of the foot. If the artist wants to break the foot down, I think he should break it down into what is called the ankle system and the heel system.

The ankle system consists of the bones on the top (D) that go down into the three inner toes (E). The heel system consists of the heel bone (F) and the bones on that side that run to the two outer toes (G). One of the great feelings of the foot, if you can capture it, is the heel system going under the mass (D) at the ankle and coming out the other side.

Let's start off with this top bone (D), sometimes called the ankle bone and also called the astragalus, and move down the ankle system. You can visualize this bone as a spool with a cylinder coming out of it. Next to that comes a bone (H) called the scaphoid or navicular. Unfortunately, there are two names. I think "navicular" is the best one to take. It means "like a ship." We get our word "navy" from that. Then come three little bones (I, J, and K) that look like little sections of Camembert cheese. They are called cunieform bones. Then we come to the metatarsal bones (B), numbered 1, 2, and 3 on this drawing. Finally, at the end of these metatarsal bones, we have the phalanges (C). There are two on the big toe, the way there are two on the thumb, and three on all the others. You will find that the ends of all the toes and fingers have little arrowheads on them to hold the nails. This is your ankle system.

The heel system starts off with the heel bone or calcaneus (F). It is a good deal like a sweet potato in shape. Next to that comes the cuboid (L), shaped a little like a cube. It has two facets on which rest the base of the metatarsal bones, numbered 4 and 5. At the end of the metatarsals you find the phalanges (C) of the fourth and fifth toe. Leonardo has put only two phalanges on the fifth (M) or little toe. It is very common for the middle phalange of that toe to be fused with the last one and this might have been the case with the foot of Leonardo's skeleton. Anthropologists say that the little toe is dying out because it does not seem to have much function anymore in that the weight is going over to the big toe. So, in a few hundred thousand years, I suppose, people will be born without little toes.

Well, there is your idea of the foot. You should of course also study the details from the bones themselves if you are interested. You can get an actual skeleton of a foot. Or you can study the detailed plates of anatomists like Albinus or medical books. But do try to get the quality of these bones if you want to draw beautiful feet.

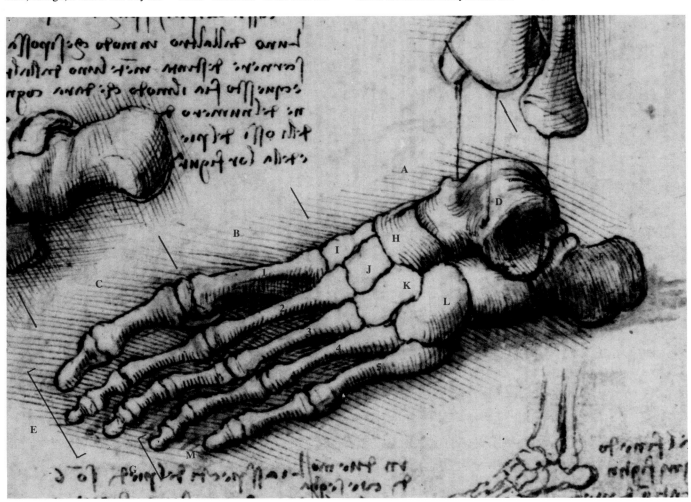

LEONARDO DA VINCI (1452–1519)
SIX STUDIES OF THE LEFT FOOT
AND ONE OF THE SHOULDER
pen and ink over black chalk

THE SHOULDER GIRDLE

TINTORETTO (JACOPO ROBUSTI) (1518–1594)
STUDY FROM MICHELANGELO GROUP
chalk
5¹¹/₁₆″ × 12¹³/₁₆″ (39.8 × 32.5 cm)

MASSING
Side View

Draftsmanship consists of imagining a mass and then running lines or values over the outside of the mass. Certainly when your figure drawing goes to pieces, it is because your mass conception has gone to pieces.

The strong value contrasts of Tintoretto's drawing suggest that he, like the other great masters, thought much in terms of mass. In this drawing he may have visualized the shoulder girdle as a blocklike form (A) sitting above the blocklike mass of the rib cage.

Study the strong blocking of the lower portion of the upper arm (B), the lower arm just above the wrist (C), and the upper legs (D and E). Remember that, although Tintoretto did this particular study from a work by Michelangelo, his knowledge of massing, perspective, and anatomy was so great that he did not have to depend on a model at all times. He could have done a drawing almost like this out of his head.

Beginners in figure drawing should spend a lot of time drawing simple geometric forms, shapes like the cube, sphere, cylinder, or ovoid (egg shaped) form, in varying positions and under diverse lighting conditions. These mass conceptions should be drawn over and over again until they can be committed to memory.

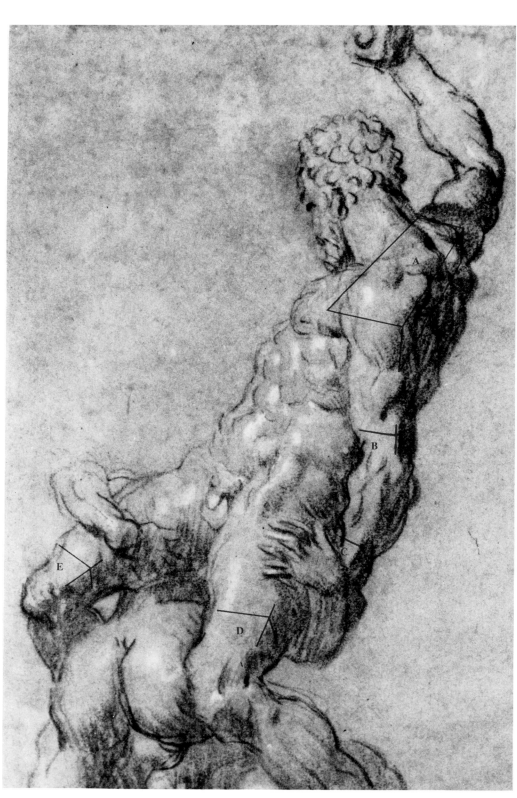

"You can't draw anything unless you know it exists."

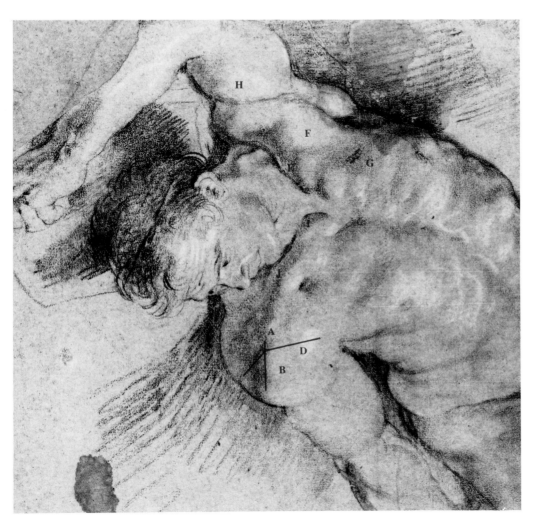

PETER PAUL RUBENS (1577–1640)
STUDY OF A RECLINING MALE NUDE
black chalk

PLANES AND VALUES
Front View

Planes, of course, do not exist any more than lines and points. By drawing planes, we are, as usual, presenting the viewer with symbols of mental conceptions. It is through the use of planes, however, that we present the illusion of three-dimensional form. We can think of a three-dimensional form, but we must realize that all we ever see of such a form are the planes that are facing us. It is only through experience that we have any idea of what is going on, on the hidden side and back of any three-dimensional form we happen to encounter or draw. Thus it is only by clearly presenting the simple symbols of the visible planes of a three-dimensional form, or its totality of visible planes, that we are able to offer the illusion of three-dimensional mass or volume.

In this unusual view, Rubens was above the model, and the dominant light source was from the right. The big plane break (A) between the light front plane (B) and the dark side plane (C) of the shoulder creates a strong and clear illusion of the blocklike mass of the shoulder girdle. This mass might be visualized as a slightly wider block just above the block on the rib cage.

The strong highlight (D) is kept distant from the strong dark (C) to symbolize in value relations the round, slowly turning form of the front portion of the deltoid mass. On the far side of the pectoralis (E), the dark side mass concept of the shoulder girdle is continued. The light side of this muscular mass (F) spirals up from the mass of the rib cage (G) to go over and behind the mass of the biceps (H) to its insertion in the outer arm. The inner edge of the clavicle (I–J) begins the illusion of a circle as the neck rises out of the circle of the first ribs at the center of the shoulder mass.

LANDMARKS
Side and Front Views

Half the job of drawing the back is to decide where the shoulder blade or scapula is. And knowing where the arm is will also help you, as we know that the scapula follows the arm around like a puppy dog.

Leonardo shows us the surface anatomy of the shoulder girdle in many different positions in this drawing. It is as if you were walking around the model from back to front. In this way you can carefully study the structure, shapes, sizes, and different landmarks of this area of the body. In the upper left figure, the seventh cervical vertebra (A) is at the top of the rib cage in the back. The shoulder girdle sits atop the rib cage. The line of the vertebral column (B) curves over the rib cage and is overlapped by the vertical edge (C) of the inner side of the scapula.

The spiral shape of light (D) is the spine at the top of the scapula. It curves out toward the arm to meet the end of the clavicle (E) at a little bump which artists look for as a landmark. The latissimus dorsi muscle (F) wraps around the base of the scapula (G) and holds it against the mass of the rib cage. We can clearly see the teres major (H) coming off the base of the scapula, overlapping the latissimus dorsi, and going under the deltoid (I) into the bone of the arm. The edges of these muscles are landmarks of muscular size, shape, and direction. Compare these anatomical studies and the landmarks you find in them to a skeleton and you will soon realize the great extent of Leonardo's knowledge.

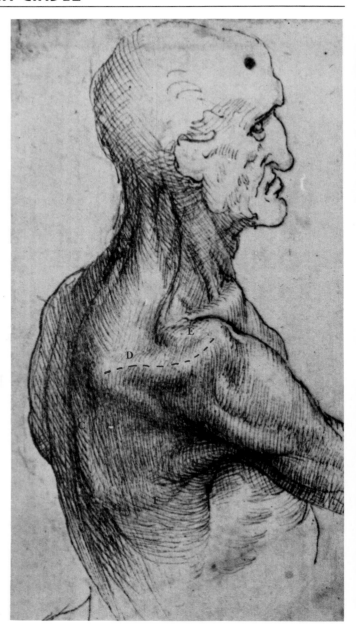

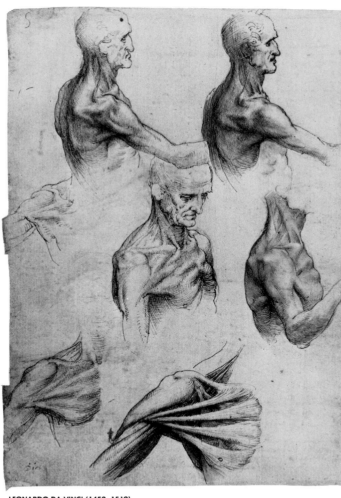

LEONARDO DA VINCI (1452–1519)
MUSCLES OF THE SHOULDER GIRDLE
pen and ink over black chalk

MUSCLES
Back View

It is rather important to differentiate between the shoulder girdle and the rest of the body as we draw. It has one very different quality from the rest of the body: it does not have much to do with gravity—the rest of the body does, but not the masses that move the shoulder girdle.

Look at this back view of a flayed figure by Vesalius. You can see that this bony shoulder girdle consists of the scapula (A) or shoulder blades in the back and the clavicle (B) that comes around from the front to meet it at the point of the shoulder (C). I suppose the humerus bone (D) of the arm is almost a part of it as far as the artist is concerned.

You see, there are two girdles in the body: the shoulder girdle atop the rib cage and the pelvic girdle just below the rib cage. They are very different. The pelvic girdle is a solid girdle that connects all the way around the body. We think of it as one mass. But the shoulder girdle, which sits rather loosely on top of the rib cage, has big gaps in it in the back that are connected only by muscle.

You have to understand the shoulder girdle very well because of its great freedom of movement and independence. You can easily place the position of the rib cage, but you have to be careful that you keep an eye on the shoulder blades. One shoulder blade might be much higher or lower than the other and rise well above the rib cage.

The outer end (E) of the spine (F) of the scapula meets the clavicle (B) at the level of the second dorsal vertebra (G). To the artist, who learns to see through and imagine the landmarks of the other side of the body, this is the same level as the pit of the neck in the front. The inner edge (H) of the scapula will rest pretty well along the construction line (I) of the line of the angle of the ribs when the arms are at the side of the body.

There is a muscle (J) that runs from the inner edge (H) of the scapula right to the center line (K) or vertebral column. Artists call that muscle the rhomboid mass. There are really two muscles in there, an upper and lower rhomboid, but artists never think of them that way. They think of one mass because the two have very much the same function. I think you can see their function: they draw the shoulder blade toward the backbone. You have to watch

ANDREAS VESALIUS (1514–1564)
PLATE FROM *DE HUMANI CORPORIS FABRICA*, 1543
woodcut

the arm movement because the rhomboid mass flattens out as the arm moves out; in contrast, its shape rounds out in contraction when it pulls the shoulder blade and the arm inward. As people get older, of course, they get contraction wrinkles in the rhomboids. You can always tell a woman's age by counting the wrinkles in the rhomboid.

Coming down from the top four cervical vertebrae at the back of the neck is a little muscle (L) called the lifter of the corner of the shoulder blade or levator anguli scapulae. It helps to lift the shoulder and fill out the mass of the side of the neck.

The famous trapezius muscle (M) comes out of the base (N) of the skull, contours down over the scapula (O), and covers many of the deep muscles of the back. Perhaps to get the feel of the trapezius, you might draw a rhythm line (P) across the highline of the shoulder from shoulder point (Q) to shoulder point (C).

I think everybody knows about the deltoid (R) at the top of the shoulder. It pulls on the arm from its base (S) in the scapula and lifts your arm. In this drawing we can also pick out the infraspinatus (T), the teres minor (U), and the teres major (V).

This part of the body is difficult because of the layers of muscle. Studying the details and functions will help. But only when you learn to work with mass, and not edges, will you begin to understand this area.

MUSCLES
Side and Front Views

Let's take a look at another page of beautiful drawings from Leonardo's sketchbook and consider some aspects of the front of the shoulder girdle. In this view we are greatly concerned with the pectoralis muscle (A). Leonardo's model was thin and emaciated, and the separate fibers of the muscle stand out in contraction.

Of course, the creatures that have the finest pectoralis muscles are birds because this muscle comes off the "chest" and goes into the wing (or arm) and pulls it forward. Birds do a great deal of flapping of their wings. They fly very long distances. They are very friendly animals. They winter down in Rio and summer in Bar Harbor, like the Prince of Wales. And they do practically all of it on the pectoralis muscle.

What are some of the landmarks in the front that relate to the shoulder girdle? We can think of the inner end (B) of the collar bone or clavicle moving out from the pit of the neck (C). The clavicle spirals out to meet the acromion process (D). That is the way it goes. That is the pattern for man, you see. Man has a very flat chest. It is lucky he has—he would fall over forward if he did not. But the pattern for a horse is a little different. The horse has a big chest and no collar bone. He does not need a collar bone. He does not have to play the accordion, or go to taffy pulls, or

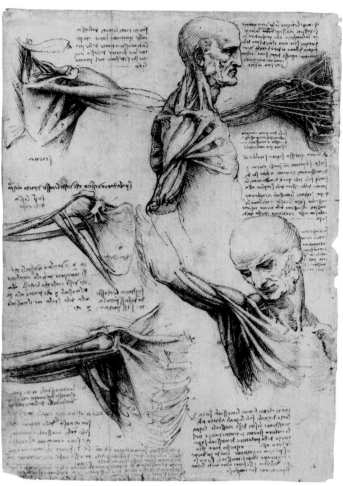

LEONARDO DA VINCI (1452–1519)
MUSCLES OF THE SHOULDER GIRDLE AND NECK, *pen and ink over black chalk*

scratch out the sides of his cave, or climb up telegraph poles. Function is everything. People who have to do those things have collar bones. It is all function.

The great pectoralis muscle (A) is really divided into two pieces. One comes off the inner (E) clavicle and is called the clavicular portion. The other, which Leonardo has divided into three separate fibers, is called the sternal portion and it comes off the sternum (F). Both of these portions of the pectoralis go under the deltoid (G) and behind the biceps (H) to find their way into the upper arm bone. I think the function of that muscle is pretty clear—to move the arm forward. Usually there is a good deal of fat on the ordinary model in the area of the armpit. But if you get a very thin model, the separate fibers may show a little.

When the model raises his arm above the horizontal, the deltoid (G) takes over to lift it further up. The little pectoralis minor (I) that attaches to the coracoid process (J) forms a platform for the pectoralis major above it. The front flap of the armpit is created by the edge (K) of the pectoralis major and the back flap by the latissimus dorsi (L) and the teres major (M).

You soon begin to realize that you have definite forms in these areas of the body. And when you begin to break up these details into groups and masses, you will be well on your way to good drawing.

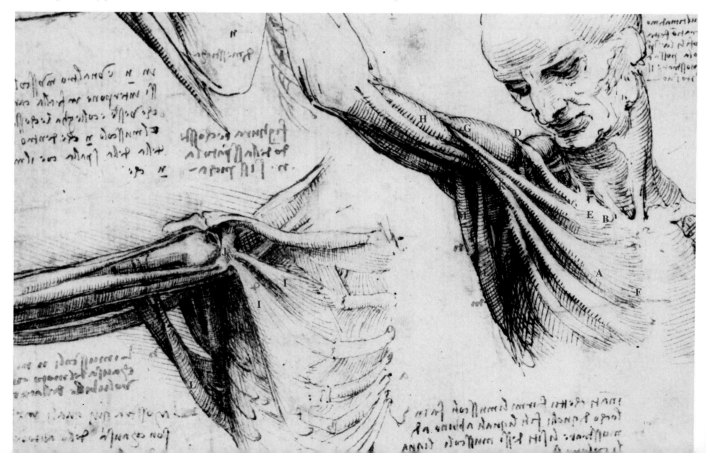

BONES
Back and Top Views

The designer of the shoulder was evidently thinking in terms of triangles when he planned the scapula or shoulder blade at the back of the shoulder girdle. As any engineer knows, the triangle is the strongest form we can think of. Probably, then, the best way to think of the scapula is as two triangles. We can visualize these two triangles in the back view in Leonardo's drawing of his dissections of the shoulder girdle. There is the feeling of a small upper triangle (A) and a larger lower triangle (B). Out of the line between these two triangles springs the spine (C) of the scapula. There is no doubt at all that this spine of the scapula is the most important thing to the artist.

I think the way to think of it is this: you can pass your hand across the top of the spine and you get a certain feeling. The feeling there would be as if you had created a vast sphere and you were feeling just a portion of it. Of course, in Leonardo's dissected figure the masses of the infraspinatus (D) and the teres minor (E) which contribute to that fullness in the back of the scapula are a little dried up and sparse. That fullness is something for you to look for and think about with the next model you draw.

The clavicle (F) moves back from the front of the body to meet the acromion process (G) at the outer end of the spine (C) of the

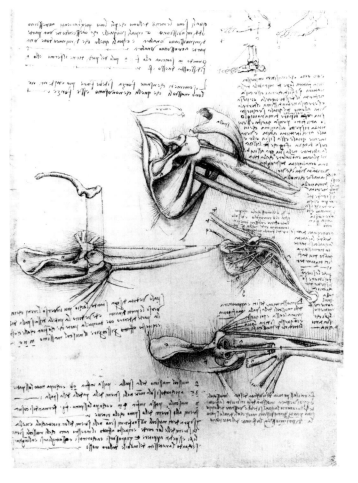

LEONARDO DA VINCI (1452–1519)
BONES AND MUSCLES OF THE SHOULDER GIRDLE, *pen and ink over black chalk*

shoulder blade. The humerus bone (H) moves into its ball-and-socket joint in the shoulder blade just under the acromion process. The partly dissected muscles are easily identified: the deltoid (I), the three heads (J, K, and L) of the triceps, the supraspinatus (M), and the lifter (N) of the shoulder blade.

In the top view, you find that the glenoid cavity (O)—the ball-and-socket joint that holds the ball-like head (P) of the humerus bone of the arm—is hidden by the acromion process (Q), which is a little to the side. The acromion process protects this joint from one side, and the coracoid process (R) hooks around the front of the joint and protects its other side. Leonardo has drawn in two vertical guidelines (S) to show the relationship and articulation of the outer end (T) of the clavicle with the acromion process (Q).

The acromion process, or shoulder process as it is sometimes called, has evidently been put there to protect the joint. If you are walking along and somebody comes and taps you there with a crowbar or something, your shoulder will be protected. That is what happens if you go walking in Central Park at night. You are pretty well protected by your acromion process. It is also a shoulder point and a well-known landmark for the artist. You can feel the hard bone there on your own shoulder.

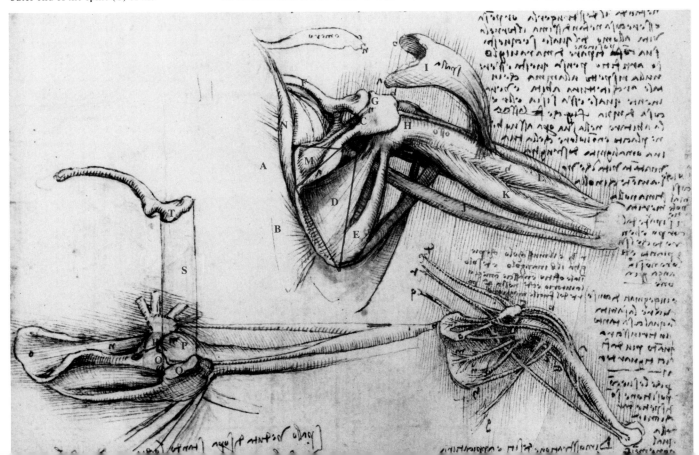

THE UPPER ARM

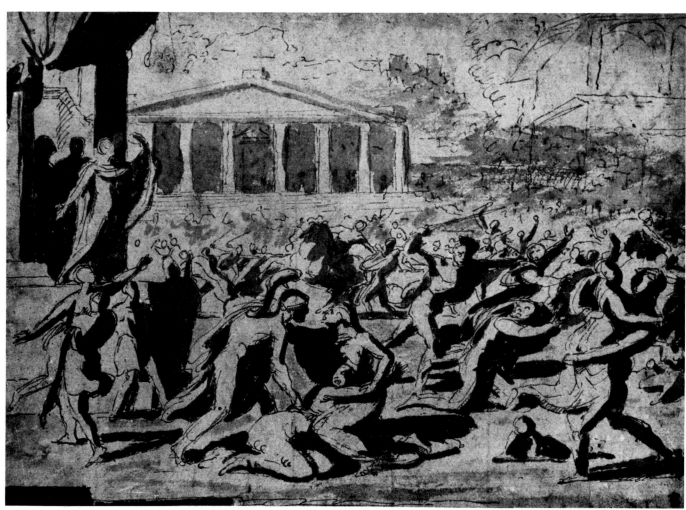

NICOLAS POUSSIN (1594–1665), STUDY FOR *THE RAPE OF THE SABINES,* pen and wash, 6⁷/₁₆" × 8⁵/₈" (16.4 × 21.9 cm)

MASSING
Side View

Mass conceptions, which the layman and beginner have probably never heard of, are by far the most powerful secret weapon the draftsman possesses to combat the problems that beset him. In planning his compositions, Poussin made many sketches like this one of large groups of figures in action. They may remind us of the underlying simplicity of Cambiaso's drawings. In this drawing the figures are washed in very simply in blocklike fashion. There

is a very sharp meeting of the masses facing toward the source (A) of light and away (B) from the light, up toward the light of the sky (C) and down away from the sky (D). Poussin was a master of visualizing complex forms in terms of very simple masses. He has fixed the forms in space so that he can plan his composition and then carve the forms out of the masses. When you study the finished painting derived from this drawing, you realize the importance of massing.

"Drawing is knowing where you're going."

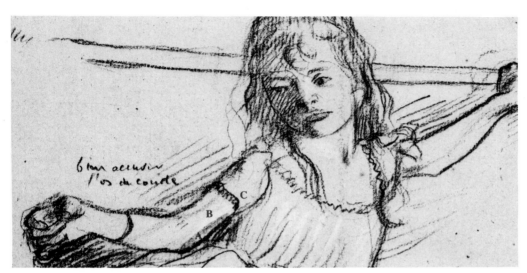

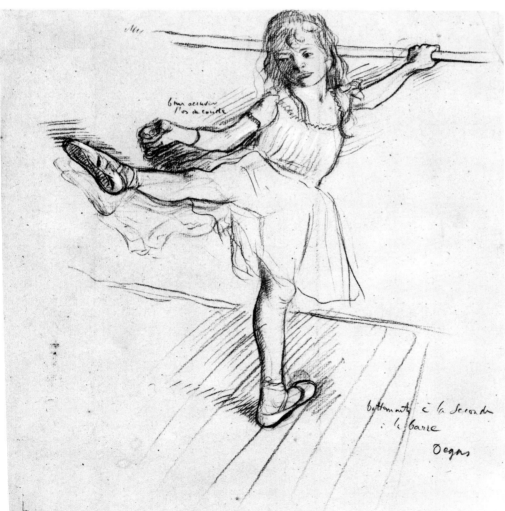

PLANES AND VALUES
Front View

Experienced artists are aware that points, lines, and planes do not really exist in our three-dimensional universe; these elements are but mental concepts. Artists are aware that when they draw a "line" with charcoal or pencil, they are creating nothing but the symbol of the mental concept of a line. And they know that the same is true of their "points" and "planes." Yet they also know that if they can set down and arrange these symbols properly on a working surface, they will present the observer with the illusion of three-dimensional form.

The artist searches for places on the body where planes meet. Often he draws a line to create the illusion of the meeting of planes. At times he masses with the side of his chalk. He knows that he can't draw exactly what he sees. He also knows that he will have a more effective drawing with greater contrast at the meeting of planes.

Degas has shown great economy of means in this rapid sketch. It captures the intensity of action in part by this very simplicity in handling. The upper arm is massed with a simple stroke of the chalk for the side plane (A) and a wide stroke of white for the front plane (B). The sharp turn of the sleeve (C) echoes the thin, blocklike form of the straining muscles in the little girl's arm. You can think of drapery as a second flesh. Notice how throughout Degas' drawing, the drapery suggests the forms over which it moves.

EDGAR DEGAS (1834–1917)
LITTLE GIRL PRACTICING AT THE BAR
charcoal and white chalk on pink paper
12 1/8" × 11 1/2" (30.8 × 29.2 cm)

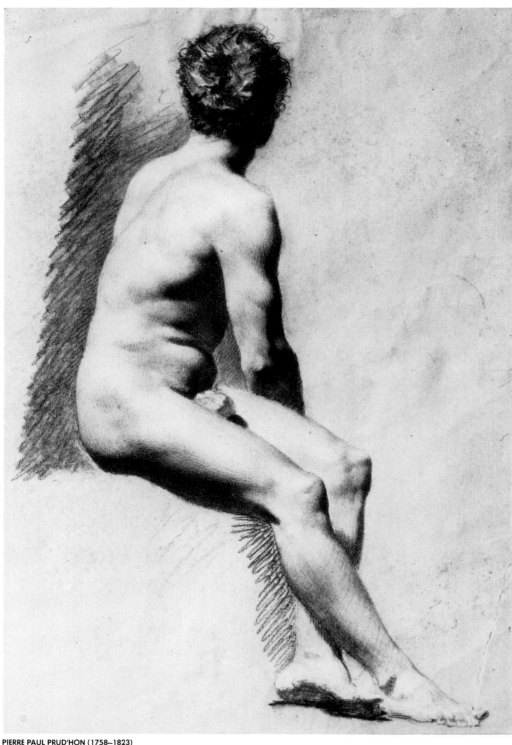

PIERRE PAUL PRUD'HON (1758–1823)
SEATED MALE NUDE
black chalk

PLANES AND VALUES
Side View

Trained artists, when they draw from the model, mostly set down a ''secret figure'' they have long since created. Through years of studying artistic anatomy and drawing the figure, they have thought out the relationships of the varied shapes, planes, and directions of the masses of the body. Laymen, of course, are unaware of the existence of the vast majority of the forms that comprise the body, nor have they thought about the shape of the few forms they are aware of. For instance, in my secret figure, the lower part of the deltoid (A) on the upper arm, where the plane dips inward to insert on the bone, is on about the same level as the bottom of the shoulder blade (B) in the back. Again, the lower termination of the fleshy body of the tensor fasciae latae, where Prud'hon has placed a little down plane dark (C), is on the same level as the bottom of the buttocks (D). Now, on the model this termination might be a touch higher, or a touch lower, but in my drawing, I will follow my secret figure. And why not? Am I going to get up and fetch a pair of calipers and determine the exact line of termination on the model? Certainly not. It would impede the flow of my style, and I am aware that hardly anyone in the world knows that this form on the body exists.

The dominant plane breaks of the upper arm that Prud'hon has used in his drawing are on the side of the deltoid (E), on the outer head of the triceps (F), and on the side of the common tendon (G) of the triceps. The dominant plane breaks of my secret figure will vary with the direction and angle of the lighting. They might vary a little from those used by Prud'hon with the lighting on his model. If I call upon my secret figure in remembering some of the possible plane breaks of the figure, who is to know? And of course, I will probably change these plane breaks and forms a little to suit the lighting and my compositional intent.

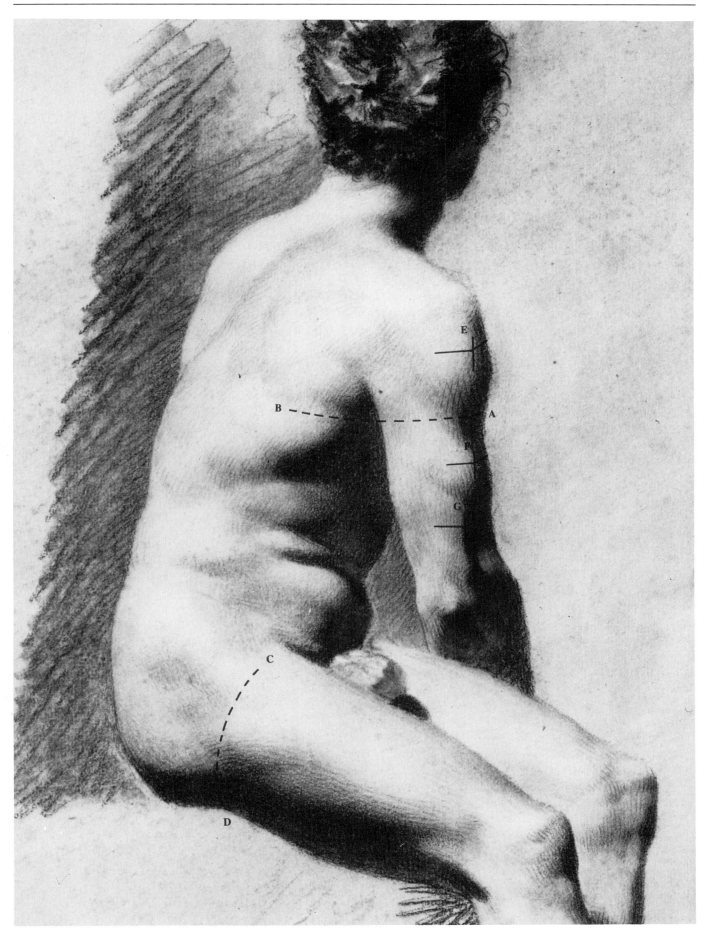

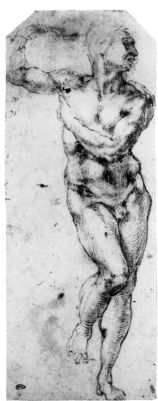

MICHELANGELO BUONARROTI (1475–1564)
MALE NUDE FACING RIGHT
pen and black ink

PLANES AND VALUES
Side View

Remember that our problem as artists is to learn the form and then, of course, to give the illusion of the form on our paper when we draw. To a great extent, that's done by becoming aware of what light does to form. You have to understand that light can destroy the form, you know. It destroys it terribly, and that's why in the beginning people get bad results—because they copy exactly what they see. And what they see is the light destroying the form because of the many lights in the studio and cast shadows coming from all directions at once.

When you have learned to select or imagine a dominant light from one direction with a reflected light from the side, the values on the model will remain the same unless the model moves. Understanding value relationships can help you to explain any movement and the changing relationships of the different parts of the body in your drawing. Contrasting the value relationships will help to convey the illusion of movement of the parts and to clarify their positions. For example, if the model is posed with one leg forward and one leg back, as in Michelangelo's drawing, the forward leg (A) may be given an overall lighter value than the back leg (B). Of course, this brings the

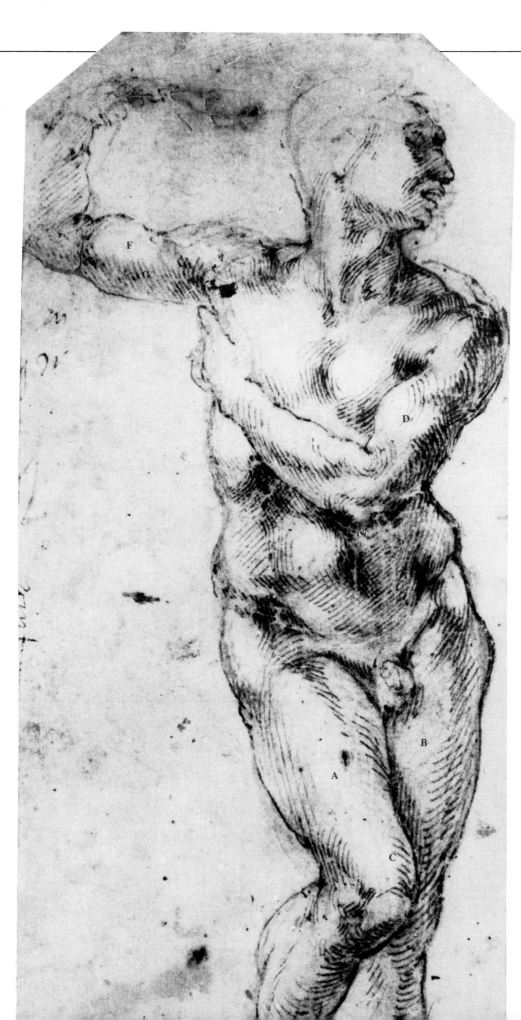

forward leg more to your visual attention. The back leg becomes slightly subdued. The fact that the forward leg overlaps the back leg, with a strong value contrast just above the knee (C), completes the illusion.

In the upper part of the figure, you can observe a difference in value contrasts within the near and distant arms. The light front plane (D) and the dark side plane (E) of the near arm are stronger in value contrast than the light up plane (F) and the dark down plane (G) of the distant arm. This heightens the illusion of depth and distance and the atmospheric effects of the forms in perspective.

The subject of planes and values is really something difficult for the new student, and even very hard for teachers to explain. The reason is that every individual artist, once he is experienced, should make up his own planes and values. Beginners look at a book and say, "This head or torso is cut up in such a way. It has these exact values, and that must be the final truth." But it never is. Like Michelangelo, you shouldn't just copy exactly what you see or follow a fixed formula for each pose and each form on the body. You must learn to invent and supply the planes and values that give the illusions you wish to create in your composition.

LANDMARKS
Front View

When you come to think of it, a lot of people don't even know they have a pelvis. And there are some people walking around out there who don't know they have a humerus bone. But they have. Everybody has them. So I thought we'd start by learning about the landmarks of the arm that give us clues to the humerus bone beneath.

We already know that beginners just put down outlines when they draw. But professional artists create lines that show shape, size, planes, and function. And they like to draw their lines to known points or landmarks. In Domenichino's drawing we can see how bony landmarks like the olecranon or elbow (A) and the inner condyle (B) of the humerus bone helped him to place the outer end of the upper arm. The little dip (C) at the inner end of the deltoid (D) is a clue to the position of the inner end of the humerus bone of the upper arm. We also know that the deltoid dips in to its insertion (E) about halfway down the humerus.

Begin to learn about the bony points, lines, edges, shapes, and size relations throughout the body. These landmarks are valuable points of reference.

DOMENICHINO (1581–1641), CHRIST ON THE CROSS, *black chalk, 18¹¹/₁₆" × 15⁷/₁₆" (47.5 × 39.2 cm)*

MUSCLES
Multiple Views

In this lecture we are going to take up the muscles of the upper arm. If you think back to the leg and its basic function, you will easily understand the arm. You probably remember that the main function of those big muscular masses that make up the front and back of the upper leg was to move the lower leg. Well, in the arm it is much the same. The masses in the upper arm move the lower arm.

Study the side view (A) of the dissected shoulder in Leonardo's magnificent page of arm and shoulder drawings. Look at the shoulder blade (B), which is a support and fulcrum for the humerus bone (C) of the upper arm much as the pelvis is the supporting point for the bone of the upper leg. Note the ball (D) of the head of the humerus fitting into the glenoid cavity (E) of the shoulder blade in this unusually detailed and accurate drawing.

On one side of the arm there is a big mass (F) called the biceps, which has a function similar to that of the hamstring mass in the back of the leg. It bends or flexes one limb against the other. It brings the limbs closer to one another—that is, it bends your arm. Everybody knows the biceps. All the little boys show it to the little girls. It is one of the few muscles that the layman knows. The biceps muscle also rotates your hand into the position of palm up,

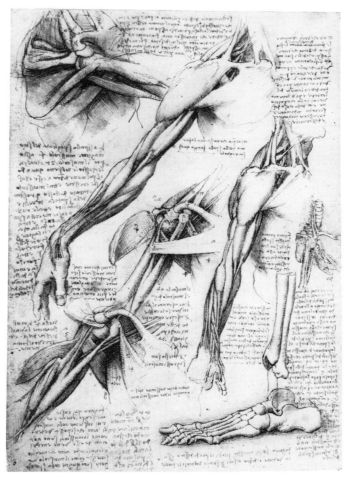

LEONARDO DA VINCI (1452–1519)
STUDIES OF THE SHOULDER, ARM, AND BONES OF FOOT, *pen and ink over black chalk*

called supination.

In the back is another muscular mass (G)—the triceps—which is the antagonist or opposing muscle to the biceps. It pulls the lower arm the opposite way. It straightens out your arm.

There is a big piece of muscle, the deltoid (H), that comes off the spine (I) of the shoulder blade and the clavicle (J) and tries to get in between the biceps (F) and the triceps (G). The deltoid is much like the gluteus medius of the pelvic area. It reaches down to the bone below to pull it up or to one side or the other. You see, if you investigate a little, the functional analogies between the arm and the leg are very clear.

There is also a small muscle (K) at the side of the arm, called the brachialis. It lies between the biceps (F) and the triceps (G), just below the deltoid (H). We often think of it as the "pillow muscle," a little pillow behind the biceps. Like the biceps, it goes down into the lower arm and helps you to bend your lower arm up against the upper arm.

Drawing the figure is a matter of understanding the position, shape, size, direction, and function of the forms of the body. The artist knows where these forms are going and where they end. In other words, drawing is knowing where you are going. Drawing is a language, and you learn to draw by coming to simple shape conclusions about the complex forms

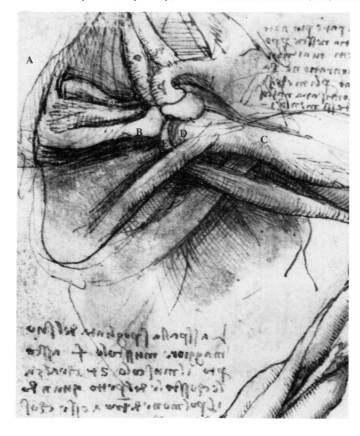

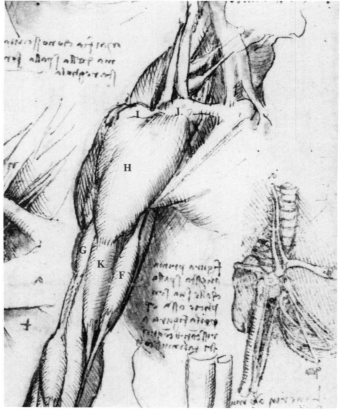

of the body. If I say something about a part of the body, I will say it pretty clearly if the forms of that part of the body are very clear in my own mind. Then if I throw a little light on those forms, applying a little knowledge of the principles of planes and value gradations to them, I will be able to convey my impression of these forms to you.

BONE
Front and Back Views

Let's go after the bone of the upper arm. When we think of the upper arm and its function, of course, we think a good deal about the shoulder blade. Let's take the front view of the arm in Richer's drawing. We might block in the shoulder blade with a small upper triangle (A) and a large lower triangle (B). That's the feel of the big shape of the shoulder blade: two triangles. The glenoid cavity (C) looks out, forward, and up a little. The protecting acromion process (D), at the outside of the spine of the scapula, hovers above the joint. The coracoid process (E) hooks out and around to protect the front. We can see how the ball (F) or head of the humerus bone fits into the shallow glenoid cavity (C). The cavity is very shallow so that you get great freedom of action there. The fact that the glenoid cavity looks forward, up, and out will influence our drawing. Because if the cavity looks that way, it means that the front of the shoulder is always pushed a little forward.

We can feel the ball pressing into that glenoid cavity and we can see the greater tuberosity (G) of the humerus on the outside. The shaft (H) of the bone descends in a long cylindrical form to an enlarged mass (I) below. You might think of the length of the humerus bone as a couple of scapula or sternum lengths, or about one and a half head lengths.

When we get down to the bottom of the shaft, we will find a very recognizable bump (J) called the inner condyle. It becomes a very important landmark to us as we study the arm. You will be able to see it on the model, and you can easily feel it on yourself. It is something that every artist places as he draws an arm. He knows where it is and gets a great many facts from it. Notice how the outline (K) of the inner side of the arm flows from the bump (J) of the inner condyle. That is because the mass of the flexor mus-

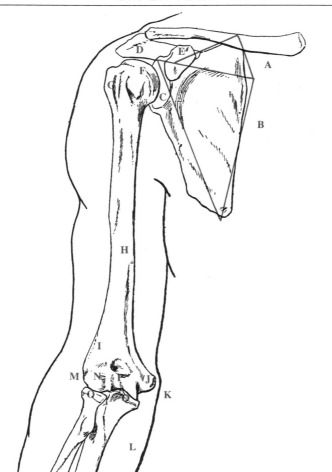

cles (L) originates in the inner condyle and moves down the arm from that landmark.

On the other side, of course, we get the outer condyle (M). The outer condyle is generally pretty hard to see, but we know where it is because we can always feel and see the inner condyle. Here is a little trick for you. If the model is posed so that you cannot see the inner condyle, put your arm in the same position as the model's arm. You can always feel your inner condyle no matter how the model is posed, and you can assume it is in the same place on the model.

Next to the outer condyle is the little ball of the capitulum (N) that holds the head (O) of the radius and allows you to rotate the radius across the ulna and turn your hand over with it. It is a ball-and-socket joint. Further inside the base of the humerus bone is a spool-shaped form (P) called the trochlea. At the end of the ulna (Q) what looks like a parrot's beak bites the spool and creates a hinge joint for the flexion and extension movements of the lower arm.

Become familiar with the bony structure and landmarks of the arm. Think of the functional relationships of bone and muscle, and relate these forms as variations of your mass conception of the arm.

ANTERIOR ASPECT POSTERIOR ASPECT

THE LOWER ARM

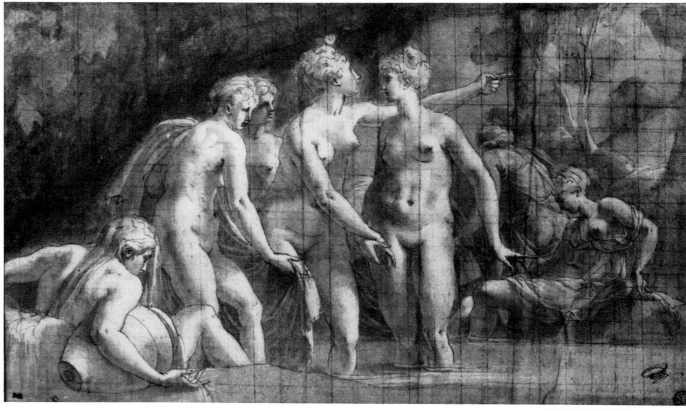

FRANCESCO PRIMATICCIO (1504–1570)
DIANA AT THE BATH
black and white chalk

MASSING
Multiple Views

The artist must decide on the exact position of a form in space before drawing it, and he must also decide on its exact aspect in relation to himself if he wishes to create the illusion of reality on his pad or canvas. In order to do this, he must reduce the forms to simple symbols like the block and cylinder. The suggestion of these underlying forms creates a solid and forceful foundation for the secondary shapes, lines, textures, and values that follow.

In this delicate drawing we can speculate that Primaticcio saw the arm as a cylinder (A and B). Its slowly turning mass would be a suitable concept for the softness and gentle value changes of the female arm. The lower half of the lower arm (C) is always visualized more as a blocklike form when the hand is in the palm-up or supinated position, as it is here.

"Drawing is a series of thoughts with lines around them."

JOSE DE RIBERA (ca. 1590–1652)
MARTYRDOM OF A SAINT
red chalk on browned paper
10¹/₁₆" × 6³/₈" (25.5 × 16.2 cm)

PLANES AND VALUES
Back and Front Views

The word "plane," for the artist, may imply a surface of many planes—the front plane of the body, for instance, or the side plane of the head. Or a plane may be simply that area of the body illuminated by a specific light source.

In drawing the figure we think first of the big dominant planes, not just the little details on the body, and we put the shading where the big planes meet. The dominant plane breaks are not at fixed points, but vary according to the position of the light.

Here Ribera decided on a three-quarter front light from above. The plane break (A) on the upraised arm is well to the side and the artist has indicated the side plane (B) with a simple, long shape of dark mass that is varied in size and graded from darker (C) at one end to lighter (D) at the other. He has put his values in lightly to allow for emphasis on the strong linear overlappings (E, F, G, and H) that add to the illusion of the figure's painful contortions. Nevertheless, he has congregated his darks on the side of the figure away from the light for a unified lighting effect.

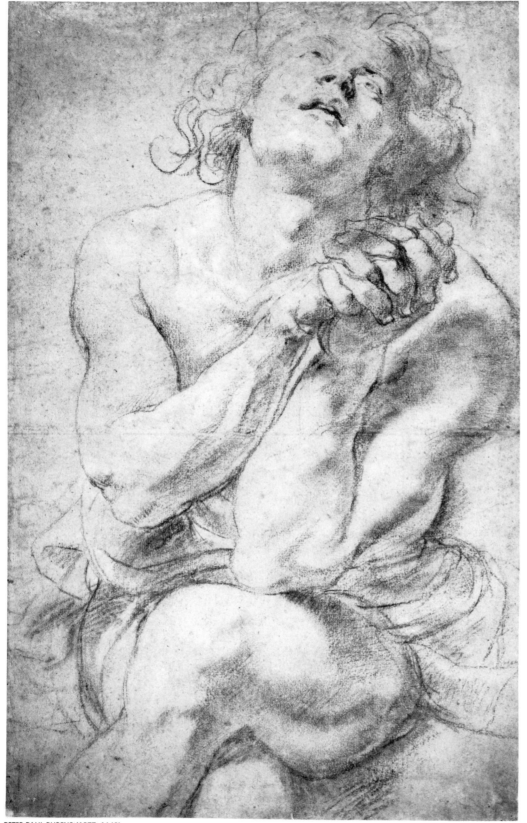

PETER PAUL RUBENS (1577–1640)
STUDY FOR DANIEL IN THE LION'S DEN
black chalk heightened with white on pale gray paper
19³/₄″ × 11¹³/₁₆″ (50.2 × 30 cm)

PLANES AND VALUES
Side View

Let's get into why the artists think that visualizing plane breaks is valuable. Of course, they think it's valuable because at these plane breaks the front plane that faces the light meets the side plane that is away from the light. I think that when the artist first looks at the model, he sees these planes slightly flatter than they are. In this Rubens drawing there is no doubt that A is a front plane, and that B is a side plane. Also, C is another front plane and D is a side plane. You can see that these plane breaks do not just move up the arm in one straight line. There is a rhythmic shift of the edge line (E–F and G–H) to allow for the internal plane break (I) of the ulnar furrow. Rubens has made the value contrasts of the dominant external plane breaks (A–B and C–D) stronger than the internal plane break (I) so as not to break up the big massing of the arm. As artists, we know that if the lights and darks that we see on the form create spotty little pieces then, in order to complete the illusion, we have to go back to our intellectual concept of big plane breaks.

One problem that we encounter is that values usually move in two directions. That is one reason drawing is hard. But if you can't grade your values, you can't get your form. So you think a lot about the movement of values, and you copy drawings by the great masters. You might even go to the museums to copy from the originals as the values in some books become too dark with repeated printings. Remember, Rubens copied Michelangelo, Titian, Leonardo, and Raphael in addition to drawing constantly from the model.

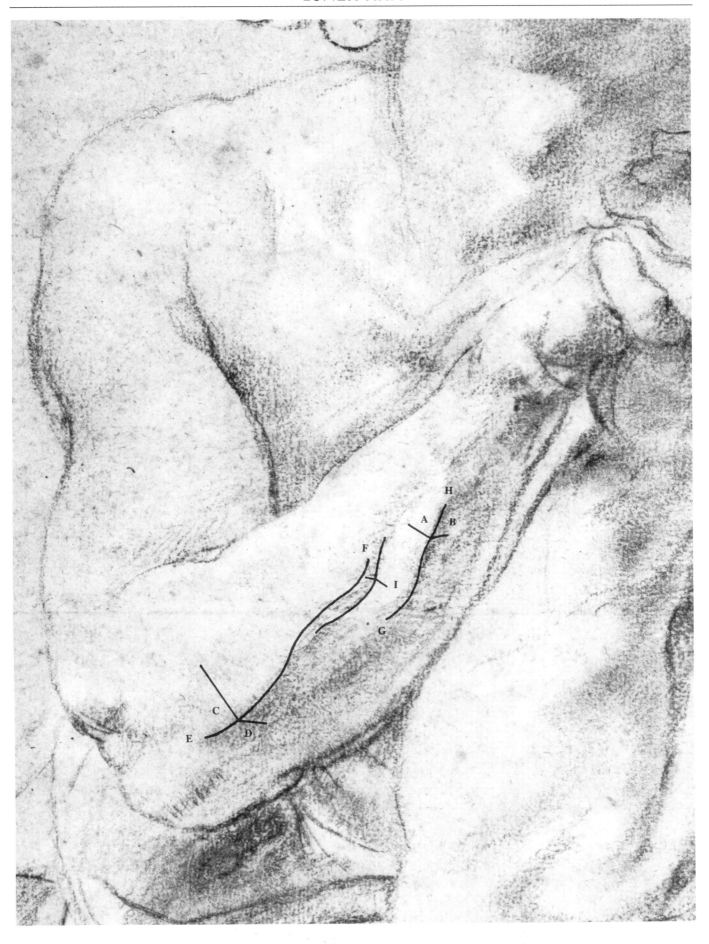

LANDMARKS
Front View

Artists like to say that lines run over conceived or imagined forms. By "forms" they mean mass concepts like the simple block, the cylinder, or the sphere. So practice running contour lines over the front and back of your mass conceptions. Contour lines follow the exact changes in the contours of the surface of a form. You can think of them as rubber bands that circle the basic form. Draw a horizontal rubber band around an upright cylinder. Then tip the cylinder forward or backward. See what happens to the line. Note how the direction of the curve of the rubber band changes. The center line of the mouth runs over such a semicylinder of the teeth. What will happen to this line when the head is tilted? Learn to draw contour lines over mass conceptions of all the different parts of the body to reveal the directions of the masses and the lines that travel over these masses.

Leonardo has drawn a series of short, little contour lines (A) over the upraised arm of the figure in this drawing. They serve a double purpose. These lines both describe the cylindrical shape of the arm and, as a group of parallel lines, they give the illusion of a dark side plane much like regular hatching lines. Leonardo was certainly capable of producing an enormous amount of detail if he wished. But in this rapid sketch, a few simple landmarks are enough to clue us to the basic forms and divisions of the body. Note the bump (B) of the olecranon at the elbow. The short little line (C) at the side of the styloid of the ulna overlaps the mass of the extensors (D) at the back.

Note the important landmark line (E) of the ulnar furrow that runs from the elbow (B) to the styloid of the ulna (C). These and numerous other simple lines, bumps, overlapping masses, and shapes can be found throughout this drawing. They are a kind of shorthand that reveals Leonardo's great skill in the use of landmarks.

LEONARDO DA VINCI (1452–1519), NEPTUNE WITH HIS SEA HORSES
black chalk on white paper, 9⁷⁄₈" × 15⁷⁄₁₆" (25.1 × 39.2 cm)

MUSCLES
Side and Back Views

Now we get into the problem of the muscles of the lower arm. But let's see what they do, because from a knowledge of function we can simplify our masses. The hand is largely moved by the muscles in the top of the lower arm. That is why if you type a lot, you begin to get pains in that area. When you think what these muscles do, you become able to mass the lower arm. By and large, they do three things to the hand: flexion, extension, and rotation. With flexion, you bend your hand to touch your wrist. In extension, you bend your hand back as if to wave to someone. And in rotation, you move your hand from the palm-up position of supination to the palm-down position of pronation. This means that for these three actions you can expect to find three masses in the upper half of the lower arm to create these movements of the hand: the flexors (A), extensors (B), and the supinator (C). That is the way the artist looks at the problem. It would be almost impossible for anybody to remember all the muscles in there, so that is why the artist breaks down this part of the arm into three masses.

Let's see what goes on here. The movements of flexion and extension are common to creatures with limbs. But we are the only animal that can really do pronation and supination very well. We have this incredible facility for putting keys into keyholes, turning doorknobs, and pulling corks out of bottles and all the rest of it, which your horse cannot do. Some animals do it a little more than others. Animals that have to scratch inside their tunnels, like moles, can do it pretty well. Cats have to play with mice for some reason I could never understand. But most animals cannot do that.

Leonardo wrote and sketched from right to left so he started this study of arm movement on the right (D) with the lower arm in demipronation. That is, halfway between palm up (supination) and palm down (pronation). He gradually rotated the arm in each view until, in the last view on the left, the hand is in forced pronation.

What do you think causes that? Well, there's a little muscle called the pronator (E) that does this. It comes off the inner condyle (F) and reaches across the arm to the radius (G) on the outside of the arm. It pulls the radius and the thumb side of the hand across to the inside. So if you can remember the pronator, you can remember what pronation is.

When the arm gets into pronation, as in the arm on the left, it has to be pulled back into su-

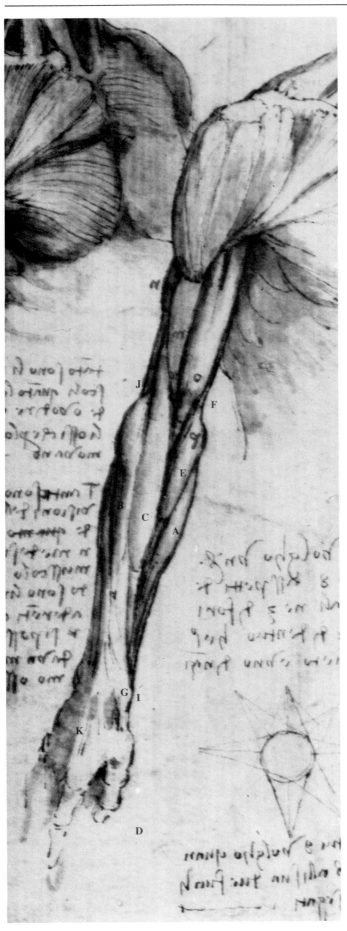

pination—so you can carry a bowl of soup. You will find there is a great big muscle called the supinator longus (C) that does much of this. I believe every artist who draws at all knows this muscle that comes off the upper arm (H) and goes into the little bump (I) of the styloid of the radius bone just above the base of the thumb.

Experiment with the changing shapes in your own arm as you rotate it from supination to pronation. With the palm of your hand up in supination, you will notice that the lower arm is shaped like an oval in the upper half, and more like a block in the lower half. Rotate your hand so that the palm is facing down. Now you will see that the shape of the lower arm has changed. It has become more cylindrical in both the upper and lower halves.

That takes care of rotation.

Now we have to think about moving the hand forward in flexion and backward in extension. Flexion is taken care of by the muscular mass (A) of the flexors that comes off the inner condyle (F). There are a good many muscles in there, but the artist usually thinks about the mass. And you are going to find a mass (B) called the extensors on the opposite side. It is the mass that comes off the outer condyle (J). It goes to the back (K) of the hand, moves the hand back (extension), and opens up the fingers.

I know that it is hard to get this information just from this lecture without a certain amount of study by yourself later on. The complications of the movements of the arm and hand are almost too much to grasp quickly. But it is well worth the artist's trouble to begin studying these facts.

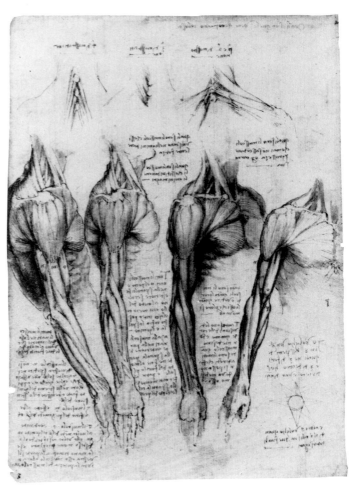

LEONARDO DA VINCI (1452–1519)
ANATOMICAL STUDIES OF THE
RIGHT ARM, SHOULDER, AND NECK
pen and ink over black chalk

BONES
Front and Side Views

Now let's look at the bones of the lower arm a bit. Leonardo was extremely interested in the bones of the arms and legs. His reverse writing in this drawing refers to the mechanism of pronation and supination in rotating the arm and hand as well as his methods of dissection and determining proportions. His main purpose here was to show the mechanical action of rotation. For this reason, he showed the two chief muscles concerned in this movement: the pronator teres (A) and the biceps brachii (B). Leonardo knew that the biceps is a chief supinator as well as a flexor and that the supinator longus, which we talked about in the last lecture, also performs both of these functions.

The middle drawing shows a front view of the right arm. The radius (C) and the ulna (D) bones are parallel to each other and the hand is in supination or palm up. We can think of the parrot's beak of the olecranon (E) of the ulna biting the spool (F) at the base of the humerus bone (G). The back of the olecranon (E) creates the point of the elbow.

The action of the ulna (D) is purely and simply flexion and extension. It bends your arm and straightens it. That is all the ulna can do. It spends its life doing that. The shaft of the ulna reaches down to the styloid (H) or bump on the little finger side of the hand. The radius (C) has a little hollow in the head (I) or thickened portion where it meets the humerus bone (G). This little hollow pushes up against a little ball (J) called the capitulum, which is at the base of the humerus. The shaft of the radius (C) moves down to the bulge (K) of the styloid on the thumb side of the hand. The radius really holds the hand. The hand belongs to the ra-

dius and not to the ulna. I think you might almost say that the elbow, the olecranon (E), belongs to the ulna and the hand belongs to the radius.

In the drawing just below, the radius (L) has rotated across the ulna (M) and carried the mass of the hand with it. The hand has moved from a palm-up position in the drawing above to a palm-down position in this drawing, where we see the back of the hand. The thumb is now pointing in the opposite direction.

All the old masters could draw beautiful arms. This is because they had memorized the bones, landmarks, proportions, and planes of this part of the body so thoroughly. You'll find, with a little practice, that it is not too difficult. Actually, most of the problems you encounter in drawing the figure may be solved by studying anatomy and the elements of drawing.

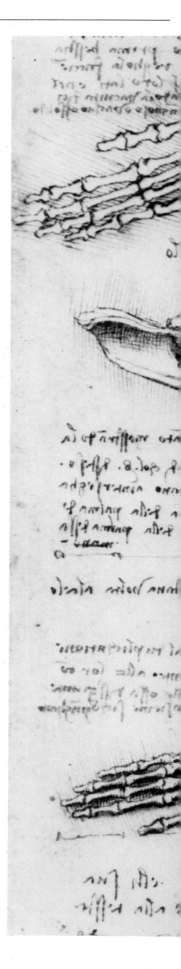

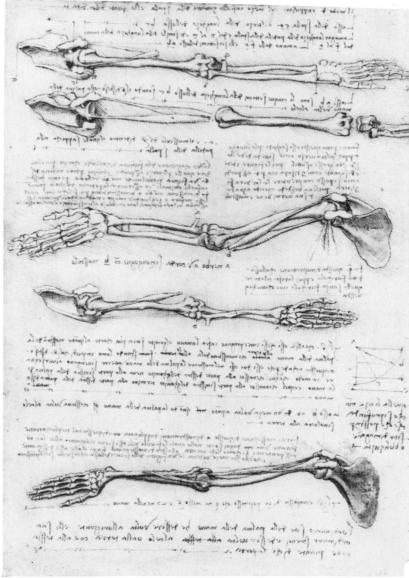

LEONARDO DA VINCI (1452–1519), STUDIES OF THE BONES OF THE ARM AND HAND, *pen and ink over black chalk*

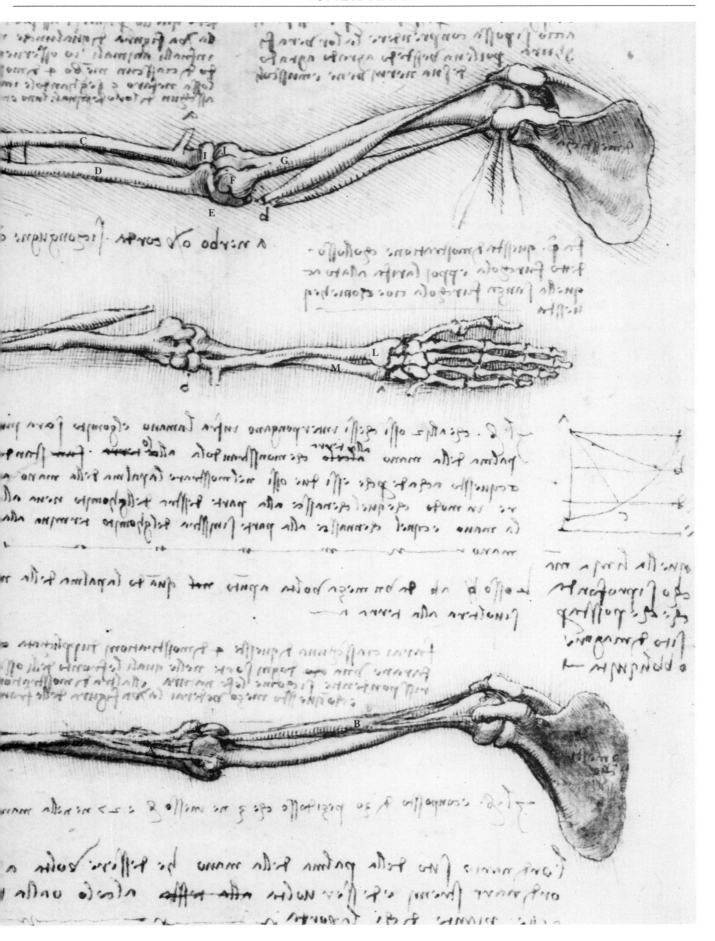

THE HAND

ALBRECHT DÜRER (1471–1528)
STEREOMETRIC MAN WITH
CROSS-SECTIONS OF HEAD, NECK,
RIB CAGE, KNEE, ANKLE, AND FOOT
pen and ink
11⅜" × 8" (28.9 × 20.3 cm)

MASSING
Back and Side Views

If it is accepted that a line cannot be drawn until the form over which it is to move has been conceived by the artist, then it must be agreed that the line cannot be drawn until the artist has decided on the direction of that form. For, as far as the direction of form varies, the line on the form will also vary. Accordingly, the artist must first decide on the thrust of the body of the hand before he creates the lines on the hand.

At times, in order to present the illusion of the true shape of a form, its direction must be altered. A cube or block copied head-on (A), as in the figure's right hand in this Dürer drawing, gives the illusion of a flat, square plane. In order to visualize it more clearly, it must be moved so that its two sides are brought into view (B) and its true identity revealed. Only a master can render a finger pointed directly at him. The rest of us must move it a little this way or that. Direct front and back views of parts of the figure are avoided by most artists as the sides are subordinated and there is little movement of planes or lines to explain the actual shape or suggest perspective.

"We are from the sea, with webbed fingers, no concave planes, and our tears and blood are salt."

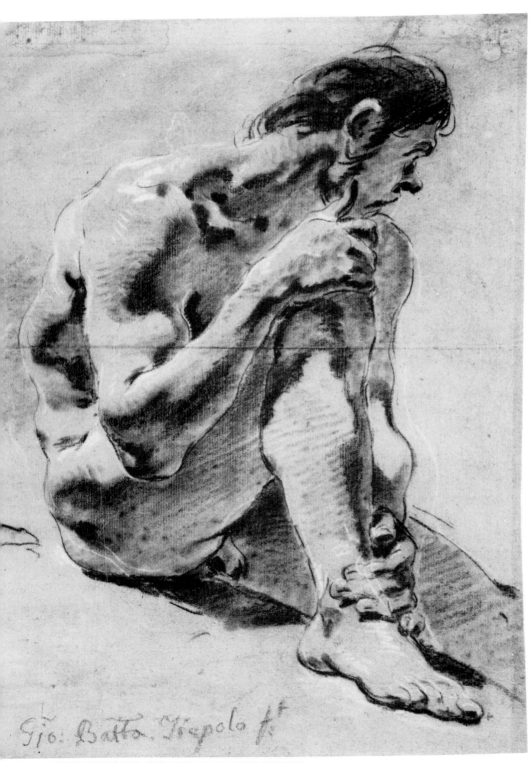

GIOVANNI BATTISTA TIEPOLO (1696–1770), SEATED NUDE FIGURE TURNED TO RIGHT
red and white chalk, 13⅞" × 9½" (35.3 × 24.1 cm)

MASSING
Back View

Mass conceptions are even more valuable than conceptions of planes in determining the values of light and shade to be applied to a complex form. (Naturally there is always a relationship between the two, as planes can always be thought of as the surfaces of masses.) Frequently the artist, in shading a form, will allow the values he imagines as lying on the controlling or dominant mass to greatly influence his drawing. Let us take an example. In this drawing of a seated male figure, Tiepolo wished to depict the back of the hand and the upper portion of a finger. Of course he understood about mass conceptions and could visualize the back of the hand (A) as a square block, with the finger (B) as a long box. In his mind he threw direct and reflected light on the block and the long box and visualized the resulting values. He then transferred these values in great measure to his drawing of the parts of the hand. It is important to realize that in so doing he may well have rejected the values of light and shade that he actually saw on the hand itself, offering instead the light and shade he imagined on the controlling masses—the block and the box.

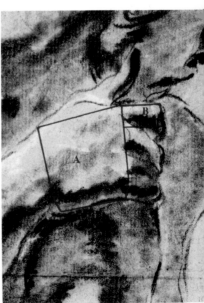

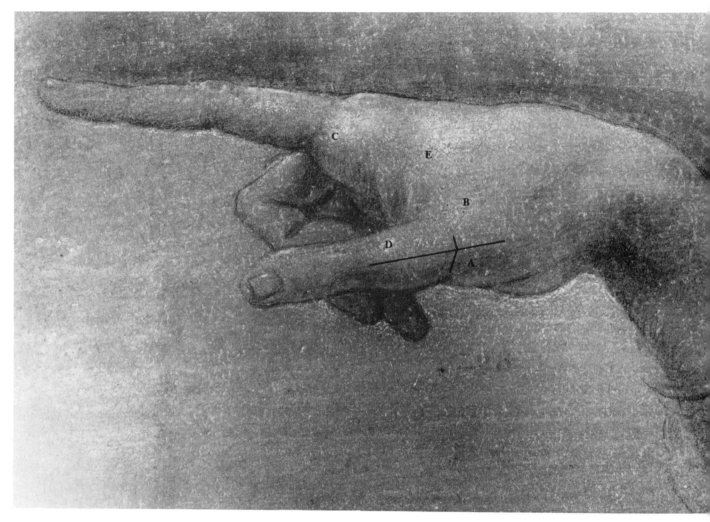

PLANES AND VALUES
Side View

You're all going to be professional artists, I hope. You just can't be copycats. Somehow children know that, and copycat is a word appropriate for what it is in art school, too. Don't copy the model. Your object is to create an illusion on paper. Everybody thinks in the beginning, "I'm going to copy the model just the way my little camera takes an instantaneous photograph." But that's not the process. It's very different. The snapshot that you get with bad lighting is like the spotty drawing done in an art class with 40 lights shining on the model. Everybody does it. Amateurs take the most terrible pictures usually. I may say, if you go to art school for a little while, you take pretty good pictures. You begin to understand light, composition, and a few other things.

There are certain things that artists know. They know about having a dominant source of light and a secondary light. They know that if they don't have the simplified light of their own studio, they must take the light out of their heads. They know how massing and plane breaks simplify perspective and the big planes of light and dark. And, of course, they know about the gradual movement of values or gradation and modeling.

Leonardo knew that if you draw with more than two lights at a time you can't model the values. So, in drawing the hand of the Virgin, he gave this study a dominant light from the left with a secondary or reflected light from the right. The sensitively modeled dark masses of the down plane (A) are all connected and read as a mass, as do the tones in the light of the up plane (B). Variety in the gradation of lights is introduced by a few highlights at selected points such as the side of the knuckle of the index finger (C), the base of the first phalange of the thumb (D), and the side of the abductor mass (E) of the index finger.

Because Leonardo could visualize the separate parts of the fingers as either blocks or cylinders, he could be very confident of his ability to mass and to gradate the values in order to describe and express his view of form.

LEONARDO DA VINCI (1452–1519)
STUDY FOR *THE VIRGIN OF THE ROCKS*
black and white chalk

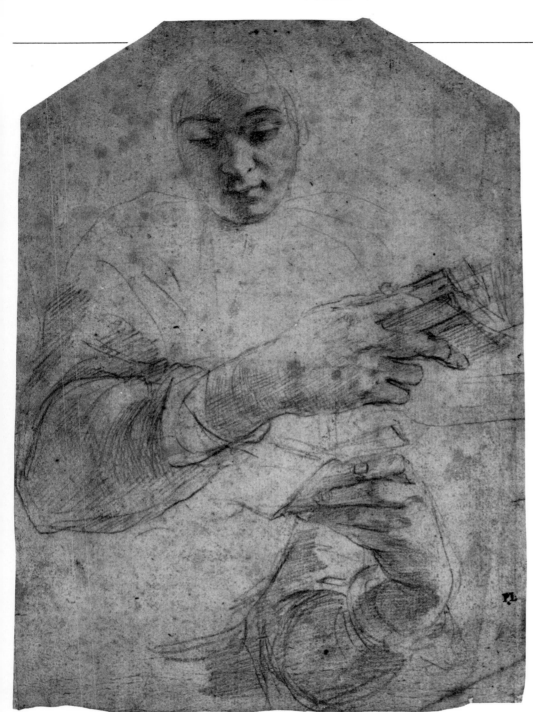

PLANES AND VALUES
Back and Side Views

What would you think of a drawing of the hand shaded the way everybody does at the beginning? You know, with the spotty skin disease shade. Now what sort of illusion is that? Here we come to a great big impediment to the creation of form. As artists, we are, of course, illusion makers. We're not creating reality, we're creating illusions. Well now, apply that idea to the handling of the fingers in the lower hand of Polidoro's drawing. We don't even have to draw in our imaginary block or plane break. We can see the forward finger clearly as a simple block with a front plane (A) and a side plane (B) as well as a down plane (C). This dominant finger clarifies the shapes of the others, which are more subtly handled. By contrast, the back of the hand is seen more as a cylinder, with the values moving more gradually from light (D) to dark (E).

Perhaps you can see that if values do not move, you lose the form—it appears either flat or jumpy. Of course, you won't often see these values on the model in an orderly or designed way. But as an artist and a designer, you will be able to create the illusions that render form visually understandable as well as expressive.

POLIDORO CALDARA DA CARAVAGGIO
(ca. 1496–1543)
YOUTH HOLDING A BOOK
chalk
8 1/8" × 5 7/8" (20.6 × 14.9 cm)

LANDMARKS
Back and Side Views

A good instructor can always point out many uses of line and landmarks that are of great value to the student. Line can be used at landmarks to create the illusion of foreshortening. Raphael has emphasized the feeling of depth in his drawing by extending the outline (A) of the styloid of the radius so that it flows into the outline (B) of the extensor tendon of the thumb and overlaps the thenar mass (C) of the thumb.

Contour lines can be used to explain the shape of the form over which they travel. Shading lines are often, though not always, made up of contour lines. They are also a great help in suggesting the direction of the forms, as they can inform us which way the skin is pointing. Contour lines will take on the values of the forms over which they travel. For example, if the skin is pointing directly at the light source, you know that the skin will be light and the contour lines also will be light. By running contour lines (D and E) of varying strength over the hand, Raphael has suggested the movement of light and shade on the forms of the hand.

The curved parallel lines (F, G, and H) on the fingers create the illusion of both the cylindrical shape of these masses and of planes that are in shade. The hatching lines (I) that are placed closely together indicate the dark side plane of an important landmark: the styloid (J) of the ulna bone at the wrist.

RAPHAEL SANZIO (1483–1520)
STUDY FOR THE ANGEL
SIBYL FOR THE CHIGI CHAPEL,
SANTA MARIA DELLA PACE
red chalk
8¹¹/₁₆″ × 8½″ (22 × 21.5 cm)

LANDMARKS
Back and Side Views

Artists make lines, wrinkles, and other landmarks on the body not only to explain the forms, but also to correctly establish their proportions. No professional puts down a line unless he knows where it is going to go. He makes comparisons of the positions and sizes of the different anatomical parts so that eventually he will know where to draw his lines.

Dürer made numerous sketches and studies in preparation for his planned four-volume "Treatise on Human Proportions." When he died in 1528, he had completed only two of the volumes. But, fortunately, the sketches were preserved and now show us some of the working methods of this great master.

Dürer made this diagrammatic sketch to analyze the proportions of the hand. The long horizontal lines across this page indicate his measurements of the lengths of the different fingers. The curved arc (A–B) passes through the knuckles of the back of the hand. A series of straight lines (C, D, E, and F) marks the extension folds of the four fingers, and another line (G) denotes the fold at the back of the thumb.

These drawings might have been made from tracings of Dürer's own hand. You could try tracing the outline of your own hand and noting the relative distances between landmarks. The hand is one of the most difficult parts of the body to draw. I assure you, many studies like these were made by other great masters to increase their knowledge of the hand.

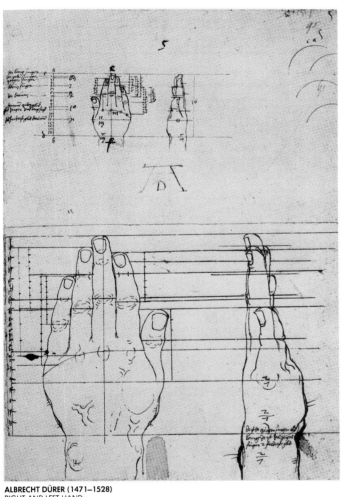

ALBRECHT DÜRER (1471–1528)
RIGHT AND LEFT HAND:
OUTSIDE VIEW IN PROFILE
pen and ink
11½" × 8⅛" (29.2 × 20.6 cm)

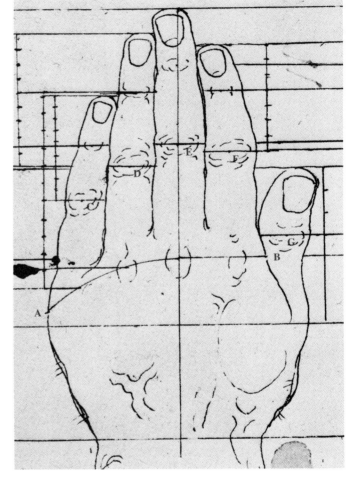

GIOVANNI BATTISTA PIAZZETTA (1682–1754)
LITTLE FLOWER OF LOVE
black chalk heightened with white on tan-gray paper
15¹³/₁₆" × 21³/₈" (40.2 × 54.3 cm)

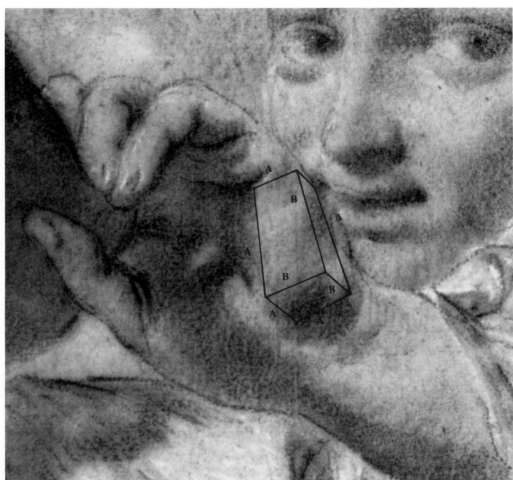

LANDMARKS
Palm View

The beginner must realize that points, lines, and planes have no actual existence in our three-dimensional world. They are but symbols used by the artist. A plane has two dimensions, a line but the dimension of length, and a point doesn't have any dimension at all—it has only position. The layman thinks that when he is drawing a "line" he is drawing a line. But examine his line under a powerful microscope and you will see a Himalayan mountain range of charcoal or lead. The same is true of a "point." Under the microscope his point will have the three-dimensionality of Mt. Ever-est. And the "plane" he draws will be nothing but a patch of paper, pockmarked like the moon and surrounded by the now-familiar mountain range.

Perhaps if we simply draw a block on the hypothenar or little finger group in Piazzetta's drawing, we may understand some of the real significance of line in the creation of the illusion of reality. The outer lines (A) symbolize the edges of the cube and the inner lines (B) symbolize the plane breaks or places where the planes meet on the cube. Actually you can't draw the figure perfectly unless you can visualize its front and side planes, which are readily revealed by these simple construction lines.

SHORT MUSCLES
Palm

In this lecture we are going to take up some of the details of the hand, especially the short muscles of the hand. If you have already studied the foot, you know a great deal about the hand. They are very much the same. You may have met monkeys, and if you looked at them carefully you found there was not much difference between their hands and their feet. We started off very much the same way, but we have changed a bit. The anatomical problem of the hand is just like that of the foot. We studied the long muscles that move the mass of the hand when we studied the lower arm. Those long muscles that move the whole hand are in the upper half of the lower arm and send down long tendons to move the hand. The short muscles that give us subtle movements like pinching and picking up food are located in the hand.

We can study Leonardo's beautifully detailed and accurate drawings of the hand. He has given us four views of the palm of the hand at different stages of dissection. On the right he has drawn the skeleton of the hand. To get the feel of the spread hand, a good trick is to draw radiating lines from the tuberosity (A) of the scaphoid bone of the carpus out to the tips of the fingers.

LEONARDO DA VINCI (1452–1519)
FOUR STUDIES OF THE RIGHT HAND SHOWING BONES AND MUSCLES, *pen and ink over black chalk*

In the upper left drawing, Leonardo shows us the outer muscles of the palm. The tendons of the long muscles that pass from the lower arm and through the hand to the tips of the fingers do not show in this view. They are shown in the two views below in a deeper dissection. Most of the short muscles of the hand are in the area of the palm.

Artists generally mass together the many details of the short muscles and think of two big masses or groups: one on the thumb side (B), called the thenar eminence or thumb group, and the other on the little finger side (C), called the hypothenar eminence or little finger group. Of course, for you experts out there, Leonardo breaks up the thumb group into the opponens of the thumb (D), the short abductor of the thumb (E), and the short flexor of the thumb (F). In the little finger group, he shows the abductor of the little finger (G) and the flexor of the little finger (H). And just inside that he draws in two of the four deep lumbrical muscles (I and J) that help fill up the hollow of the palm and flex the fingers and bring them toward the thumb. The little triangular shape (K) is the adductor of the thumb, which moves it across the palm.

On the inside of the hand, the tendon of the long flexor carpi ulnaris (L) moves to the pisiform bone (M). This tendon fills the gap at the wrist. It also creates a

strong plane break at the side and helps the artist mass the wrist. Below that we see the ulna (N) and the radius (O) bones moving up to the hand.

Drawing hands is a matter of continuous practice. I do not believe anybody can draw hands well until he has drawn a good many of them. The problem of beginners reminds me of that poem about Napoleon: ''I like to draw Napoleon best/ He keeps his hand within his breast.'' That's pretty true. But bit by bit you can figure it out if you study the hand. The drawing problem has a lot to do with reducing the forms to simple masses and remembering the directions of these masses. The hand is confusing because it is made up of the wrist, body, and individual fingers, and they are always going in different directions at once. It is your own decision as an artist. When you realize that, it begins to clarify the problem for you. How well the hand looks depends of course on how much of an artist you are when you apply all your knowledge, and I do not know that I can do very much about that. What is an artist? An artist is a person who knows his craft, cannot be bought, and can express the truth as he sees it. That will make a difference in the way you draw that hand.

BONES
Multiple Views

You will find that the bones in the hand are much like the bones in the feet. We can learn more about it by examining Leonardo's very accurate drawings of the skeleton of the hand.

Look first at his drawing on the upper left of the back of a right hand in the palm-up or supinated position. The radius (A) and the ulna (B) bones are parallel to each other in this position. Notice also that the styloid (C) of the radius, the little bump that you see at the side of your wrist, is just a little lower than the styloid of the ulna (D). The radius fits right up against most of the body of the hand and, you might say, owns the hand. The ulna sits pretty much at the side. The hand moves with the radius.

The term ''wrist'' is much used by the layman. But it is too vague a word for the artist. He thinks of the wrist as the place where the radius (C) and ulna (D) meet the upper bones (E) of the carpus.

The hand might be divided into two main segments: the body (F) of the hand, which is made up of the carpus (G) and the row of five

LEONARDO DA VINCI (1452–1519)
ANATOMICAL STUDIES OF THE BONES OF THE HAND, *pen and ink over black chalk*

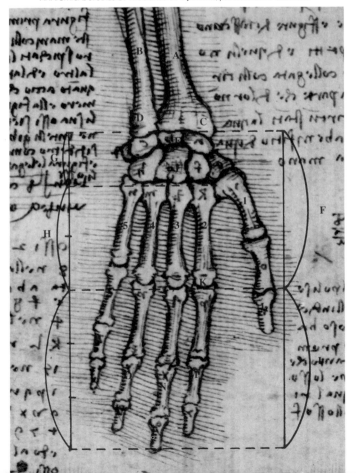

metacarpal bones (H), and the movable portion of the hand, the fingers (I) or phalanges. You can first think of the carpus (G) as a package of eight bones with the overall shape of something like the back of the rubber heel of your shoe. These eight little bones are arranged in two rows of four each. I do not expect in this lecture to have time to give you much of the character of each. You will have to study them independently sometime if you are interested. They are important. I do not believe you will be able to draw hands like those by Dürer or Leonardo until you study the carpus a little bit. These bones act as shock absorbers in the hand and provide useful landmarks in drawing the wrist and hand. We do not think of individual bones too much. We think of the carpus as a whole. The carpus is our mass. Once again, the artist thinks of mass first and detail later. He does have to know detail, but the mass is most important.

Right away you get a little bit of information. You find that the second row (J) of the carpus is wider than the first row (E). That is why you have the feeling that the hand tapers down at the wrist.

Out of the carpus come the metacarpal bones (H), numbered 1 to 5. The only thing we have to remember about their shape is that they start as a sort of boxlike shape at the carpus, then become a long rod, and turn rapidly into a ball where they meet the phalanges and form the knuckles (K). Out of the metacarpals come the phalanges (I). The thumb (L) has two phalanges, and the other four—the index finger (M), the middle finger (N), the ring finger (O), and the little finger (P)—all have three phalanges.

Normally we think of the hand as very rounded. In fact, we should think of the back of the hand as convex, not concave. But if the model puts his hand up against the edge of the table, it all becomes flat. The hand is very flexible. Many of you have shaken hands with great big guys and had them get the metacarpal of the little finger up against the metacarpal of the next finger and squeeze. It really hurts. To prevent that, the trick is to get your hand way up into the hand of such people when they shake your hand.

Artists often think of the proportions of the hand as a little longer than a sternum length, three ears, six eye widths, the distance from the chin to the hairline or widow's peak, and about one-fifth the size of the ulna.

THE NECK

MASSING
Front View

Artists usually conceive the mass of the neck as a cylinder that arises from the circle of the first ribs. Here Dürer was obviously thinking in blocks in differing aspects in space. He blocked the neck (A) in the simplest form possible to aid his study of proportions and clarify the directional relationship of the block of the head (B) to the neck. You can see that there is absolutely no question of which direction these parts of the body are facing.

The beginner usually makes the neck exactly vertical to the top line (C) of the mass of the rib cage. As an artist exceptionally knowledgeable in anatomy and figure drawing, Dürer was aware that the slight forward thrust of the neck reflects the direction of the cervical portion of the vertebral column. His technical knowledge was such that he moved with ease in the realm of massing and perspective.

ALBRECHT DÜRER (1471–1528)
STEREOMETRIC MAN, PERSPECTIVE BOXES, AND DRAPERY STUDY
pen and ink
11¹/₂″ × 8¹/₈″ (29.2 × 20.6 cm)

"We don't know well until we see well."

MASSING
Front View

It is helpful to remember that all lines travel over imagined form. Sometimes the part of the body you are drawing is a very complicated combination of masses. Then it is especially important for the artist to simplify. If the neck is thought of as a cylinder, then a ribbon around the neck is but a circle around that cylinder. If the rib cage is thought of as an egg, the ribs become but lines upon the surface of the egg.

The stylus marks (A) on the neck in Raphael's drawing indicate that he thought of the neck as a cylinder. The curved lines around the breast (B) tell us that he was thinking of a sphere, and the stylus lines on the rib cage (C) suggest an egg or cylinder. Visualizing the neck as a block in the previous drawing helped Dürer solve the problem of the direction of the mass of the neck. In this drawing, the cylinder concept clarifies the side-to-side movement of the mass of the neck and helps solve problems of the shape and direction of details on that mass.

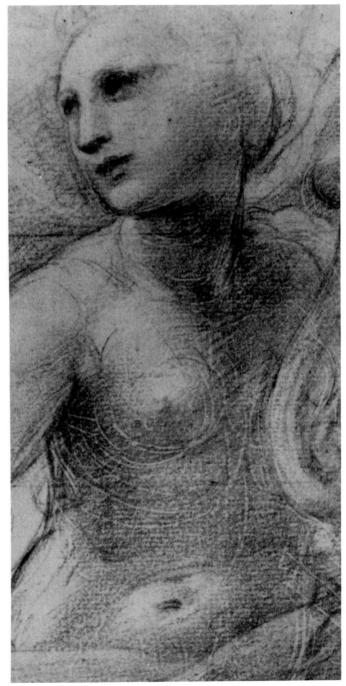

RAPHAEL SANZIO (1483–1520)
POETRY
gray chalk over sketch with stylus
14³/₁₆" × 8¹⁵/₁₆" (36 × 22.7 cm).

LEONARDO DA VINCI (1452–1519)
HEAD AND BUST OF A WOMAN
silverpoint on cream-prepared surface
12¹³/₁₆″ × 7⁷/₈″ (32.5 × 20 cm)

MASSING
Side View

Symbols can help to differentiate forms. Smoke is a symbol that can make the long, thin shape-symbol of a cylinder into a cigarette. A wick can make that cylinder represent a firecracker. Add a stem to the basic symbol of a sphere and you have an apple, or put a nipple within the sphere and it may become a breast.

A spiral is a symbol for tension or twisting. Muscles that are rotators are thought of as spiral forms. The sternomastoid (A) which is lightly indicated in Leonardo's drawing, rotates the head upon the neck. It moves from its origin in the pit of the neck (B) in the front to the base of the skull (C) in back. It is thought of as a long, thin cylinder spiraling over the larger cylinder of the neck. The front (D) and side (E) planes of this muscle suggest the general direction of light, which is from above and to the right. These two planes are enough to define the big mass of the neck, which is mostly in shadow.

Of course, Leonardo has not placed a big black hole of a cast shadow on the front plane (F) of the neck as a beginner would. Instead, he has subdued the cast shadow that he probably saw there on the model and put his strong shadow on the down plane of the chin (G). Thus, he has saved his strong darks for the meeting of planes and preserved his illusion of form.

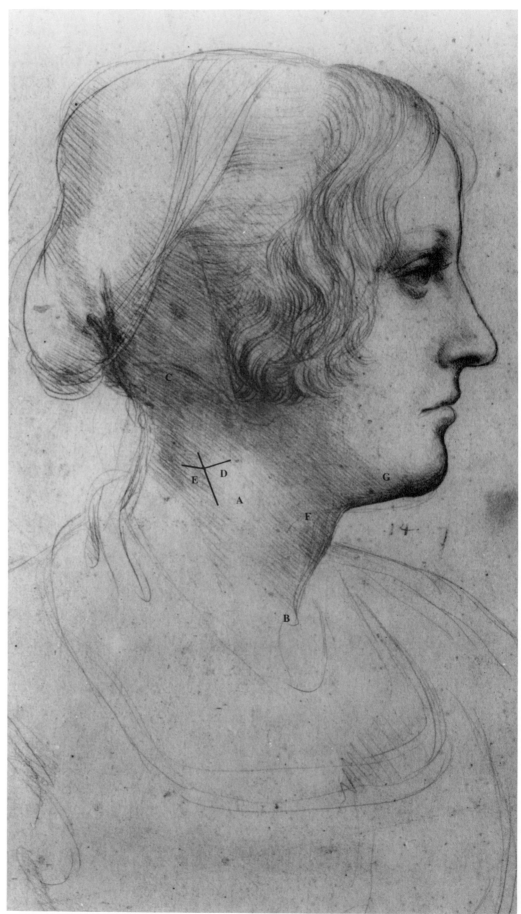

PLANES AND VALUES
Front View

In drawing the human figure artists are seldom free of the problem of foreshortening. Rarely are planes exactly parallel to the picture plane and flat as in anatomical diagrams. Though such diagrams are a necessity in studying bones, muscles, and proportions, they do not give us the real three-dimensional shape or the forms of the body. The beginner clings to outline. The artist must learn to project the large and small masses, the planes and lines of the body, into perspective.

Overlapping is one of the most valuable devices in creating the illusion of foreshortening and depth. In this dynamic drawing by Titian, the cylindrical mass of the neck (A) is pushed back into space by overlapping it with the mass of the upper side of the pectoralis (B). In order that the viewer's eye will not miss this illusion, the overlapping is reinforced by a strong line (C) that defines the edge of the near muscle.

Value contrast is another important element used by the artist in foreshortening. The beginner tries to create contrast by darkening the background behind the forms. The professional darkens the planes on the form. The light plane (B) on the near mass of the overlapping pectoralis is obviously lighter and appears nearer than the light plane (A) of the neck. The contrast of the dark line (C) against the light plane (B) further emphasizes the nearness of the light and adds depth to the illusion of foreshortening.

Fortunately, there are many simple solutions to the many difficult problems that arise in rendering the figure. That's what the study of artistic anatomy and these drawing and anatomy lessons are all about.

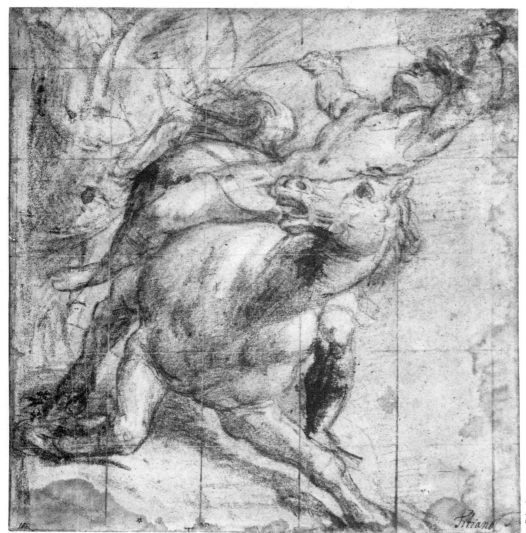

TITIAN (ca. 1490–1576)
A HORSE AND RIDER FALLING
black chalk on gray paper
10¹³/₁₆″ × 10⁵/₁₆″ (27.4 × 26.2 cm)

PLANES AND VALUES
Front View

Very often the values and smaller masses on the dark or light side of a complex area like the neck appear so nearly alike that it is hard to distinguish one from the other. At such times it is wise to connect these diverse forms and make them part of either the large, dark side plane or the light front plane mass. In this way you soon develop the ability to simplify, and your drawing gains in sureness and strength. This is why beginners are often advised to squint. With your eyes half-closed, the masses become simplified, and shapes, planes, and values don't fight each other for attention. Instead, they become part of a larger shape pattern.

Cellini has simplified the masses of the light front plane (A) and the dark side plane (B) of the neck in this drawing. We can be sure that he knew that a very strong cast shadow on the dark plane of the neck might obscure this meeting of planes. To prevent this, he virtually eliminated the cast shadow that he might have seen on the neck. Cast shadows cause brutal contrasts, which should be reserved for the meeting of the great planes of the body.

BENEVENUTO CELLINI (1500–1571)
JUNONE
chalk

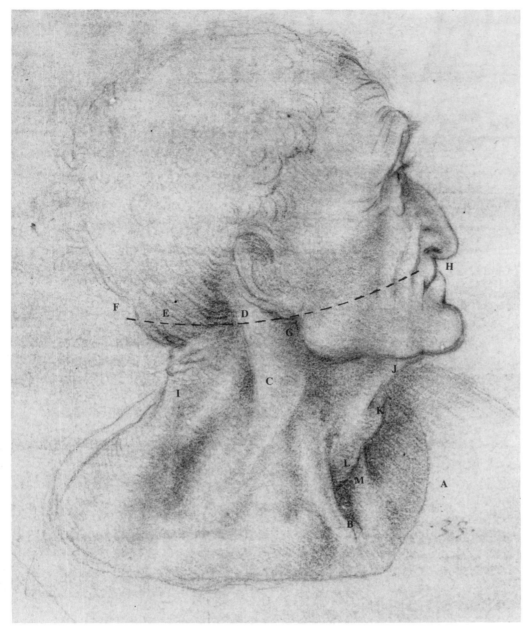

LEONARDO DA VINCI (1452–1519)
HEAD OF APOSTLE IN PROFILE TO RIGHT
red chalk on red paper
7¹/₁₆″ × 5⁷/₈″ (18 × 15 cm)

LANDMARKS
Side View

The curved shape of the cylinder of the neck is echoed in the line (A) of the garment in Leonardo's drawing. The landmark that gives us the base of the neck in the front is the jugular notch (B). It is also called the suprasternal notch or, more popularly, the pit of the neck. The sternomastoid muscle (C) originates at the pit of the neck. It moves up and obliquely across the column of the neck to its insertion in the mastoid process (D) just behind the ear. When this muscle contracts between these two landmarks it can turn your head, incline it to the side, or tilt it backward.

The top of the neck in the back is the bump of the occipital tubercle (E) at the base of the skull. Here it is covered by a mass of hair. The dip (F) in the outline is our clue to that landmark.

A construction line can be drawn through the base (F) of the occipital tubercle, the base of the ear (G), and the base of the nose (H). These points would all be on the same level in the straight profile view. Here the head is turned into perspective so this construction line is not flat. It becomes a contour line that curves around the form, giving it the feel of a cylinder.

At the back of the neck, the trapezius (I) curves down from the occipital tubercle (E). In the front, the line of the mylohyoid (J) overlaps the thyroid cartilage (K), known as the "Adam's apple." Just below this, the mass of the thyroid gland and windpipe (L) overlaps the sternomastoid (M) of the far side.

The landmarks in Leonardo's drawing are much exaggerated, but they are a helpful study for the more subtle uses we might make of them when we do portrait painting.

LANDMARKS
Front View

We know that very often a line can carry out many functions at once. It can suggest the meeting of planes, edges of an object, value changes on that object where the planes meet, as well as the meeting of shapes and colors. We also know that lines and shapes of light can do the same thing.

In this drawing by van de Velde, the simple line or shape of light (A) on the front plane of the sternomastoid muscle of the neck symbolizes the change in planes where front and side planes meet. It gives us an accent of light—an abrupt change in values where light meets dark. It might also signify a change in color where the warm of the light meets the cool of the shade.

The small shape of light (B) represents the inner end of the clavicle at the pit of the neck. A dark accent (C) defines the far side of the neck and the side of the sternomastoid muscle of that side. At the back of the head, the bun of hair curves inward to the occipital tubercle (D) of the skull just behind the base of the ear. This is the upper limit of the neck in the back.

You can often spot the work of a beginner by the black spot of cast shadow below the chin, which makes a hole and wipes out the shapes of the neck. Here the artist has knowingly subdued the case shadow on the neck (E and F). And, to heighten the illusion of depth, he has added a reflected light (G) at the back of the neck on the side away from the source of light.

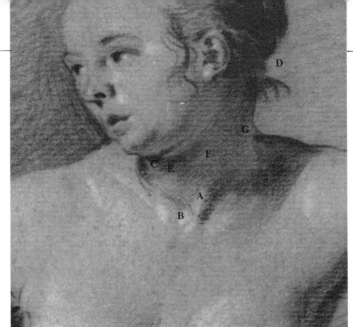

ADRIAEN VAN DE VELDE (1636–1672)
SEATED FEMALE NUDE FACING LEFT
black and white chalk
11¹⁵/₁₆″ × 8⁷/₁₆″ (30.3 × 21.4 cm)

MUSCLES
Multiple Views

When I give these lectures on anatomy, I don't rush through them. There are so many points to cover that one might just hurry through the major anatomical points. But that would be a shame because anatomy doesn't do you any good as an artist unless you know about its relationship to other things.

Life has changed, I know. Things tend to go very rapidly. But when you study anatomy and the elements of drawing you really have to do it very leisurely. I often remember how, when I was a little boy, we used to go twice a week to the market in a town about eight miles away. We'd harness up the horse, you know, and I'd go off with my mother. And we'd be going along at a leisurely pace and my mother would say, "Well, there's a four-leaf clover." So I would get out of the carriage and she'd point out the four-leaf clover, and I would pick it up and get back in the carriage. Now, of course, you go along the superhighways, and you don't see any four-leaf clovers. You miss a lot of details.

LEONARDO DA VINCI (1452–1519)
STUDIES OF THE NECK AND HEAD
pen and ink over black chalk

Let's go into the anatomy of the neck. We get the conception that the neck has two bases. You can see that in Leonardo's drawing of the top view of the neck and shoulders. The first two ribs create the inner circle (A) that Leonardo has indicated, which is one of the bases. The clavicle (B) in the front and the spine (C) of the scapula in the back create the outer base of the neck.

When you look at the clavicle (D) in the front view, you think of that bone as an S-curve coming toward you as it moves out from the pit of the neck (E), and then going away from you. You have to decide where you are in relation to the model. If you are well above or below the model, the S-curve will be more pronounced. If your eye is level with the clavicle, the S-curve will not be very apparent and the clavicle will appear almost straight. In Leonardo's drawing, the model is just a little above your eye level, so the S-curve shows a little.

The trapezius (F) has a great deal to do with forming the neck. It grows out of the base of the skull at the back, just a little above the level of the base of the ear. You can imagine a construc-

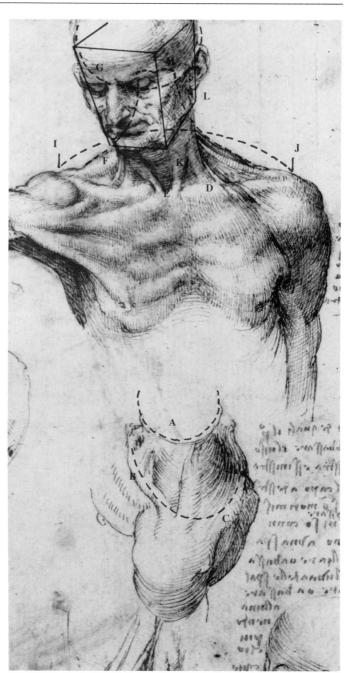

tion line (G) completing the circle of the ball of the skull. You can then virtually see through to the origin (H) of the trapezius muscle on the superior curved line of the occipital protuberance at the back. This solves the difficult problem of where to bring out the line of the side of the neck when you are doing the front view and can't see the back.

Another valuable construction line can be drawn from shoulder joint (I) to shoulder joint (J) to get the "highline" of the neck.

The sternocleidomastoid (K) originates at the pit of the neck (E) and moves up to the mastoid process (L) just below the ear. Leonardo has clearly indicated the little slip of that muscle

that goes to the clavicle (D). Think of the sternocleidomastoid as part of the cylindrical mass of the neck.

You can think of the neck as about one-fourth the width of the shoulders. Women's shoulders usually slope down due to a smaller rib cage, and this makes the neck appear longer. Remember also that the neck is short in children, longer in adults, but shorter again in the aged due to physical change and posture. Knowing how age, sex, and posture help determine the position, size, and shape of the forms of the body can help you check and vary your points of reference to make your drawing a lot more accurate and expressive.

BONES AND DEEP MUSCLES
Back View

Now we are going to go into a little detail on the important bony structure and deep muscles of the neck. If we come down from the mass of the skull (A) in this anatomical plate by Albinus, we can feel the backbone (B) descending like a great piece of rubber hose. You feel the rhythm running down through the whole backbone.

We can think about the top two bones in this cervical column, that is, the first two vertebrae. They are called the atlas (C), the bone that supports the skull, and the axis (D), on which the atlas rotates when you turn your head. These bones are shaped like a thick ring and have little hollows and knuckles that fit into each other to allow the flexible movement of the neck. The spinal cord goes down through a hollow in the center of the vertebrae. When these two bones revolve one upon the other, that is what permits you to shake your head and say "no." That is pretty difficult. You will find it gives a sort of grinding noise in the pit of your neck. That is why they pay executives such great sums of money—because they can grind those bones! But saying "yes" is easy; it's just rocking your head back and forth. It is much easier than saying "no"—that's probably why we are all here today.

Of course, the neck has to be supported. So the first thing we run into are these important strong cords (E) or erectors of the spine. Some doctors would call them the complexus, but I do not believe that has to bother us very much. We can feel one of these great strong cords on either side of the neck growing out of the bottom part (F) of the skull in the back. They move down into the dorsal vertebrae (G) and help to support the mass of the skull on the bones of the neck.

Another deep muscle of the neck is the "bandage muscle" or splenius capitis (H). It originates in the spines (I) of the vertebrae and moves up to the back and side (J) of the skull. This muscle helps you to make the "yes" and "no" movements of the head and helps fill out the mass of the side of the neck. The splenius capitis is of enormous importance in animal drawing. The horse needs it because his head is so heavy. It is the muscle that makes your bulldog slip his collar. It gives him all that bulk around the neck.

In studying artistic anatomy it is most helpful to adopt the evolutionary point of view and to remember that we are descended from four-legged animals. We retain not only their basic skeletal design, but also a similar musculature designed to set the skeletal elements in motion. Therefore, if you wish to fully understand the anatomy of man, it would seem helpful to also study the anatomy of animals. Incidentally, if you learn human anatomy well, you will instinctively understand animal anatomy and you will be able to draw any animal you wish in no time at all.

The cervical portion of the vertebral column (B)—the first seven vertebrae that support the column of the neck—is the most flexible portion of the whole backbone. And, of course, it is this top portion of the backbone that forces the form of the neck. You feel the influence of its curve on both the front and back outlines of the side view of the neck.

XXIII.
Biventer cervicis cum Complexo.

XIX.
Rectus internus major capitis.

XX.
Recti interni majoris capitis.

XXI.
Trachelomastoideus.

XXII.
Trachelomastoideus.

XXIV.
Biventer cervicis cum Complexo.

XXV.
Sternomastoideus cum Cleidomastoideo.

XXVI.
Sternomastoideus cum Cleidomastoideo.

XXVII.
Splenius capitis.

B. Wandelaar ad ipsa corpora hominum delineavit idemque incidit. Prostat Leidae Batavorum apud J. & H. Verbeek, Bibliop.

THE SKULL

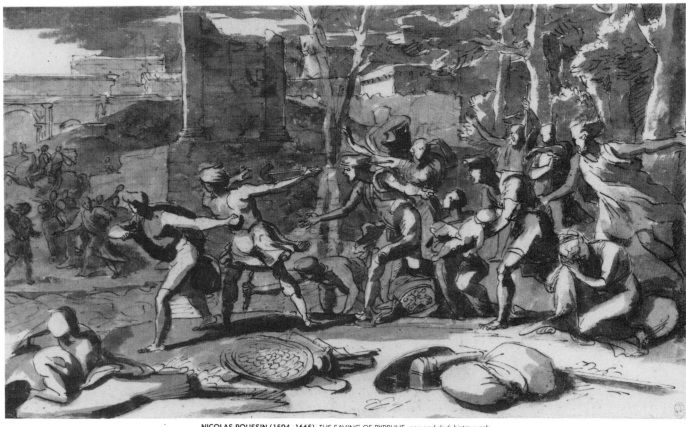

NICOLAS POUSSIN (1594–1665), THE SAVING OF PYRRHUS, *pen and dark bistre wash*

MASSING
Back View

In drawing the head, the beginner always starts with the detail of the features. He places them in all sorts of odd positions, unrelated to each other or to the head as a whole. A trained artist thinks first of the head block and its three line systems, which we can easily visualize in this drawing by Poussin. They are the height lines (A), the width lines (B), and the depth lines (C). The artist at once runs lines, real or imagined, from the sides of this head block to vanishing points that converge outside the picture and give the illusion of forms receding within the picture space. One aim of the artist in a perspective drawing is to give the illusion of a three-dimensional reality on the two-dimensional surface of the drawing pad or canvas.

Just as beginners learn to

square up the skull, art students often square up their drawings or, if they wish, consider the outer edges of their pad to be the rectangular frame. This helps them to sense the approximately 60-degree width of the field of vision before distortion takes place. They should learn to locate the eye level or horizon line, the place where the artist is standing (the station point), as well as the vanishing points for the line systems of the dominant forms. In freehand drawing the artist must sense all these things. Now I should like to ask a question: How in the world can you understand, draw, visualize, or meaningfully absorb these ideas unless you study perspective? To fully understand perspective, you must go to the books and draw and redraw their diagrams until you truly understand them.

"First the general, and then the particular."

ALBRECHT DÜRER (1471–1528)
STEREOMETRIC MAN, PERSPECTIVE BOXES IN SPACE
AND AROUND THE RIB CAGE, JOINED MANNEQUIN
pen and ink, 11½″ × 8⅛″ (29.2 × 20.6 cm)

MASSING
Side View

We know that Dürer experimented constantly with forms in space, as he did in this page of his sketchbook. In the upper study of the figure, he thought of all the forms of the body as blocks. The mass of the head is drawn as a boxlike mass. If lines are projected from the three line systems of the box—the height lines (A), the width lines (B), and the depth lines (C)—you can see the three-dimensional illusion of perspective.

In reality a cube has twelve edges or lines. You can count them. These lines fall into the three systems of parallel lines. If one of these systems is not parallel to the picture plane, the cube will be in one-point perspective. If two of these systems are not parallel to the picture plane, the cube will be in two-point perspective. And if all three systems are not parallel to the picture plane, the cube will be in three-point perspective.

If you wish to insinuate perspective into your figure drawing, there is one ability you must acquire above all others. You must learn to draw a cube, like the simplified head in Dürer's sketch, in perspective in any position and any aspect. To do this, it is best to start off drawing lots of cubes on your sketchpad; try them in various positions as Dürer has done.

PLANES AND VALUES
Front View

A valuable thing to keep in mind is the first rule of planes: Where planes meet, there must be a contrast. In drawing this portrait, Rubens may have first visualized a simple plane break at the side of the front portion of the skull or forehead with a front (A) and a side (B) plane. He has massed his strong darks on the side plane (B) away from the light source, and his strong lights on the front plane (A) facing the light.

If the front and side plane masses of the forehead met at right angles like the angle of a box, then the lightest light and the darkest dark would be very close together. But the forehead is only visualized with a boxlike plane

break for mass conception and a simplified concept of planes and values. Because the forehead is slightly rounded, it must be refined. An additional plane (C) or transitional value movement is added between the front (A) and side (B) planes. This midtone unites the strong light and dark and slowly turns the form. The illusion becomes more cylindrical. Artists are constantly adjusting the values in their drawings to vary the illusion of form and to give expression to their renderings.

There is another very important rule: In relation to the source of light, up and front planes are light, and down and side planes are dark. In Rubens' drawing, where the dominant light source is from the left and above, we see that the up plane (D) and the front plane (A) are light, and the down plane (E) and the side plane (B) are dark. If you squint, you will first see the darks and lights as simple abstract shapes, as Rubens probably saw them.

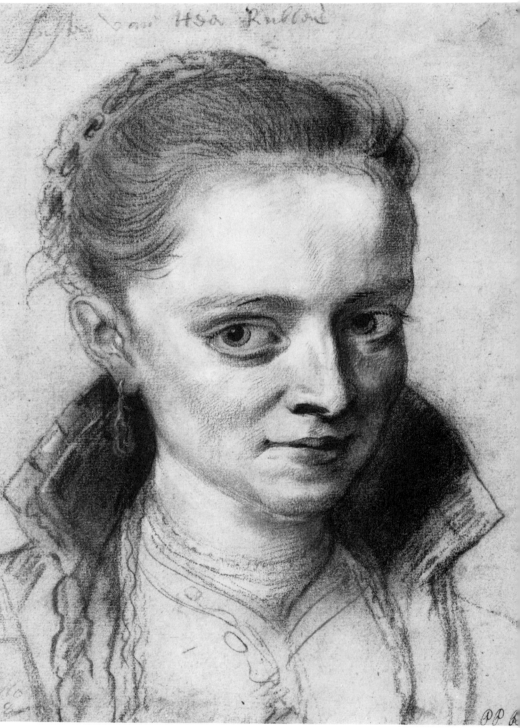

PETER PAUL RUBENS (1577–1640)
PORTRAIT OF SUSANNA FOURMENT
red chalk
13⁹/₁₆″ × 10¹/₄″ (34.4 × 26 cm)

LANDMARKS
Front and Side Views

The skull, of course, is of great importance to those of you who want to draw heads because it lies right under the skin. My advice to anybody who wants to draw heads well is that they go out and get a skull—by fair means or foul, somehow, but see if you can get hold of a skull. If you get a skull, do not get a very feminine skull because it won't have any bumps on it. They will be there, but you will hardly be able to see them. See if you can get the skull of some old, tough truck driver who chewed nails—really a good masculine skull.

Of course, I would like everybody to get a skeleton, but they are not so easy to get hold of. But you can get them if you look around, and you can learn a lot from a skeleton. If you cannot get anything, at least get a plaster skull. You can buy one in an art store. If you really plan to make a profession out of drawing, however, it will soon disappoint you because it does not have any of the beautiful detail that an actual skull has. But it will help you in throwing the mass this way and that.

If we study this skull by Albinus, we might first look at the side view and feel our masses. There is the egg or the ovoid (A) in the front and the ball (B) in the back. You can also feel this in the front view, where the bottom of the ball (C) runs right under the nose. That gives you a good start on the head.

BERNARD SIEGFRIED ALBINUS (1697–1770)
PLATES FROM *TABULAE SCELETI ET
MUSCULORUM CORPORIS HUMANI*, 1747
engraving

In the front view, the orbit (D) is pretty much a circle. From this point of view, you feel a circle looking out a little to the side. The reason is that animals of prey—that is, animals that eat other animals—have eyes that look straight ahead. But animals that are likely to be eaten have their eyes looking out on the side. We are fairly ferocious, so we look fairly straight ahead. A curious think is that the orbits of men look a little more straight ahead than the orbits of women do. The orbits of women look a little out to the side.

The artist goes beyond interest in the medical names of the parts of the skull. He thinks more of the size, shape, direction, and the relationships of the parts. He knows that the average size of the Western European skull is about five parts wide to seven parts high in the front view and six wide to seven high in the side view. He compares the size and shape of different heads. The artist knows that in the front view the average skull is widest at a point (E) just above the ears, and in the side view it is widest at a point (F) level with the top of the orbit. He knows that all skulls vary. He checks the facial angle (G), a reference line handed down by the French anatomist Camper. By using this line he can make comparisons with other skulls. Furthermore, he can estimate with great accuracy the position of the different parts of the features in relation to the line of the facial angle. This is invaluable in getting a likeness in portraits.

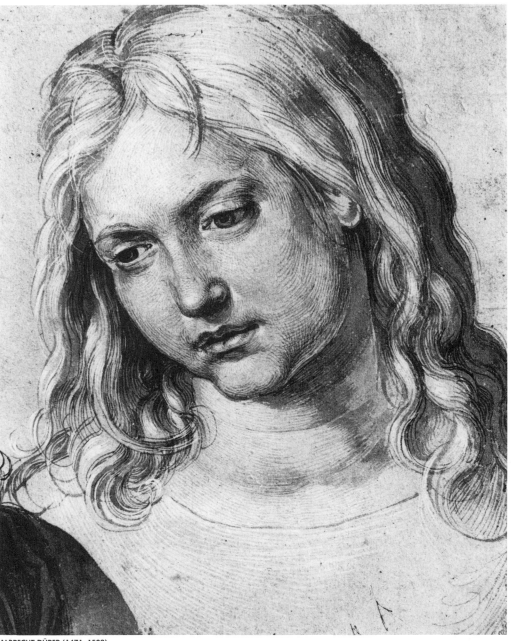

ALBRECHT DÜRER (1471–1528)
HEAD OF JESUS
pen and wash
10¹³/₁₆″ × 8⁵/₁₆″ (27.5 × 21.1 cm)

LANDMARKS
Front View

One of the best ways to analyze Dürer's drawing might be to ask yourself, "What is the position or aspect of this head in space?" Think of it first in terms of a cylinder in space. You might then draw or imagine a cylinder (A) over the head. Then, of course, you will easily see that as you throw the head down, the line of the mouth (B) has to go in the same direction as the contour line (C) that is also on the cylinder we have imagined on the head. If you move the head up, the cylinder will move upward as will the curve of all the contour lines drawn on that cylinder.

You can draw other contour lines on the cylindrical concept of the head to help you locate the position of the forms of the face in correct relation to the mass of the skull. Draw a line (D–E) to locate the positions of the base of the nose (F), the base of the malar or cheekbone (G), the bottom of the ear (H), and the little dip in the hair (I) at the back, which is a clue to the base of the ball of the skull.

If you draw another contour line (J–K) around our imaginary cylinder just above the eyes, you will locate the level of the brows (L); the top of the little down plane of the glabella (M), which lies between the eyes; and the position of the top of the ear (N), which is covered with hair in this drawing.

Now, to be accurate in estimating the direction and size of the features, you can draw the straight center line (O–P). This line will pass through the middle of the frontal eminence (Q) and through the centers of the glabella (R), the nasal bone (S), the base of the nose (F), the lips (T), and the chin (U).

Making comparisons between these construction lines run over the cylinder and the landmarks of the face can be an invaluable aid in observing the many subtle variations in facial structure. It will help you to "catch a likeness."

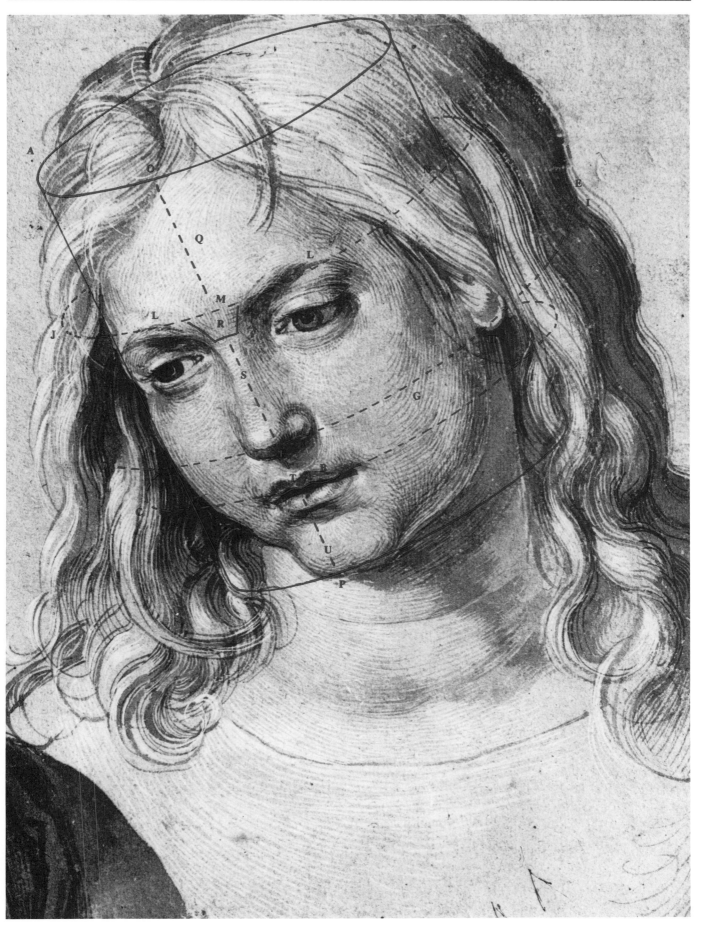

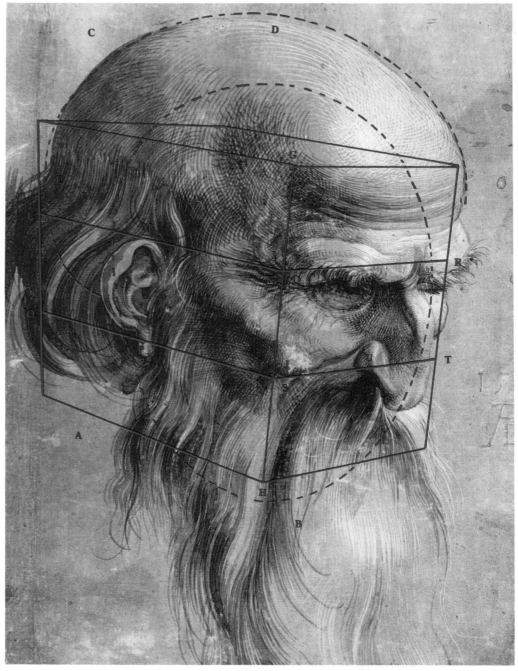

ALBRECHT DÜRER (1471–1528)
HEAD OF AN APOSTLE
IN THE HELLER ALTARPIECE
brush drawing
12¹/₂" × 8³/₄" (31.7 × 21.2 cm)

LANDMARKS
Side View

The invaluable lines called construction lines should be used constantly by students. These lines will indicate the facts of perspective, give you the general shape of the skull and suggest its proportions, help to determine the relative positions of anatomical landmarks, and simplify the direction of light in relation to the mass. You must use these lines again and again while you are learning and only later discard them.

At first, students hate to use construction lines because they feel that they mess up their pretty drawings. And they always like to point out that they never see these lines in the finished drawings of accomplished artists. They don't realize that the accomplished artist has used them so much in his training that he doesn't have to use them anymore. He is able to visualize them. If he does use one occasionally in starting a highly finished portrait, he may lay it in lightly and draw over it or rub it out. You see, he doesn't want to mess up his drawings either.

The skull in Dürer's drawing can be imagined as being inside a block (A). The beginner usually cuts off the back of the skull because he is thinking only of the details of the face and not of the basic shapes of the skull. The experienced artist usually thinks of the head as an egg (B) in front and a ball (C) in the back.

This bald head by Dürer shows the ball-like form of the top and back of the skull very clearly. The highest part (D) of the ball part of

the skull is near the center in the front view and the widest part (E) is a little above the level of the brows (F). A good idea is to just take a look at a man's or a woman's hat—you can get the cross-section or top view of the head around the ball part. There's a hat company you can go to which has an extraordinary machine. They put it on your head, press a button, and a bell rings, and a lot of little things touch your head. A paper jumps out of the top of the machine and you get a cross-section of your head. You do not have to buy a hat, you see.

The lines of our imagined block will help us locate the landmarks of the skull and the features. The

near height line (G–H) of our box gives us a feel for the general meeting of the big front and side planes of the head and the dominant source of light on the right. This lines goes through the outside of the orbit (I) of the eye and through the point (J) of the malar or cheekbone. A depth line (K–L) moves back from the level of the brow (F) and locates the top (M) of the ear. Another depth line (N–O) is at the level of the malar (J) and runs through the base (P) of the ear. A width line (Q–R) runs through both brows. Another width line (S–T) gives us the position in perspective of the point (J) of the malar and the base (U) of the nasal opening.

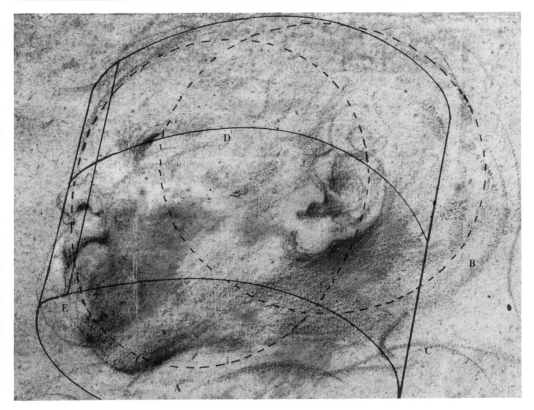

CHILD'S SKULL
Side View

When you think of the head, any head—whether it be that of an adult or child—you think of it in terms of mass. Mass conceptions, they call it. We think of it as a ball in back frozen into an egg in front. That's the artist's first idea of the head. That's the mass conception of the head. He takes the rest of his life refining that. If you don't figure it that way, you're very liable to cut off the back of the head as all laymen do. I don't quite know why. I've thought it over for years. All laymen except perhaps mothers. I know why mothers don't do it. It's because they carry their children on their knee very often. They look down and they see the cross-section of the head from the top. Of course, they'd never think that. But they realize without knowing it that there is as much of the skull behind the ear as there is in front of it. This is especially noticeable on very young children, as the face is small in relation to the rest of the skull and the head is much larger in proportion to the rest of the body than in an older child.

If you want to throw a head up or down, you have to think in terms of three dimensions and get a feeling for perspective. In studying Rubens' drawing, we might start off by feeling the mass of the oval (A) or ovoid looking up and the ball (B) a little down in the back. And then perhaps for a moment we would visualize it as a cylinder (C). We could throw a circle (D) around that cylinder so that we get the upward thrust or direction. Then, draw a center line (E) to make sure everything is looking in the same direction.

In the beginning let your ideas be very simple like these, and then refine them perhaps as you go through life.

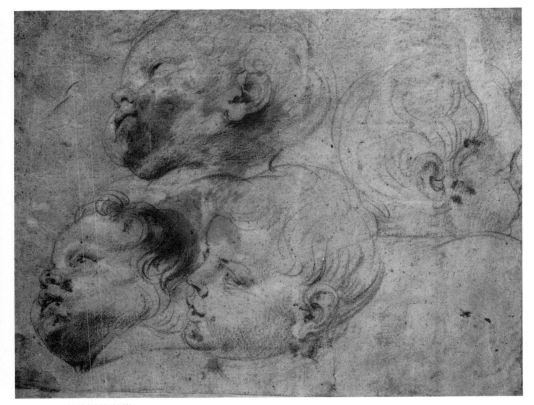

PETER PAUL RUBENS (1577–1640)
FOUR STUDIES OF CHILDREN'S HEADS
black chalk
13¹¹/₁₆″ × 19⁹/₁₆″ (34.8 × 49.6 cm)

THE FEATURES

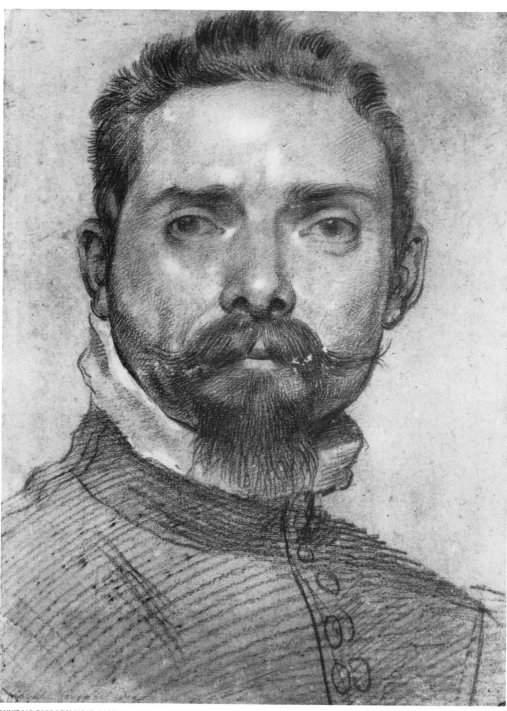

ANNIBALE CARRACCI (1560–1609)
PORTRAIT OF LUTE PLAYER MASCHERONI
red chalk heightened with white
16⅛" × 11⅛" (40.9 × 28.2 cm)

THE EYE
Frontal Bone, Glabella, Orbit, and Eyeball

Now we'll take up the features. Let's really see how an eye is constructed and how it fits into the bony eye socket. In this drawing Carracci has lit up the bony masses of the superciliary eminence (A) of the lower portion of the frontal bone (B). He was aware that, as an up plane facing the source of light from above, this portion of the skull would best show its direction by placing a light on it. Below the superciliary eminence, a small part of the frontal bone, called the glabella (C), moves down to meet the upper bone of the nose (D). The artist puts a little shade on the glabella because it is a down plane.

The bony opening of the orbit or eye socket runs horizontally (E) out from the top of the glabella (C), makes a downward turn around the corner (F), drops vertically (G), moves back inward (H), and then goes upward (I).

The first thing you have to remember about the eye is that it is a ball—a simple ball. That ball is placed a little above center (J) in the cup of the orbit. There it moves in a cushion of fat. Of course, it may be that the character you are drawing will have a little touch of thyroid and his eyes will stick way out or they may be sunk deep in the socket through some sort of nervous affliction. Look for that. Sometimes the eye sticks out and takes over the outline. You have to watch for things like that when you draw the eye.

"You learn to draw by coming to shape conclusions."

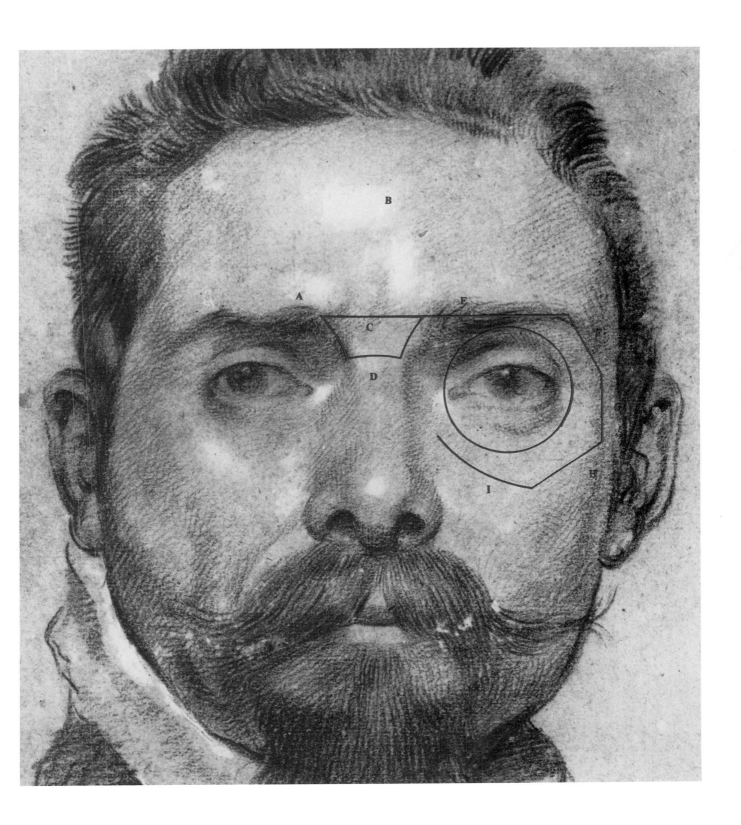

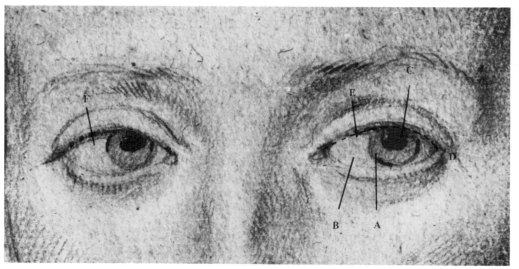

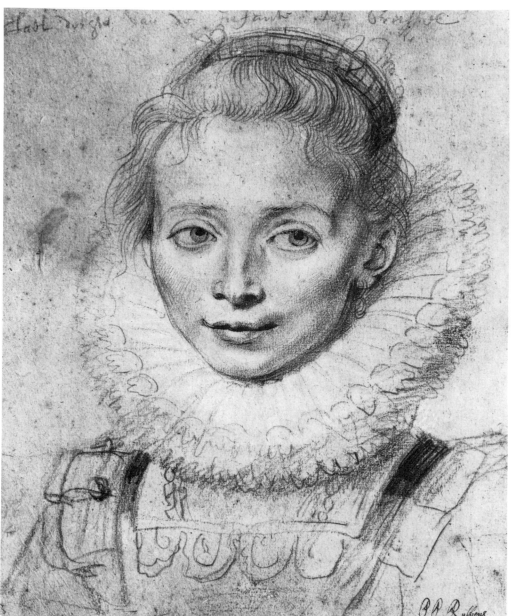

PETER PAUL RUBENS (1577–1640), PORTRAIT OF A YOUNG LADY OF THE COURT
OF THE INFANTA ISABELLA AT BRUSSELS, *chalk, 13¹³/₁₆″ × 11¹/₈″ (35 × 28.3 cm)*

THE EYE
*Sclera, Iris, Pupil,
and Upper Eyelid*

In the center of the eyeball is the colored part which is really quite big and which we call the iris (A). By darkening the iris, Rubens creates a strong and dramatic value contrast with the grayish sclera (B) or "white" of the eye. In the center of the iris is the still darker pupil (C) through which we look. It gives variety to the dark of the iris and further expression to the eyes.

In his beautiful drawing, Rubens also demonstrates how the upper eyelid is just a simple contour line (D) curving over the ball of the eye and just clearing the top of the pupil. As an artist of great experience, Rubens knew that the upper eyelid has a strong little down plane (E) along its lower edge where it meets the open eye, so he put a shadow along this plane. In the other eye, you can see where he added a cast shadow (F), curving over the "white" of the eye just below the upper lid to suggest overhanging eyelashes.

LUCAS CRANACH THE YOUNGER (1515–1586)
THE YOUNGER ELIZABETH OF SAXONY
black and white chalk

THE EYE
Lower Eyelid

Let's look at this front view of the eyelid by Cranach. On a young person, the lower eyelid will just clear the bottom of the iris (A). Of course, this lid has a very strong up plane (B), which artists love to light up. They might even brighten it with a touch of highlight (C), as Cranach has done here. One of the reasons that a trained artist does this is that he knows that nothing pulls the eye of the observer more than value contrast. And so, if you are starting to draw eyes, be aware of all your contrasts on them.

Of course, the eyelashes go up on the upper lid and down on the lower lid. If they didn't they would get all tangled up when you closed your eyes.

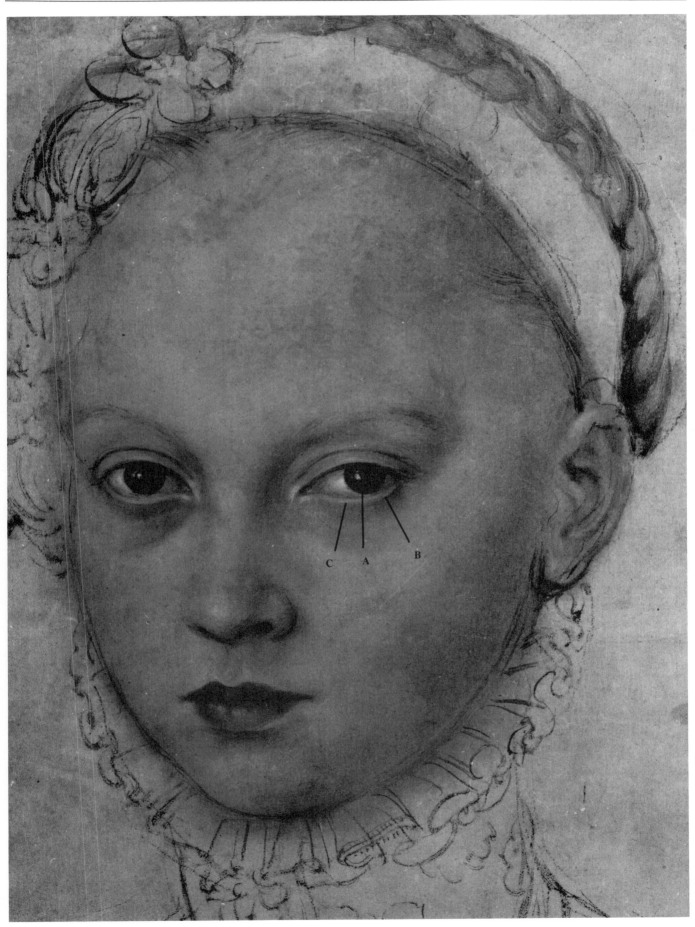

THE EYE
Caruncula and Plica

In this drawing by Pontormo, we can see, at the inside corner of the eye, the tiny little pink gland called the caruncula (A). Right next to it is a curious, much darker, red film known as the plica (B). It is the evolutionary remains of the third eyelid. Many animals have a third eyelid; horses have. But there is not much left of man's third eyelid. As a matter of fact, I remember one story of how primitive man used to come home from a day's hunting and draw the third eyelid across his eyes while his wife cooked the stag he had killed! But it is not true. Man has never really had a third eyelid, even primitive man. Still, to liven up the inside corner of the eye, you can add that little pinkish, reddish fold of skin.

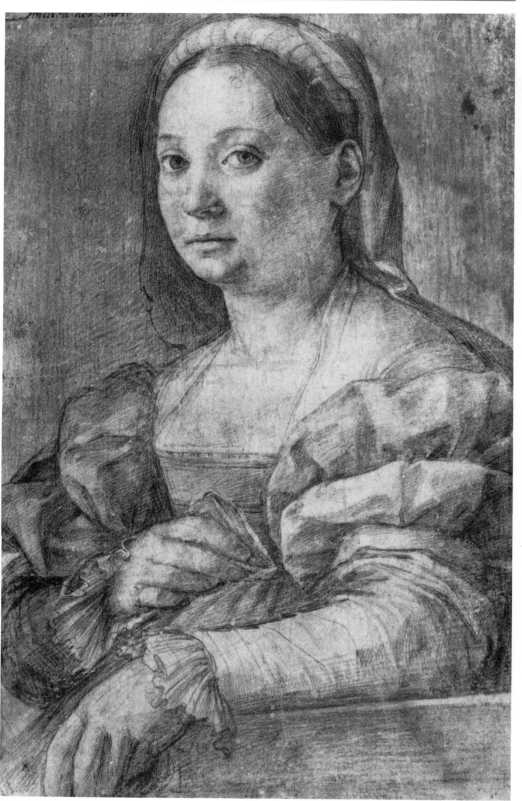

JACOPO DA PONTORMO (1494–1556)
PORTRAIT OF A LADY
black chalk
15⁵/16″ × 9⁹/16″ (38.9 × 24.3 cm)

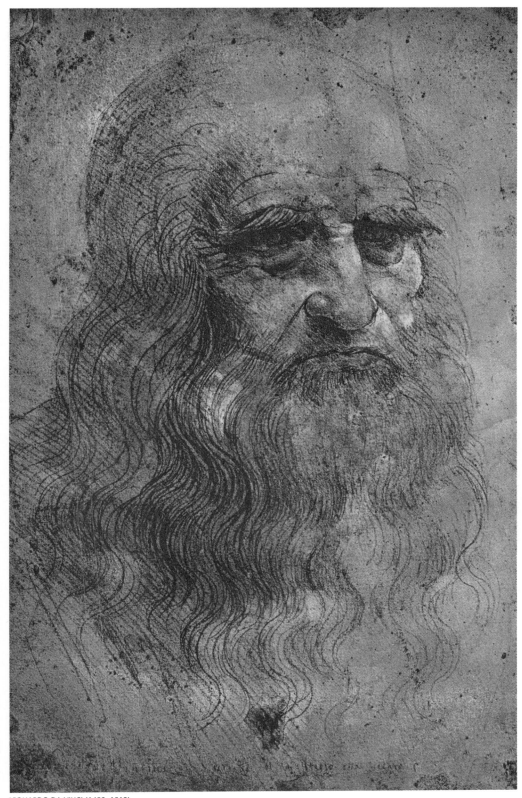

LEONARDO DA VINCI (1452–1519)
SELF-PORTRAIT
red chalk

THE EYE
Tear Bag

Underneath the lower eyelid is a vague form called the tear bag (A). Leonardo was aware that the line (B) on most people between the lower lid and the tear bag isn't always very clear. So in this self-portrait he has only lightly suggested it. The tear bag has nothing to do with tears, actually. It is misnamed because the tears generate in the thick upper eyelid, which has the tear glands in it. The tear bag is a soft bag of skin you see in elderly people more often than in young people. You may see it in young people if they have a hangover! It is sometimes used by artists to show decadence and dissoluteness.

TINTORETTO (JACOPO ROBUSTI) (1518–1594)
HEAD OF EMPEROR VITELLIUS
charcoal heightened with white
13¹¹/₁₆″ × 9¹³/₁₆″ (33.2 × 24.9 cm)

SAMUEL PALMER (1805–1881)
SELF-PORTRAIT
black and white chalk

THE EYE
Sausage

In this study of the eye by Tintoretto, you will notice that the upper line of the upper eyelid (A) is the base of an overhanging form (B) that artists call the sausage. It is a mass made up of two fleshy lumps (C and D) that lie above the eye on the outside. It is formed by the outer supraorbital eminence (the bony rim of the orbit of the eye) and the upper portion of the orbicularis muscle of the eye.

The "sausage" changes a good deal with age. As people grow older, like everything else, it begins to hang down. Old men look like eagles because the sausage falls down over the eye. And of course, the older they get, the lower it falls. When we get older, everything falls down. That's one of the terrible things about age!

THE EYE
Eyebrows

The eyebrows generally follow the upper line of the orbit. They are really like gutters. They carry the sweat or debris to the outside of the eye. You will notice that in this drawing, Palmer has lightened the outer part of the brows as they pass through the light (A) of the bony supraorbital eminence (B) above the eye. The inner part of the brow (C) is darkened because it is heavier and faces down, away from the light. We learn that the brows follow the curve and the lighting of the bony mass over which they travel.

Those are the principal facts about the eye, except the shading probably. The great idea in drawing any part of the figure, of course, is to see your masses and to throw your light on these masses. And keep your values simple. When students use more than two light sources, they often get into trouble.

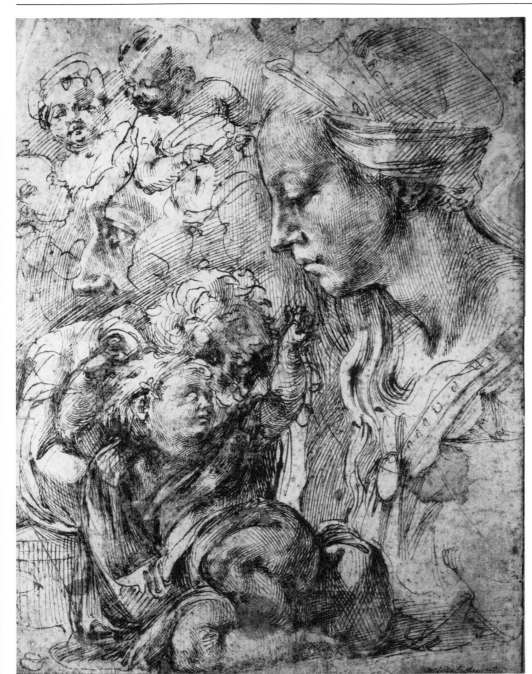

MICHELANGELO BUONARROTI (1475–1564)
SKETCHES AND LIFE STUDIES FOR THE TADDEI MADONNA
pen and ink
11¼″ × 8¼″ (28.6 × 20.9 cm)

THE EYE
Side View

We might look at a drawing of the side view of the eye from a page in Michelangelo's sketchbook. Artists sometimes drop a center line (A) from the up plane of the supraorbital bump (B). The growing back of the down plane of the glabella (C) is clearly in directional contrast to the up plane of the nasal bone (D). The orbit (E) of the eye moves back, down, and around. The essential thing is to feel the ball (F) of the eye protruding from the opening of the orbit and the lids circling over that ball. But that's not quite the whole story because the eye has a lens or cornea in front of it which bulges out. So if you draw a contour line (G) over a ball to get an eye, you have to draw your line not only around the ball, but also around the slight bulge of the cornea in front of the eye.

THE NOSE
Massing

Artists have very simple ways of
blocking the planes of the nose.
Here is an example of how Dürer
may have visualized it. With the
light coming from above left, we
can clearly see in this blocked-up
head the darkened down (A) and
side (B) planes, as well as the
light-struck up (C) planes of the
nose.

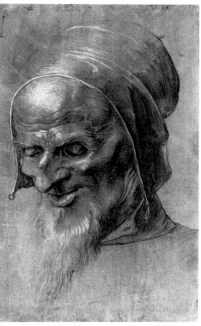

ALBRECHT DÜRER (1471–1528)
HEAD OF AN APOSTLE IN THE HELLER ALTARPIECE
brush drawing with black and white ink
12½″ × 8⅜″ (31.7 × 21.2 cm)

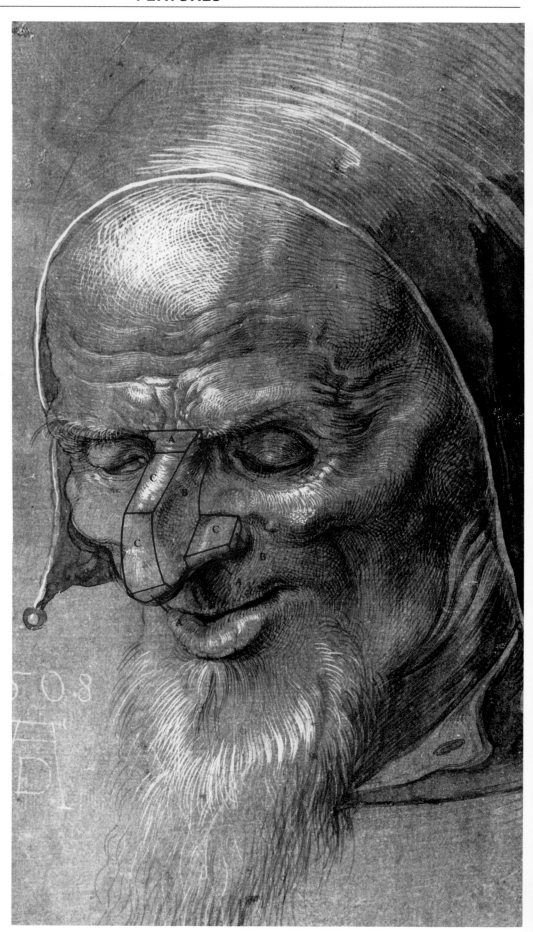

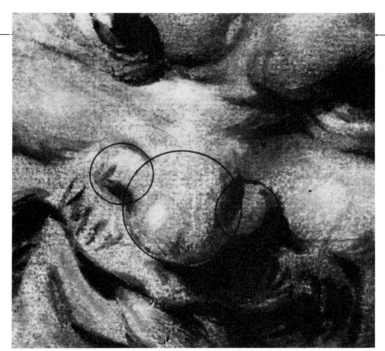

THE NOSE
Massing

An almost universal conception of the base of the nose used by the artist is simply three balls. The nose in Rubens' drawing is a variation on this simple concept. You will find that the ball is one of the most extraordinary symbols— you can't throw it out of perspective.

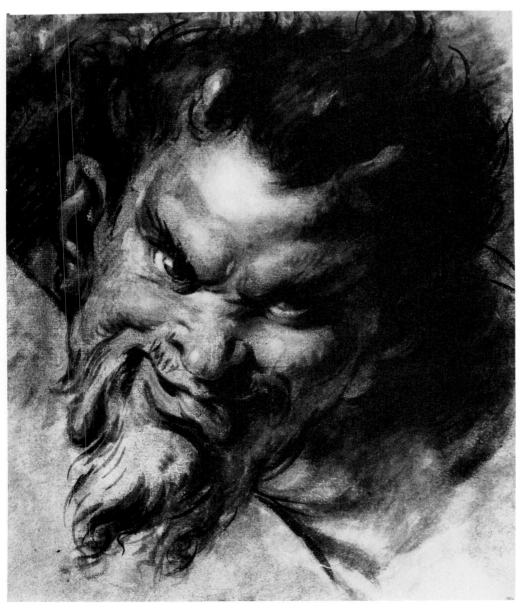

PETER PAUL RUBENS (1577–1640)
HEAD OF A SATYR
black and red crayon
10⅛" × 7½" (25.7 × 19 cm)

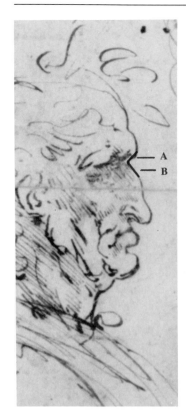

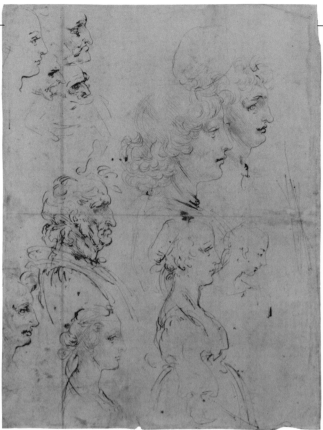

LEONARDO DA VINCI (1452–1519)
HEADS OF GIRLS AND YOUNG AND OLD MEN
pen and ink
15¹⁵/₁₆″ × 11⁷/₁₆″ (40.5 × 29 cm)

THE NOSE
Nasal Bone

Here in this drawing from one of Leonardo's sketchbooks, we can clearly see the plane change between the down plane of the glabella (A) and the up plane of the nasal bone (B). The glabella goes sharply backward and down, and the nasal bone just as sharply moves forward and up. This plane break is usually much less pronounced in female heads. Leonardo has probably exaggerated the softness of this plane change in the females on this page to contrast the feminine features with the rough angularity of the male.

LEONARDO DA VINCI (1452–1519)
STUDIES FOR *LEDA*
pen and ink over black chalk

THE NOSE
Nasal Bone

Leonardo knew that with the light from above, the up planes would be light. So he put a strong light on the up plane of the nasal bone (A). He then decided to put a little dark on the glabella (B) so that we would know that it is a down plane. The contrast of light and dark helps us to see the change of direction in these two planes.

THE NOSE
Nasal Angle

On both of the figures in this Dürer drawing, you can clearly see the nasal angle (A) or the change in angle and plane at the end of the nasal bone. This takes place at mid-nose, where the nose turns slightly downward from the bony upper portion (B) into the softer cartilage (C) of the lower nose.

ALBRECHT DÜRER (1471–1528)
HEADS OF YOUNG WOMAN
AND OLD WOMAN FROM BERGEN
silverpoint
5¹¹/₁₆" × 7½" (12.9 × 19.1 cm)

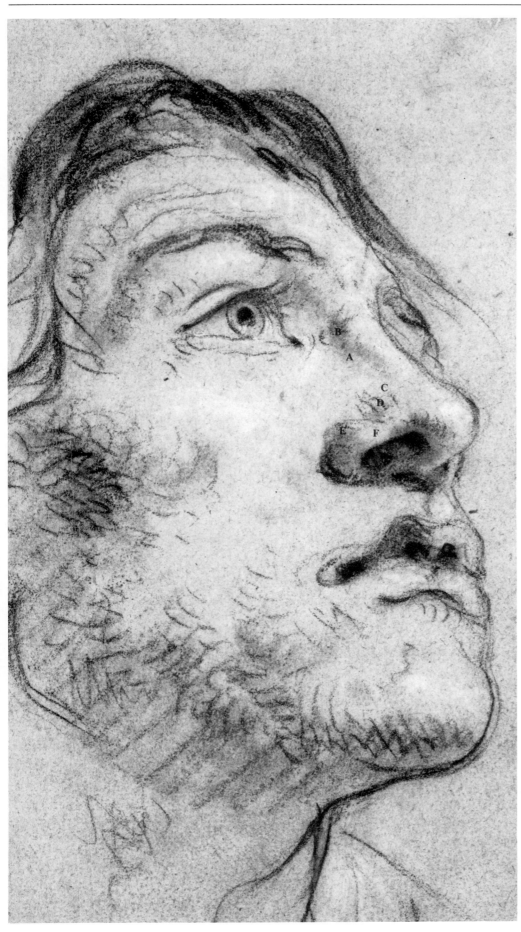

THE NOSE
Upper and Lower Lateral Ligaments and Wing

On either side of the nose is a ligament that makes a sort of roof on the side of the lower nose (A). It is called the upper lateral ligament. This ligament fills out the side of the nose in Tiepolo's drawing just below the dark side plane (B) of the nasal bone.

The lower lateral ligament (C), just under the upper lateral ligament, is sometimes called the comma cartilage because of its shape. Tiepolo has placed a group of curved hatch marks (D) to represent the shape and the dark down plane of this ligament. You can see this ligament very clearly on your horse—if you have a horse! It is just like yours, but the horse has a little bit more around the nose. You can feel the split if you touch your nose there. It curves downward and helps to form the inner part of the wing of the nose. The wing of the nose (E) is just a mixture of fat and skin. The nostrils (F), which are hooked onto the lower lateral ligament, are made up of cartilage and fat. All these things vary in size in different individuals.

The wing of the nose is very movable indeed, and it is responsible for a great many expressions: for instance, pulling up the nose in disgust. This expression comes from pulling up the wing of the nose. Watch the wing of the nose. Sometimes it goes up; sometimes it comes down. It gives a lot of character to the nose.

GIOVANNI BATTISTA TIEPOLO (1696–1770)
HEAD OF A YOUNG MAN
sanguine heightened with white on blue-gray paper
8³/₄″ × 6″ (22.2 × 15.3 cm)

THE MOUTH
Massing

Let's go down to the mouth. The nose is placed above the mouth, of course, so you can smell whatever goes into the mouth! The most important thing about the mouth is the feeling that it lies on a cylinder; in other words, it goes around the teeth. That is what is going to give form to the mouth. Think of false teeth, and think of how the lips go around them.

The line of the center of the mouth (A) will follow the direction of the cylinder, as it does in this Fragonard wash drawing. That is the most important thing. If the head is down, the cylinder and the line of the mouth on that cylinder both curve downward. This head is up so the cylinder and the line of the mouth curve upward. So, conceive your form and run the line over it. That is one of the secrets of craftsmanship.

JEAN-HONORÉ FRAGONARD (1732–1806)
HEAD OF AN ORIENTAL
wash drawing over black pencil

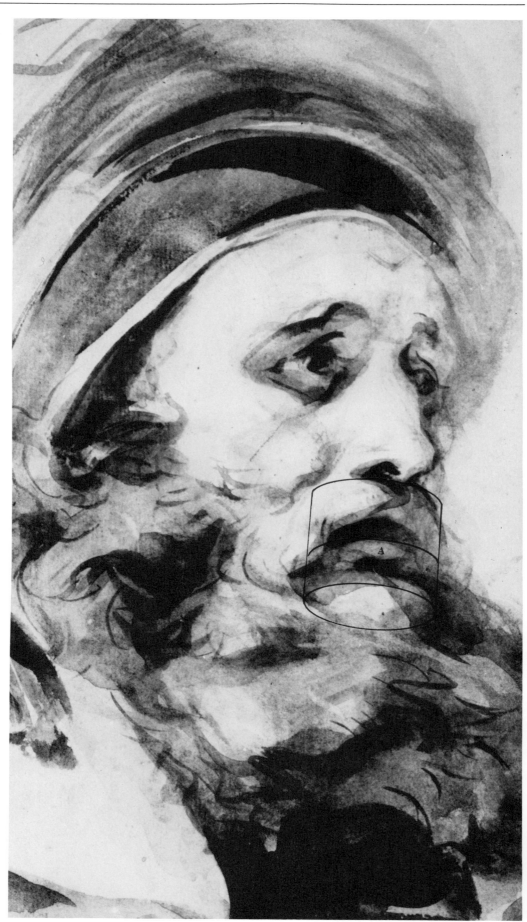

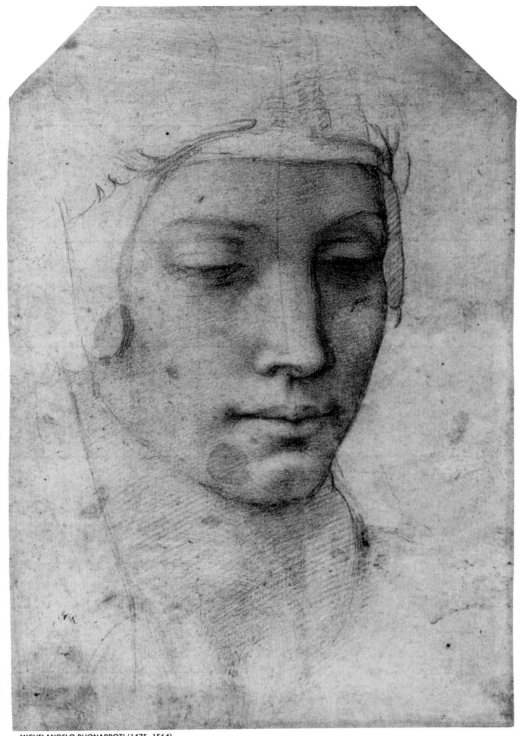

MICHELANGELO BUONARROTI (1475–1564)
HEAD OF A YOUNG WOMAN
black chalk

THE MOUTH
Lobes of the Lips

People think of the mouth as a cupid's bow and you see it so designated in books. I am not so sure you should only think of it that way because that is a pretty flat conception. You have to think of the lines of the mouth as moving over form. It helps to break the big masses of the upper and lower lips into the separate forms of the lobes. We can see these divisions clearly in Michelangelo's drawing. Anatomically, the upper lip has three lobes: the center lobe (A) and a lobe on either side (B and C). The lower lip has two lobes (D and E). When you draw the lips, think of the movement of the flesh. Carry the lines of the mouth over and around the masses of the lobes.

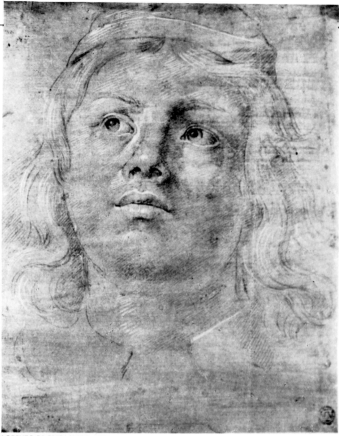

LORENZO DI CREDI (1459–1537)
HEAD OF BOY
chalk

THE MOUTH
New Skin

There is a curious thing, seldom mentioned. I have never even found it in the medical books. It's just a little string of white around the top of the upper lip (A), which has been called the "new skin." It's neither lip nor skin, however, and it is almost enough to be a little plane. It also runs along the bottom lip. Credi has emphasized it in his drawing with strong lights only above the upper lip. If you are observant, you will see it on a lot of people. If you are painting a portrait, watch it carefully. It is liable to take quite a bit of light in the planes facing the light. Of course, it will vary a little in width and in value as it moves across the masses of the lips.

EDGAR DEGAS (1834–1917)
GIOVANNA BELLELLI
black chalk

THE MOUTH
Philtrum

In this very sensitive Degas drawing, notice the space (A) in the center above the upper lip bounded by two slightly curved lines (B and C), which are really a meeting of light and dark planes. This little space is called the philtrum—from the Greek, "love filter." Degas has lit up the planes facing the light on the right and darkened the side planes facing away from the light. Note that the cast shadow from the nose in Degas' drawing doesn't make the black hole over the philtrum that you usually see in the drawings of beginners. This would destroy the meeting of planes in this delicate area. Instead, Degas moves the shadow a little to the side, and its softened edge curves subtly over the philtrum, echoing its shape.

LEONARDO DA VINCI (1452–1519)
STUDY FOR ST. BARTHOLOMEW IN *THE LAST SUPPER*
red chalk on red paper

THE EAR
Side View

Now, the ear. It is pretty easy to see ears at art school because there are a lot around! But at home it is pretty hard to see them without a mirror, and even then it is difficult.

In this Leonardo drawing, you can break down the ear anatomically into the outer rim of cartilage called the helix (A) and, on the inside, the antihelix (B), which goes upward and divides at the top. Below there is a small lobe named the tragus (C) on the inside of the opening of the concha (D). Opposite the tragus is another lobe called the antitragus (E) and, below, the very familiar large lobe of the ear (F).

The great feeling of the ear really is the feeling of an ear trumpet. That's what it is really—a trumpet. If you can get that feeling, ears are not too difficult to draw.

PROPORTIONS
Side View

Let's see what the artist does about solving the problems of proportion in drawing the head and features. Drawing portraits is a very difficult thing to do, and through the years artists have invented many aids to make it a little easier. The artist must first decide where things are in terms of mass. In other words, as we already know, you must still the object in space and then draw it from one aspect. The usual egg-and-ball concept of the head gives you the feel of the ball of the skull and the oval of the face. But it is not enough to give you direction. The only mass that will really give you a full sense of direction is a block. So the artist first puts the head of the model in a box.

In this drawing Leonardo has boxed up the head and given us some valuable rules for proportions of the head and features.

The overall proportions of this head measure about seven eye widths high by six eye widths wide. Leonardo has marked off what has become the traditional "rule of three" of the face. In the reverse writing alongside this sketch, he explains his divisions: "The roots of the hair (A) to the top of the head (B) ought to be equal to the distance from the bottom of the nose (C) to the meeting of the lips (D) in the middle of the mouth." He then marks off three equal distances: from the roots of the hair (A) or "widow's peak" to the eyebrow (E); from the eyebrow (E) to the base of the nose (C); and from the base of the nose (C) to the base of the chin (F). A second rule of three for the placement of the mouth puts the opening between the lips at the upper third (D) of the distance between the base of the nose (C) and the base of the chin (F).

Leonardo has placed a line (G) at the level of the pupil of the eye,

which falls in the middle of the head—that is, halfway between the top of the head (B) and the base of the chin (F). He also informs us that the distance from the angle or corner (H) of the eye socket to the ear hole (I) or auditory canal, on which he has made a little accent, is the same as the length (E–C) of the ear. And, if you drop a vertical line from the corner of the eye (H), it will pass through the bottom point (J) of the malar bone.

Of course, artists know that these proportions vary from person to person and that they are only average proportions from which to judge the variations. The reason that we talk about boxing up and dividing the masses, and urge you to practice these proportional devices often, is that not only will you be more sure and accurate, but you will also be able to deal more easily with the relationships of the features in more difficult poses. If you can think of

these forms as having some definite shape and size in your mind, and when you draw them you throw a little light on them, you have solved much of the problem of drawing. The drawing of portraits or of the whole body is a creative process, really. You have to create the shapes and then you throw a little light on them, and that is about all figure drawing is. You just create shapes to your heart's desire; that is part of the fun of being an artist. A verse from the *Rubaiyat of Omar Khayyam* illustrates that:

Ah Love! could you and I with Fate conspire
To grasp this sorry Scheme of Things Entire,
Would not we shatter it to bits—and then
Re-mold it nearer to the Heart's desire!

Figure drawing is very much like that.

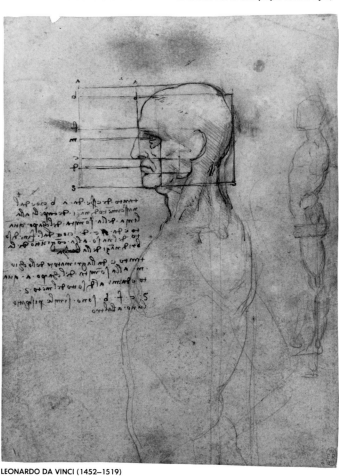

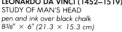

LEONARDO DA VINCI (1452–1519)
STUDY OF MAN'S HEAD
pen and ink over black chalk
8³⁄₈" × 6" (21.3 × 15.3 cm)

CREDITS

Grateful acknowledgment is made to the following museums, libraries, and collections for permission to reproduce artworks by the indicated artists:

Albertina, Vienna: works by Carracci (pp. 122–123), Dürer (pp. 5, 28–29, 118–119, 120, 130), Michelangelo follower (p. 49), Pontormo (p. 126), Raphael (pp. 98, 116), Rubens (p. 124).

Art Museum, Princeton University, Princeton, New Jersey: works by Cambiaso (p. 14, bequest of Dan Fellows Platt; p. 30, Laura P. Hall Memorial Collection).

Ashmolean Museum, Oxford: works by Guercino (p. 48), Palmer (p. 128), Parmigianino (p. 50), Titian (p. 107).

British Museum, London: works by Michelangelo (pp. 32, 36, 44–45), Polidoro (p. 97), Rembrandt (p. 21), Sarto (p. 13), Signorelli (p. 35).

Casa Buonarroti, Florence: work by Michelangelo (p. 1).

Clark Art Institute, Williamstown, Massachusetts: works by Degas (p. 59), Puvis de Chavannes (p. 31).

Cleveland Museum of Art, Cleveland: works by Piazzetta (pp. 100–101, purchase from the J. H. Wade Fund), Tiepolo (p. 135, Charles W. Harkness Endowment Fund).

Devonshire Collection, Chatsworth, by permission of the Trustees of Chatsworth Settlement; photographs courtesy of Cortauld Institute of Art, London: works by Poussin (p. 78), Rubens (p. 22).

Indiana University Art Museum, Bloomington: work by de Ribera (p. 87, William Lowe Bryan Memorial Collection).

Kunsthalle, Bremen: work by Dürer (p. 18).

Louvre, Paris: works by Cellini (p. 108), Credi (p. 138), Degas (p. 138), Fragonard (p. 136), Michelangelo (p. 82), Primaticcio (p. 86), Prud'hon (pp. 80–81), Rubens (pp. 73, 131).

Metropolitan Museum of Art, New York: work by Degas (p. 79, H. O. Havemeyer Collection, bequest of Mrs. H. O. Havemeyer, 1929).

Musée Bonnat, Bayonne, France: works by Delacroix (p. 33), Tintoretto (p. 72).

Musée Conde, Chantilly, France: work by Dürer (p. 134, from the *Netherlands Sketchbook*).

Musée Wicar, Palais des Beaux Arts, Lille: work by Raphael (p. 40).

National Gallery of Art, Washington, D.C.: work by Cambiaso (p. 56, Alisa Melon Bruce Collection).

New York Academy of Medicine, New York: plates by Albinus (pp. 24, 46, 54, 69, 112–113, 117, all from *Tabulae Sceleti et Musculorum Corporis Humani*), Vesalius (pp. 61, 62, 68, 75, all from *De Humani Corporis Fabrica*).

Philadelphia Museum of Art, Philadelphia: work by Eakins (p. 23, gift of Mrs. Thomas Eakins and Miss Mary A. Williams).

Pierpont Morgan Library, New York: works by Rubens (pp. 88–89), Tintoretto (p. 128).

Royal Library, Turin: work by Leonardo (p. 127).

Royal Library, Windsor, by gracious permission of Her Majesty the Queen: works by Domenichino (pp. 58, 83), Leonardo (pp. 9, 19, 25, 27, 43, 51, 70–71, 74, 76, 77, 84, 90, 91, 92–93, 96, 102, 103, 106, 109, 111, 133, 133–134, 139, 140), Michelangelo (pp. 38–39, 137), Poussin (p. 114), Raphael (pp. 15, 52–53, 105), Giulio Romano (p. 41).

Saxon State Library, Dresden: works by Dürer (pp. 17, 34, 64, 65, 66, 67, 94, 99, 104, 115).

Staatliche Museum, Berlin: works by Cranach the Younger (pp. 124–125), Michelangelo (p. 129), Rubens (pp. 20, 60, 121), van de Velde (p. 110).

Staatsgallerie, Stuttgart: work by Tiepolo (p. 95).

Städelsches Kunstitut and Städtische Gallerie, Frankfurt: work by Raphael (p. 57).

Teyler Museum, Haarlem: works by Michelangelo (p. 2), Raphael (p. 16).

Uffizi, Florence: work by Tintoretto (p. 42).

BIBLIOGRAPHY

ADDITIONAL BOOKS BY ROBERT BEVERLY HALE

Anatomy Lessons from the Great Masters (co-authored by Terence Coyle). New York: Watson-Guptill Publications, 1977

Drawing Lessons from the Great Masters. New York: Watson-Guptill Publications, 1964.

AUDIOVISUAL MATERIAL BY ROBERT BEVERLY HALE

Video Lectures on Artistic Anatomy and Figure Drawing. New York: Jo-An Pictures Ltd. Available at: The Art Students League of New York, 215 West 57th Street, New York, N.Y. 10019.

FURTHER READING ON ANATOMY

Gray, Henry, F. R. S., *Gray's Anatomy: The Classic Collector's Edition.* New York: Bounty Books, 1977 (originally published 1901).

Richer, Dr. Paul, *Artistic Anatomy,* edited and translated by Robert Beverly Hale. New York: Watson-Guptill Publications, 1971.

FURTHER READING ON THE ELEMENTS OF DRAWING

Blake, Vernon, *The Art and Craft of Drawing.* New York: Dover, 1951. (Reproduction of 1927 ed. New York: Hacker, 1971.)

D'Amelio, Joseph, *Perspective Drawing Handbook.* New York: Van Nostrand Reinhold, 1984.

INDEX

A

Abdomen, 27, 31, 36, 40
Abductors, 45, 46, 69, 96, 97, 102
Acetabulum, 47
Achilles' tendon, 62, 69
Acromion process, 76, 77, 85
Adam's apple, 109
Adductors, 45, 46, 50, 69, 102
Albinus, Bernard Siegfried, 24, 46, 54, 69, 71, 112–113, 117
Ankle, 34, 60, 63, 65, 67, 69, 71
Anterior superior iliac spine, 37
Antihelix, 139
Antitragus, 139
Arm, *see* Upper arm; Lower arm
Astragalus, 71
Atlas, 112
Axis, 112

B

Back, muscles of, 21, 24
Backbone, *see* Vertebral column
Biceps, 73, 76, 84; brachii, 92; femoris, 46, 49, 55
Blocking, *see* Massing
Bones, of foot, 71; of hand, 103; of knee, 55; of lower arm, 85; of lower leg, 63; of neck, 112–113; of pelvis, 36–37; of rib cage, 25–26; of shoulder girdle, 77; of upper arm, 85; of upper leg, 47
Brachialis, 84
Breast, 23, 26, 105, 106
Bursa, 55
Buttocks, 26, 80

C

Calcaneus (heel bone), 47, 62, 63, 71
Calf, 58, 61, 62, 67, 69
Cambiaso, Luca, 14, 15, 30, 56, 57, 78
Camper, 117
Capitulum, 85, 92
Carpus, 102, 103
Carracci, Annibale, 122, 123
Caruncula, 126
Cellini, Benevenuto, 108
Cervical vertebra, 19, 25, 26, 74, 75, 112
Cheekbone, *see* Malar
Chin, 106, 118, 140
Clavicle (collar bone), 18, 25, 27, 34, 37, 73–77, 85, 110, 111
Clavicular portion, 76
Collar bone, *see* Clavicle
Comma cartilage, 135

Complexus, *see* Erectors of spine
Condyles, 47, 48, 55, 63, 83, 85
Coracoid process, 77, 85
Cornea, 129
Cranach, Lucas, the Younger, 124–125
Credi, Lorenzo di, 138
Cuboid, 63, 71

D

Degas, Edgar, 59, 78, 138
Delacroix, Eugène, 33
Deltoid mass, 73–77, 80, 83, 84
Domenichino, 58, 83
Dorsal vertebrae, 27, 75, 112
Double aspect, 57
Dürer, Albrecht, 17, 18, 28, 29, 34, 64–67, 94, 99, 104, 105, 115, 118–120, 130, 134

E

Eakins, Thomas, 23
Ear, 109–111, 118, 120, 121, 139, 140
Elbow, *see* Olecranon
Ensiform cartilage, 26
Erectors of spine, 21, 24, 112
Extensors, 60, 61, 68, 90
External oblique, 21, 22, 31–33, 35, 36, 45
Eye, 118, 120, 122–129, 140; construction of, 122; side view of, 129
Eyeball, 122, 124, 129
Eyebrows, 118, 128
Eyelashes, 124
Eyelid, 124; "third," 126

F

Features, 122–140; proportions of, 140; *see also* Ear, Eye, Head, Mouth, Nose
Femur (thighbone), 35, 36, 42, 45, 47, 48, 50, 55, 63
Fibula, 46, 47, 49, 53, 58, 63, 69
Fingers, 91, 94, 95, 97–99, 103
Flesh, 21, 25
Flexor(s), 85, 90, 91; carpi ulnaris, 102
Foot, 60, 64–71; bones of, 71; landmarks of, 66–67; massing of, 64; muscles of, 68–69; planes and values of, 65
Forehead, 116
Foreshortening, 107
Form, basic, 14, 15, 90; of breast, 23; illusion of, 82, 94; light and, 82; three-dimensional, 73
Fragonard, Jean-Honoré, 136
Frontal bone, 122
Frontal eminence, 118

G

Gastrocnemius, 60, 62, 68
Glabella, 118, 122, 129, 132
Glenoid cavity, 77, 84, 85
Gluteal fold, 35
Gluteus maximus, 27, 33, 35
Gluteus medius, 33, 35, 36, 45, 46, 84
Groin, 36
Guercino, 48

H

Hair, 109, 118, 140
Hamstring group, 41, 42, 46, 53–55, 58, 62, 69, 84
Hand, 84, 94–103; bones of, 103; landmarks of, 98–101; massing of, 94–95; planes and values of, 96–97; short muscles of, 102–103
Head, 27, 106, 109, 121; features of, 122–140; proportions of, 140; *see also* Skull
Heel bone, *see* Calcaneus
Helix, 139
Hips, 32; *see also* Pelvis
Humerus, 75, 77, 83–85
Hypothenar eminence, 102

I

Iliotibial band, 43
Ilium, 36
Infraspinatus, 75, 77
Innominate bones, 36
Instep, 60, 69
Iris, 124
Ischium, 36, 37, 46, 47

J

Jugular notch, *see* Neck, pit of

K

Knee, 25, 46, 48–55, 69, 83; bones of, 55; landmarks of, 51; massing of, 48; muscles of, 53–54; planes and values of, 49–50; proportions of, 48
Knuckles, 99, 103

L

Landmarks, of foot, 66–67; of hand, 98–101; of knee, 51; of lower arm, 90; of lower leg, 60; of neck, 109–110; of pelvis, 34, 37; of rib cage, 18–19; of shoulder girdle, 74; of skull, 117–120; of upper arm, 83; of upper leg, 43
Latissimus dorsi, 21, 22, 24, 74, 76

Leg, 39, 82; *see also* Lower leg, Upper leg
Lens, 129
Leonardo da Vinci, 19, 25, 27, 43, 44, 51, 70–71, 74, 76, 77, 84, 88, 90, 92–93, 96, 97, 102, 103, 106, 109, 111, 127, 133–134, 139
Levator anguli scapulae, 75
Lighting, 16, 31, 33, 42, 82, 87, 96; on back, 22; on breast, 23; on foot, 65; *see also* Values
Line of angle of ribs, 37
Linea alba, 21
Lips, 118, 137, 140
Longitudinal arch, 68, 69
Lower arm, 72, 84, 86–93; bones of, 92; landmarks of, 90; massing of, 86; muscles of, 90–91; planes and values of, 87–88
Lower leg, 56–63; bones of, 63; landmarks of, 60; massing of, 56–57; muscles of, 60–62; planes and values of, 58–59
Lumbrical muscles, 102

M

Malar (cheekbone), 118, 120, 140
Massing, of foot, 64; of hand, 94–95; of knee, 48; of lower arm, 86; of lower leg, 56; of mouth, 136; of neck, 104–106; of nose, 130–131; of pelvis, 28, 30; of rib cage, 14–15; of shoulder girdle, 72; of skull, 114–115; of upper arm, 78; of upper leg, 39
Mastoid process, 109, 111
Matisse, Henri, 39
Metacarpals, 85, 103
Metatarsals, 60, 62, 64, 71
Michelangelo Buonarroti, 32, 36, 38–39, 45, 60, 67, 72, 82, 83, 88, 129, 137
Model stand, 56
Mouth, 136–138; lips, 118, 137, 140; massing of, 136
Muscles, of back, 21, 24; of foot, 68–69; of hand, 102–103; of knee, 53–54; of lower arm, 90–91; of lower leg, 60–62; of neck, 111–112; origin of, 43; pelvis and, 35–36; rib cage and 20–22; of shoulder girdle, 75–76; of upper arm, 84–85; of upper leg, 45–46
Mylohyoid, 109

N

Navel, 21, 26, 31, 36
Navicular (scaphoid), 47, 63, 71, 85, 102
Neck, 73, 104–113; bones of, 112–113; landmarks of, 109–110; massing of, 104–106; muscles of, 111–112; pit of, 18, 25, 26, 34, 75, 76, 109, 110; planes and values of, 107–108
Nipple, 23, 26, 106
Nose, 26, 109, 117, 118, 130–135, 140; angle of, 134; bones of, 118, 129, 132, 135; lateral ligaments of, 135; massing of, 130, 131
Nostrils, 135

O

Occipital tubercle, 109, 110
Olecranon (elbow), 83, 90, 92
Opponens, 102
Orbicularis, 128
Orbit, 122, 128

P

Palm, 84, 86, 90, 103
Palmer, Samuel, 128
Parmigianino, 50
Patella, 45, 48–51, 53, 55, 67, 69
Pectoralis, 15, 17, 23, 107; major, 20, 73, 76; minor, 76
Pelvis, 21, 27, 28–37, 75, 83, 84; bones of, 36–37; crest of, 21, 30, 35, 46, 69; female, 28, 37; landmarks of, 34, 37; male, 37; massing of, 14, 28, 30; muscles of, 35–36; planes and values of, 31–33
Peroneus longus, 60, 68, 69
Perspective, 14, 56–57, 114, 115
Phalanges, 64, 71, 96
Philtrum, 138
Piazzetta, Giovanni Battista, 100–101
Pillow muscle, 84
Pisiform bone, 102
Planes, of foot, 65; of hand, 95–97; of knee, 49–50; of lower arm, 87–88; of lower leg, 58–59; of neck, 107–108; of pelvis, 31–33; of rib cage, 16–17; of shoulder girdle, 73; of skull, 116; of upper arm, 79–83; of upper leg, 40–42

Plica, 126
Polidoro Caldara da Caravaggio, 97
Pontormo, Jacopo da, 126
Popliteal space, 54
Poupart, Jean François, 36
Poupart's ligament, 36
Poussin, Nicolas, 78, 114
Primaticcio, Francesco, 86
Pronation, 90–92
Pronator teres, 92
Proportion 26, 30, 37, 85, 140
Prud'hon, Pierre Paul, 80, 81
Pubis, 36
Pupil, 124
Puvis de Chavannes, Pierre, 31

Q

Quadriceps group, 41–43, 45, 46, 51, 53, 54, 69

R

Radius, 85, 90, 92, 98, 103
Raphael Sanzio, 15–17, 40, 57, 88, 98, 105
Rectus abdominus, 21, 31, 36; femoris, 45, 51
Rembrandt van Rijn, 21
Rhomboid mass, 75
Rib cage, 14–27, 72–75; bones of, 25–26; breast and, 23; landmarks of, 18–19; massing of, 14–15; muscles and, 20–22, 24; pelvis and, 28, 37; planes and values of, 16–17; vertebral column and, 27
Ribera, José de, 87
Richer, Dr. Paul, 26, 37, 47, 63, 85
Romano, Giulio, 41
Rubens, Peter Paul, 20–22, 52, 53, 60, 73, 88–89, 116, 120, 124, 131
Rule of three, 140

S

Sacrum, 19, 22, 24, 30, 32, 35–37, 47
Sartorius, 31, 43, 45, 55, 60
Sausage, 128
Scaphoid (navicular), 47, 63, 71, 85, 102
Scapula (shoulder blade), 21, 25, 26, 30, 74, 75, 77, 80, 84, 85, 111

Sclera, 124
Semimembranosus, 46
Semitendinosus, 46
Serratus, 20
Sesamoid bones, 51, 55
Shape, see Form
Shinbone, see Tibia
Shoulder blade, see Scapula
Shoulder girdle, 72–77; bones of, 77; landmarks of, 74; massing of, 72; muscles of, 75–76; planes and values of, 73
Signorelli, Luca, 35
Skull, 25, 26, 75, 109–112, 114–121; child's, 121; landmarks of, 117–120; massing of, 114–115; planes and values of, 116
Soleus, 62, 68
Spinal cord, 27, 112
Spine, see Vertebral column
Spleen, 18
Splenius capitis, 112
Sternocleidomastoid, 111
Sternomastoid, 33, 106, 109, 110
Sternum, 18, 20, 23, 25, 26, 76
Sternum boxes and lengths, 26, 37, 85
Strong cords, see Erectors of spine
Styloid, of radius, 90, 92, 98, 103; of ulna, 90, 98, 103
Superciliary eminence, 122
Supination, 84, 86, 90–91, 103
Supinator longus, 90–92
Supraorbital eminence, 128, 129
Supraspinatus, 77
Suprasternal notch, see Neck, pit of
Symmetry, 23
Symphysis pubis, 36

T

Tailor's muscle, see Sartorius
Talus, 47, 63
Tarsals, 64, 71
Tear bag, 127
Tensor fasciae latae, 43, 80
Teres major, 74–76; minor, 75, 77
Thenar eminence, 102
Thenar mass, 98
Thigh, 42, 67; see also Upper leg
Thighbone, see Femur
Thoracic vertebrae, 27
Thumb, 71, 96, 98, 102, 103

Thyroid cartilage, 109
Thyroid gland, 109
Tibia (shinbone), 43, 47, 48, 54, 55, 60, 62, 63, 65, 67, 69
Tibialis anterior, 49, 60, 61, 65, 68
Tiepolo, Giovanni Battista, 95, 135
Tintoretto, 42, 72, 128
Titian, 88, 107
Toes, 65, 66, 68, 69, 71
Tragus, 139
Trapezius, 75, 109, 111
Triceps, 77, 80, 84
Trochanter, great, 34–36, 42, 45–47
Trochlea, 85

U

Ulna, 85, 90, 92, 98, 103
Ulnar furrow, 88, 90
Upper arm, 72, 78–85; bone of, 85; landmarks of, 83; massing of, 78; muscles of, 84–85; planes and values of, 79–83
Upper leg, 38–47, 72, 84; bones of, 47; landmarks of, 43; massing of, 39; muscles of, 45–46; planes and values of, 40–42

V

Values, in foot, 65; in hand, 96–97; in knee, 49–50; in lower arm, 87–88; in lower leg, 58–59; in neck, 107–108; in pelvis, 31–33; in rib cage, 16–17; in shoulder girdle, 73; in skull, 116; in upper arm, 79–83; in upper leg, 40–42; see also Lighting
Van de Velde, Adriaen, 110
Vastus externus, 41, 45, 51; internus, 43, 45, 51, 53
Vesalius, Andreas, 60–62, 68, 75
Vertebral column, 21, 22, 27, 30, 32, 35, 36, 74, 75, 112

W

Waist, 33
Water bag, 55
Windpipe, 109
Wing of nose, 135
Wrist, 72, 98, 103

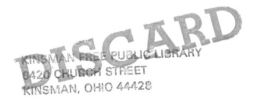
Edited by Sue Heinemann
Designed by Bob Fillie
Graphic production by Hector Campbell
Text set in 8-point Times Roman

743 45,412

Hale, Robert Beverly
Master class in figure drawing

DATE DUE
